Discover
Watercolor

NORTH LIGHT BOOKS
CINCINNATI, OHIO
WWW.ARTISTSNETWORK.COM

Contents

Introduction

Watercolor is the most popular of all the painting media, and with good reason. Its spontaneity and versatility—and ability to render the transient effects of light—are unmatched by any other medium. It can be used for work in a wide range of styles from traditional landscapes built up from layers of subtle washes, to brightly coloured semi-abstract studies in which watercolor is mingled with other media.

The first chapter, **Techniques**, shows you how to tackle some of the most familiar and difficult watercolor subjects. You'll find techniques for handling all the elements of a landscape, from skies, water and weather to the components that can be found within it, including trees, animals and buildings. With watercolor there are limited opportunities for making amendments, so planning is essential for a successful painting. You need to consider where the lightest and darkest areas are, for instance, and in what order the washes will be applied. Each subject is thoroughly analyzed and a method of working described and illustrated. To master these techniques and start developing your own style, you should work through the mini step-by-step demonstrations, and reproduce the finished images.

The second chapter, **Mixing Colors**, suggests a working palette of 12 colors, which are all you need. You are encouraged to explore each of the colors in turn and to experiment with a range of mixes. Painting your own set of charts will help you get to know the paints in your palette, as well as providing a useful reference.

The final chapter, **Projects**, offers the opportunity to observe some of the best watercolor practitioners at work on a range of landscapes, and to see the techniques from Chapter 1 put into practice. Watching other artists is one of the best ways of learning and of picking up tips, shortcuts and tricks of the trade. You can either work through the step-by-step projects, or find similar subjects and paint them using the techniques described.

The projects have been selected to provide as diverse a range of landscapes, interpretations and styles as possible. Watercolor lends itself to creating atmospheric effects. In "Country garden" (page 117), for example, a combination of watercolor and gouache achieves a study that shimmers with light. Buildings in a landscape provide other fascinating compositional possibilities, from a tumbling "Mountain hamlet" (page 127) built up from transparent wet-in-wet washes, to the exuberant study of Santa Maria della Salute hovering over the waters of "The Grand Canal" (page 205). Water itself is a unique element in a landscape, reflecting and distorting the light. Its translucent quality may be captured by working from light to dark and using fluid brushmarks, as in "Bustling harbor" (page 141).

Watercolor is a craft skill and a combination of instruction and practice is needed to acquire the deftness of touch and confidence that are essential to produce good paintings. This book not only provides a wealth of clear instruction but also a wide range of projects and images that will certainly inspire you to take up your brush and give it a try.

Much of watercolor's charm, and a lot of its difficulty, comes from its inherent unpredictability. Many watercolor processes exploit wet washes and these behave in different ways depending on the amount of water, the nature of the surface and the pigment, and the prevailing temperature and humidity. A thorough understanding of the materials and techniques will give you the best chance of mastering this demanding, but highly rewarding, medium. Combine in-depth knowledge with regular practice, and you will see immense improvements in your pictures.

This chapter deals with some of the most challenging watercolor subjects and themes. If you have ever struggled with ways of rendering light, painting convincing shadows, sparkling water or the texture of fur and feathers, you will find the explanations, suggestions and tips here of enormous value. Techniques are illustrated in several ways —in simple four-step projects, in especially commissioned illustrations or by analyzing the work of well-known watercolor artists. Even if you already have your own method of tackling a misty or snowy landscape, it is always worth adding a new technique to your repertoire.

Planning washes

In traditional watercolor painting, the white of the paper is the only white used. One of your first challenges is planning your painting so that you reserve the areas that are to be white or light in color.

Working from light to dark lets you build up color and tones gradually. This is vital because with watercolor it is very difficult to correct mistakes. Most watercolor sets include a white paint that can be used for highlights and white objects. However, in the purist forms of watercolor white paint is never used because washes lose some transparency when it is added. In what is known as transparent watercolor, it is the white paper shining through the paint layers that gives the medium its special luminosity. The white of the paper is the only white

used and is the lightest tone. Highlights and light areas are created by leaving the paper unpainted. The white of the paper stands for the white of clouds, buildings, snow and white flowers, for instance, as well as for the highlights visible on reflective surfaces.

You need to plan white areas, then develop tones and colors gradually. The simplest way of doing this is to work around highlights and any areas that are white in color. This means defining where these fall, then laying separate color washes of deepening intensity around them (see next page).

Key points

● Plan white and highlight areas first before you start applying any color.

● Plot white areas in an outline drawing and work carefully around them.

● Apply light tones first, building toward dark tones and intense colors.

● Use masking fluid to help you reserve white and lights.

● To render pale colors, dilute the paint with water instead of mixing it with white paint.

Taking a closer look

In this atmospheric painting, the artist has reserved selected areas of white paper to dramatic effect.

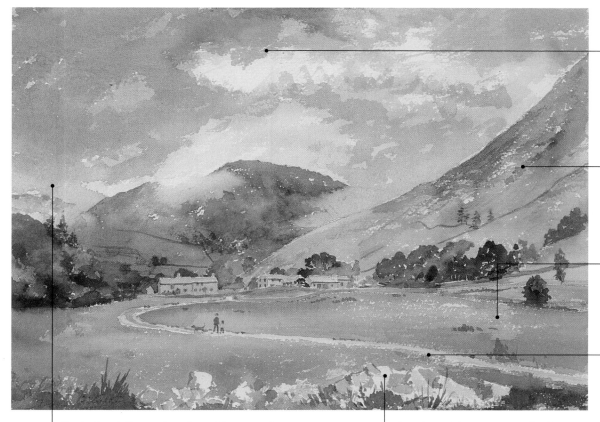

Mountain scene
by *Dennis Gilbert*

An angry sky is created working from light to dark, leaving the white paper for the lightest clouds and adding progressively darker tones that overlap.

The nearest hill is painted with a light green wash, leaving small white areas unpainted to express light on the rocky landscape.

The rough surface texture of the paper has caused small white areas to remain in the green wash. They convey a sense of dappled light.

White paper has been left to stand for the pale color of the winding path and the stone of the wall.

The farthest hills recede with a mid-gray wash. A darker tone brings the next range closer, while the palest wash is used for low cloud.

The white of the paper gives bright highlights where the strongest light falls on the rocks in the foreground.

Reserving the whites

Try this simple exercise to get used to the light-to-dark approach. You will see how the layers of wash are slowly built up, leaving the white of the paper for the lightest areas.

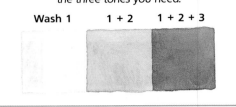
In practice **Using layered washes**

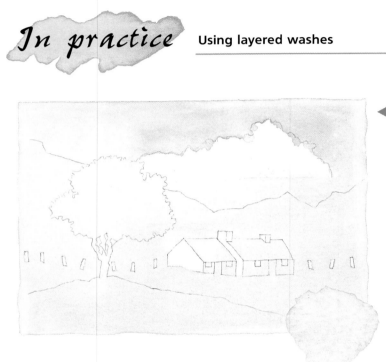

1 The simplest way to create areas of white color and white highlights is to paint around them. Start by drawing the elements of the composition in outline, including the patterns of light and shade. Using your palest wash, paint carefully around the sharp-edged areas of the cottages and the fence posts, and apply the wash more loosely around the palest clouds. Allow the paint to dry.

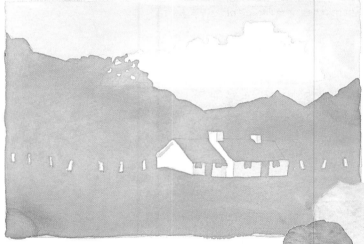

2 Using a slightly darker wash, fill in the mid-tone areas of the distant hills and the roof, door and window details on the buildings, again painting around the light areas of the cottage walls and the fence posts. Leave this second wash to dry before adding the darkest wash.

3 Add more Payne's gray to the wash and paint the areas of darkest tone and deepest shadow, thus bringing the tree and the foreground forward in the picture and emphasizing the rooftops.

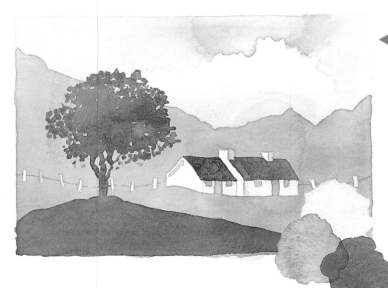

Tip

Make sure each wash is thoroughly dry before you apply the next. This will ensure the washes dry with crisp edges. A hair drier helps speed up the process, but do not hold it too close to the painting or you will blow rivulets of paint across the support.

Adding details

Watercolor is often thought of principally in terms of broad washes, but remember that details are important, too. The trick is to find the right balance between the two.

Watercolor demands careful planning. Before you start painting, think hard about what to include and what to omit. This is particularly important when it comes to details. If you are dealing with a complicated subject, for instance, it is better to start by applying light tones and generalized washes, adding the darker tones and the more precise details toward the end. This method of working gives you a considerable degree of control. Some subjects—including many landscapes—are most effective if reduced to a series of simple washes with a few key details put in at the end. In other cases, where there is more detail to consider (such as in a townscape), a more meticulous approach is required.

Taking a closer look

In this evocative and economical watercolor, the artist has combined a series of delicate washes with touches of telling detail applied wet on dry with the tip of a small brush.

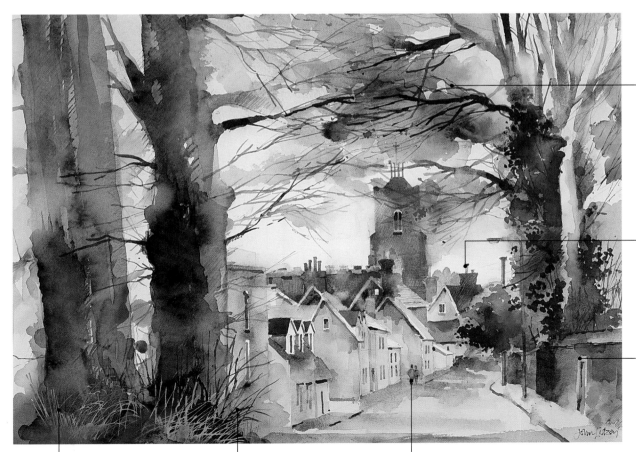

Mount Street, Diss
by *John Lidzey*

The thin branches have been painted using the tip of a small sable brush. The artist worked toward the tip of each branch.

Chimneys silhouetted against the sky give a sense of scale.

Details in the foreground—such as the doorway here—bring this area forward and convey a sense of recession in the rest of the picture.

Grasses seen light against the dark trunk have been masked with pen and masking fluid.

Grasses seen dark against light have been painted with the tip of a fine brush.

Figures are easily distinguished even when small—here they lead the eye in and provide clues to recession.

Choosing key elements

Too much detail can be confusing, but selected items can pull a picture together, lead the eye in and give clues to scale and recession.

An artist has complete freedom to select, edit, exaggerate and even invent. Decide what is important and avoid cluttering your composition with superfluous features. Every element in your painting should be there for a reason, contributing to the story you want to tell. Some subjects, such as wildlife and botanical studies, demand meticulous treatment, but mostly you need to include a certain amount of detail—not all of it.

Using specific features

Although it's easy to see the sand, sea, promontory and sky in this study (inset right), the spatial relationships are not clear, and without obvious focal points the eye wanders aimlessly. Adding details (below) makes the painting more focused and easier to read. The masts provide strong verticals, echoed in the foreground and balanced by the horizontals of the horizon and buildings. The figures, although sketchy, give a sense of scale.

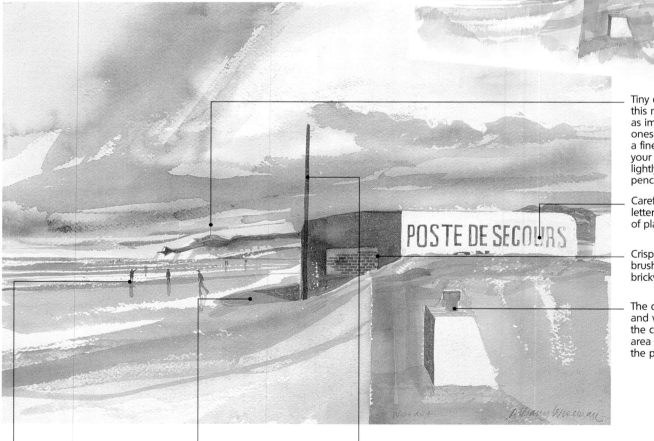

Tiny details, such as this mast, are just as important as larger ones—if you can't get a fine enough line with your brush, draw it lightly with a sharp pencil.

Carefully rendered lettering gives a sense of place.

Crisp wet-on-dry brushstrokes make the brickwork stand out.

The definite shape and warm color of the chimney pull this area to the front of the picture.

Figures help create a sense of scale.

Cast shadows establish the horizontal ground plane.

The mast in the center of the picture provides a dynamic pivot for the whole painting.

Light fantastic

Light is often the real subject of a landscape painting. It can reveal and conceal forms, establish a mood, modify colors and change apparent spatial arrangements.

Light is insubstantial, elusive and transitory. You can see its effects, but you can't touch it or feel it. We depend on light to see, and it affects the way things look and even influences our mood. In many paintings, the landscape is merely a foil for the light, a screen onto which it is projected.

The aspects of light that concern the painter are intensity and luminosity.

Capture the intensity of bright sunlight by exaggerating the contrasts between the sunlit areas and the shadows. Use wet-on-dry techniques and masking to give them crisply defined edges. Suggest the luminosity of light by making the transitions between one tone and another as imperceptible as possible—the light should appear to emanate from the support.

Key points

- Light and tone allow you to model form and create the illusion of volume and three dimensions.

- Light affects appearances—a white cat becomes gray in certain lights.

- Light affects the mood of a painting.

- Paintings that are suffused with light can be cheerful and bright or soft and delicate.

- Use body color, that is watercolor with white added, or gouache to touch in highlights.

Taking a closer look

In this subtle and luminous study, the artist has captured the warmth of the light splashing onto the pink, stuccoed facades lining a Venetian canal.

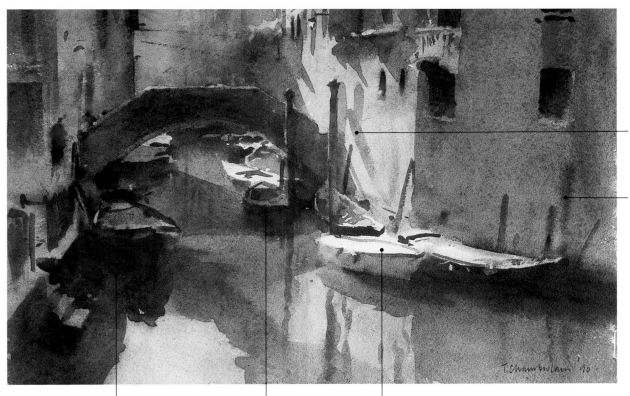

A quiet canal in Venice, 1990 by *Trevor Chamberlain* (Private collection/ Bridgeman Art Library)

Cool shadows contrast with the warmth of the sunlit areas.

A slight granulation of the wash makes this area shimmer.

Velvety dark shadows contrast dramatically with the pale reflection of the sky.

In deep shadow, the boats look blue—there is not enough light to show what color the boat really is.

In very bright sunlight, the boats appear brilliant white, regardless of their actual color.

Painting shadows

Watercolor offers a range of hard and soft edges, making it ideal for rendering shadows. Directly applied or subtly blended color, or using a layering technique, helps you to capture light effects with precision.

Shadows are not solid. They have a luminosity and depth—don't overmix colors or they will appear flat and dead. Use wet-on-dry washes for the crisply defined shadows typical of a sunny day, and wet-in-wet or wet-on-damp washes for softer effects. Loose washes capture the vibrancy of the light. Allow colors to fuse and melt wet into wet, and lift out touches of color to indicate reflected light.

You can also use a layering technique. Make sure each wash is dry before adding the next. Apply the paint cleanly and avoid disturbing the under layers so that the shadows stay fresh and luminous. If you are bold and confident, you can try painting shadows directly, applying a single layer of color. Be sure you have the right mix and remember that watercolor dries much lighter than when applied.

 In practice **Palm tree shadows**

Sea front in Turkey by *Keith Noble*

Paint wet on dry to depict the neatly defined shadows on a sunny day. Introduce fresh colors wet in wet for the variegated effects within the shadow areas. This combination of techniques captures the luminosity of the light and the color and intensity of the shadows.

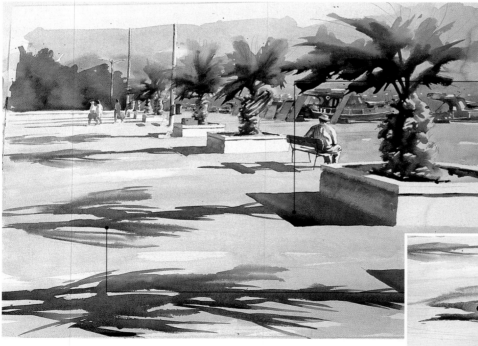

▲ CRISP AND DIFFUSED SHADOWS
The graceful shadows of palm trees falling across paving add decorative interest and color to an otherwise empty part of the composition. They emphasize the flat, horizontal ground plane, and reinforce the sense of recession.

▲ *Apply a blue/lilac mixture for the cast shadow, over raw sienna on the sides of the planters. Use the edge of the wash to define the neat edge of the shadow. While the wash is still wet, introduce touches of reflected color with the tip of the brush.*

◄ *The shadow of the palm is diffused, so dampen the paper here and there with clean water. Use the tip of the brush to "draw" the fronds in a mixture of cobalt and cerulean blue. While the paint is still wet, introduce alizarin crimson for warmth.*

Painting night scenes

Subtle tones, muted colors and dramatic, theatrical light effects make night scenes a challenge. Careful observation is the key.

The more you look at a night scene, the more you will see. At twilight, outlines blur and appear softer, colors become subdued and details disappear. Once dark, forms are visible as vague silhouettes and shadowy half tones, but it's never uniformly dark even on the darkest night. As your night vision becomes attuned, subtle colors and tones and vague forms emerge.

Natural light from the moon and stars is surprisingly bright, creating an eerie or mysterious atmosphere, while street lights have quite a different mood.

There isn't usually enough light to paint night scenes on the spot. Make a few sketches, back these up with photos and—better still—hone your visual memory by looking long and hard at the scene.

Key points

- Even on the darkest night there is some light in the sky.
- Outlines are indistinct and details are lost at night, while subtle tones replace bright daytime colors.
- Twilight is often characterized by the orange-pink tones of sunset.
- Moonlight is cold and bluish, and creates bright highlights.
- Street lights cast a yellowish light.

Taking a closer look

In this painting, the artist has captured the luminosity of the street lights and their reflections in wet pavements. He used a limited palette and the play of transparent against opaque colors to enhance the atmosphere.

Piccadilly Circus, London
by *Roy Hammond*

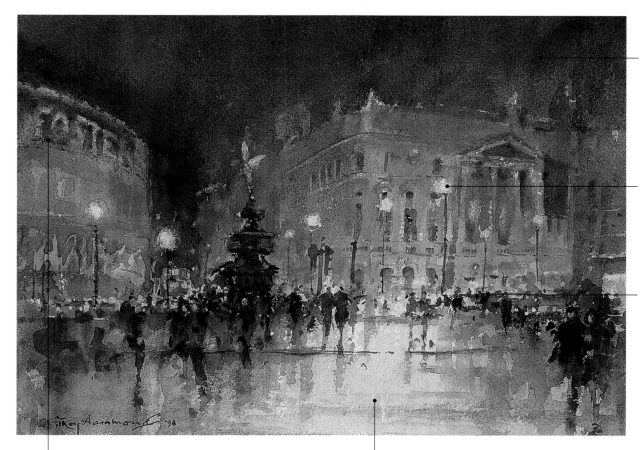

The inky depth of the night sky has been captured with thin layers of transparent wash. These granulated slightly, which added to their luminous effect.

The artist reserved the white street lights before he started, then worked back into them with body color.

The figures are loosely suggested in silhouette with no visible details and colors. Similarly, the details of the buildings are merely hinted at.

Artificial light casts a yellowish glow, so the artist chose a limited palette of mostly warm colors, working in muted tones of browns and ochers. The red bus and blue advertising lights create bright accents of color.

The bright foreground shimmers with reflected light, achieved with pale wet-in-wet and wet-on-dry washes in subtle tones.

Moonlight effects

Moonlight creates an eerie atmosphere that makes ordinary scenes mysterious. The absence of color means you can use a limited palette to great effect.

 Full moon over the sea

This subject depicts available light only. The full moon creates crisp highlights on the ripples, and a diffused luminescence that glances off the water surface. Three colors have been used.

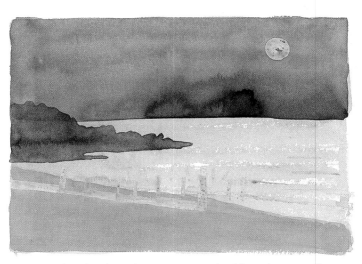

▲ **2** Darken the sky with a stronger wash of Payne's gray and Prussian blue. Let it dry, then use a different mixture of the same colors to paint the rocks wet on dry. Paint the beach with a wash of raw sienna and Payne's gray.

▲ **1** Mask out the moon and the groynes, then apply a pale wash of Payne's gray and Prussian blue over the entire picture. Skim the brush lightly over the paper, leaving white areas for the reflections in the water. Let the wash dry.

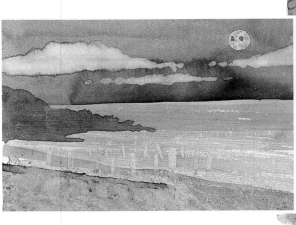

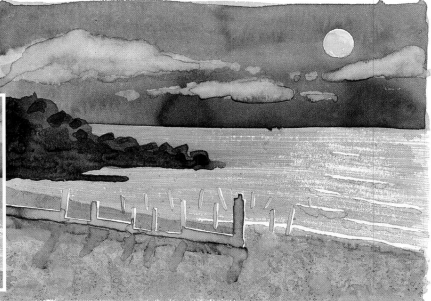

▲ **3** Lift out clouds with clean water and blot with tissue. Darken the sea with a second, dry-brushed wash. Add texture to the beach by spattering with water and a toothbrush. Blot it, let dry, then spatter a darker wash of raw sienna and Payne's gray.

▲ **4** Remove the masking fluid. Add depth to the clouds and rocks with a raw sienna/Prussian blue wash. Paint the moon and add the shadows and posts with different strengths of the same wash. Scrape off some of the sea wash with a sharp knife or scalpel to depict the luminosity on the surface.

Painting skies

The sky, a constantly changing pageant of light and clouds, provides the backdrop for a landscape. For the artist, it is the most important element in a landscape painting.

A painter has to work very quickly to record the sky before the light and mood change. Watercolor is ideal for creating fast, spontaneous and convincing sky effects. Its fluidity when used wet in wet is ideal for moody, amorphous sky effects, while wet on dry gives crisp edges for frothy white cumulus clouds. Watercolor is unpredictable, so every sky you paint will be different—but that is one of the pleasures of the medium.

Summer sky

For fluffy summer clouds, use the white of the paper for the cloud shapes and wet-in-wet and wet-on-dry washes for soft and hard edges. Use a mop brush to wet the paper, then a squirrel mop to paint with.

▲**1** Use the large mop brush to wet the paper at random, leaving some cloud-shaped areas dry.

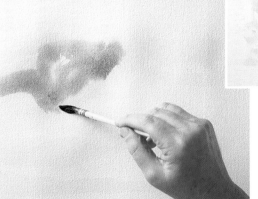

◄**2** Load the squirrel brush with cerulean blue and apply to the wet areas. Push and pull the paint around to create a variety of tones and cloud shapes. Take the brush over dry paper to create crisp edges (inset above). Let dry.

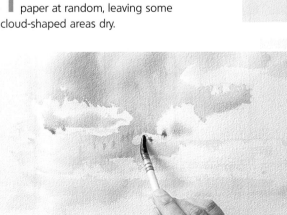

▲**3** Apply water here and there within the cloud shapes. Load the squirrel brush with a mix of ultramarine, alizarin and cobalt and use the tip of the brush to dab color into the wet areas.

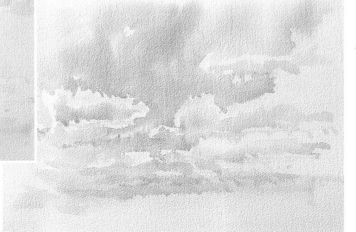

◄**4** Note that the sky is much lighter and softer when the paint has dried completely.

Key points

● The sky is not a flat wall behind the landscape. Allow color and tone to fade toward the horizon to convey a sense of recession.

● Clouds are three-dimensional—the tops usually face the sun and are therefore lighter in tone than the sides and bottom.

● Make the foreground clouds larger than those near the horizon—this will enhance the sense of space.

Change of mood

While wet-in-wet and wet-on-dry watercolor washes are excellent for sunny summer skies with white clouds, they also lend themselves to moody, rainy—even stormy—skies.

This is where wet-in-wet technique really comes into its own. Naturally, your palette takes on darker, more somber tones. There is usually a touch of blue somewhere, but grays such as Payne's gray, or a mixture of ultramarine and burnt sienna or Indian red, are ideal for brooding, rain-filled skies. The trick is to let the watercolor do the work. Wet the paper first and allow the color to flow into the wet areas—tilt the board if necessary.

 In practice **Painting a leaden sky**

Wet-in-wet washes with their subtle blendings and transitions of color are perfect for portraying rainy skies.

▲**2** Apply dabs of cerulean blue to the top left of the sky area. Mix a wash of Payne's gray and ultramarine, and apply dabs at random into the wet areas (inset above).

▲**1** Wet the paper, applying horizontal strokes of the squirrel mop brush. Don't worry about leaving dry areas—these all add variety to the effect.

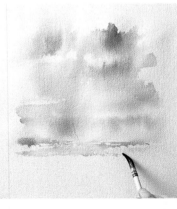

▲**4** Place the bands of wash closer together near the horizon—this will create a sense of recession. The finished wash (right) captures the effect of a rain-laden sky.

▲**3** Continue applying the dark wash, working freely and quickly with horizontal strokes of the brush.

Painting water

Water affects the mood of a landscape profoundly. It acts as a mirror to the sky and brings light into a painting. You can use a range of techniques to capture its depth, wetness and reflective qualities.

Water changes in response to light and the weather. The challenge for the artist is to capture these fleeting moments and convey water's fluidity and light-reflecting qualities. With streams and ponds, the sky is often partly obscured, with light filtering through the foliage. Light falling on water makes the water highly reflective. However, where the water is shaded, the surface becomes transparent and you can see the bed.

The key to painting water is careful observation. Look at the movement, colors and tones. A simple approach is best—don't overlay too many washes or the colors will become muddy and the sense of fluidity will be lost.

Taking a closer look

In this atmospheric painting, the artist has captured a powerful sense of bright sunlight and dappled shadows, at the same time conveying the wetness of the stream.

Albury Park by Joe Francis Dowden

Where the reflected light is strongest, you see no deeper than the glassy surface of the water.

A combination of transparent and semitransparent color suggests depth on the bend in the stream.

Vertical brushmarks suggest depth.

The strong contrasts of light and dark suggest reflected light on the surface of the water.

The shadows cast by the overhanging trees allow you to see the bed of the stream, which is rendered with a wash of burnt sienna.

Diagonal shadows emphasize the bed of the stream.

The sparkles of light are rendered with a variety of techniques, including spattered and dotted masking fluid and scratching out with a knife.

Calm, still water

The surface of still water mirrors almost exactly the colors of the sky and the features of the surrounding landscape. The reflections are sharp and clear.

Tip

Ripples break up and blur reflections. Keep vertical lines sharp in a distant reflection and soften the horizontal ones to mimic the rippling effect.

In practice **Lake on a windless day**

Follow the steps below to paint a scene with quiet water. The artist has used a number of techniques to give the reflections a sense of recession and to depict the surface of the lake.

▲**1** Apply the sky wash wet in wet, reserving the whites of the house. Turn the paper upside down and paint the water wet in wet with a strong graduated wash of phthalo blue/indigo. Darken it again while still wet, then add burnt sienna for the shallow, muddy bottom in the foreground. Leave the house reflection area white.

▲**2** Paint the reflections of the trees. Wet this area with the tip of a round brush, leaving speckles of dry paper. Brush pigment vertically through the wet area—some strokes will diffuse with a soft edge. Gently drag some color into horizontal ripples at the base of the reflection.

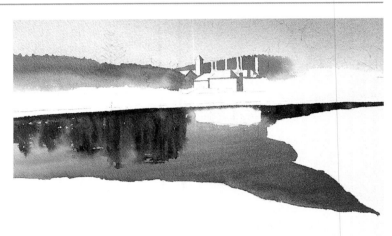

▶**3** Wet the hard edge of the house reflection. Paint the house reflection with the same wash as the house, saving whites for the windows. While still damp, add a darker mixture to the lower half of the reflection. Let it bleed into a soft edge.

▲**4** Brush darker colors down into the house reflection. Rewet the base of the reflection and darken it slightly. Streak the chimney reflections down into the water, wet on dry, with small horizontal strokes. Add the rest of the reflected house details. Rewet and blend in darker color at the lower edges of the tree reflections. Paint long ripples in the foreground.

Painting reflections

Reflections are a vital element in paintings of water. Their presence is a sure indication that water is present.

All water reflects, whether it is merely surface film, a muddy puddle, a flowing river or the open sea. The beauty is that reflections not only provide attractive patterns in a painting, they also become important compositional elements. For example, reflections help you balance solid shapes with their watery images, and give the opportunity to repeat the colors in one area of a painting in another place, thus helping to create a sense of unity and harmony.

Although reflections are at their clearest in still water, the most interesting effects appear when movement creates ripples or swells that break up the reflections into separate shapes with jagged or wavering outlines. The ripples act like lots of tilted mirrors, reflecting the sky and the sun and making the surface sparkle with reflected light.

Key points

- If a building or any other object is right by the water's edge, the reflection must be exactly the same size.

- If a building or other object is set back from the water's edge, only the top part or parts are reflected.

- In moving or disturbed water, reflections are a mixture of the surrounding colors.

- Ripples or wavelets cause reflections to fragment and blur.

Taking a closer look

A thin layer of rainwater on the paving stones in St. Mark's Square, Venice, Italy, reflects with perfect clarity the buildings, lampposts and figures. An underlying muted blue-gray wash is overlaid with precise darker washes, put in wet on dry, to stand for reflections. Minute flecks of red on the figures and umbrellas lead the eye into and around the painting.

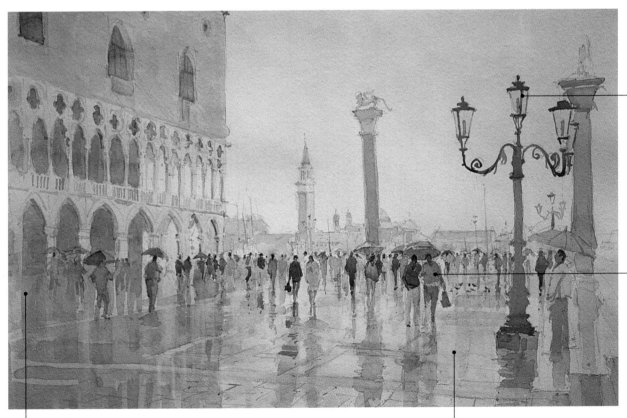

**Rain and reflections, Venice
by *Paul Banning***

The lamppost is reflected solidly in the rainwater. The darkest tone at the base is actually shadow—not reflection. Seen straight on, this reflection should be exactly the same length as the post is tall. It therefore continues out of the picture area.

The figures are moving—so their reflections are wavy and blurred in the still water. The opposite would also apply—stationary figures would appear wavy in moving water.

The Doge's Palace is casting its own shadow, so its reflection is darker than the building itself. The palace appears to stand on its own reflection because it is right at the edge of the rainwater.

The water reflects all the colors of the sky and the buildings—a medley of soft watery blues, grays and warm neutrals.

Watery images

Look closely to see what is being reflected and how far the reflections extend—and what colors the water takes from its surroundings.

The position of the items reflected relative to the water affects just how much of them you see—for example, a house right by the water's edge is reflected in its entirety, while one set farther back is reflected in part only. The wet-on-dry technique is excellent for painting reflections—you can create crisp details and precise colors on top of underlying washes.

Expert advice

Proof that the building below is right at the water's edge lies in the fact that its reflection stretches exactly as far into the water as the building is high. Use a pencil to check these proportions in the field. Line up your pencil with the building or other object in question and slide your thumb down to the measurement you see. Then, keeping your thumb in position, check the measurement of the reflection in the water.

In practice — Reflections in still and rippling water

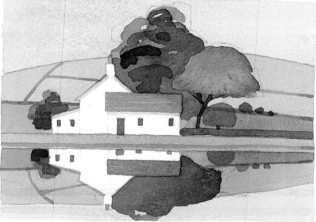

◀ STILL WATER
Here the reflections are not affected by the direction of the light and they appear directly beneath the object. This house is quite close to the water's edge, so it measures nearly the same below the water as it does above.

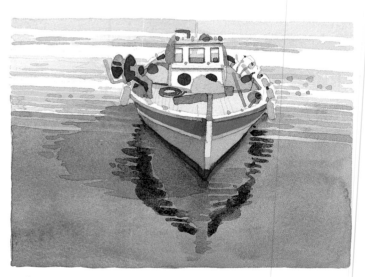

▲ MOVING WATER
When water is moving—as with the ripples in the river here—the reflection becomes fragmented and blurred. The surface of the water becomes faceted, so that each ripple or wavelet acts as a separate, tilted, curved mirror.

▲ REFLECTIONS AND SHADOWS
Shadows are affected by the position of the sun or other light source—here the boat is casting a distinct shadow to the left, indicating that the source of light is coming from the right. The reflection, on the other hand, is not affected by the light source. Both sides of the boat's hull are reflected in the water directly under the boat itself.

Painting seas

Capturing the changing sea is a great challenge. Using wet-on-dry washes is a key technique for portraying the sea convincingly—whether it's calm and rippling or has breakers crashing on the shore.

As with skies, painting the sea requires quick work because the water is never still—and no two ripples or breakers are exactly the same. The secret is to convey a sense of movement by laying in an initial broad, flat, pale wash that is then broken up with a series of irregular darker bands, laid down wet on dry.

For a calm, rippling sea this need be no more than one darker wash laid over a lighter one. You can introduce a sense of recession very effectively by ensuring that the ripples become smaller and closer together the farther away they are, and that the ripples nearest to you are darker than those farther back.

For waves rising, peaking and then breaking on the shore, areas of darker shadow are vital for giving form and substance to the water.

In practice — Calm sea—gentle waves

These studies show you how to capture the qualities of a calm sea. Here the artist used a mix of cerulean blue and Payne's gray for his basic wash, starting from a very light mix and gradually darkening it for the nearest rippling waves.

1 Paint the sky first, then lay in a flat wash of color for the sea, using a mix of cerulean blue and Payne's gray and working downward from the horizon. Leave the white of the paper for the foam on the shore. Paint in the cliffs, the beach and the green clifftops. Let dry.

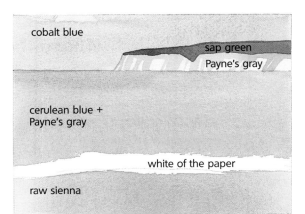

cobalt blue

sap green

Payne's gray

cerulean blue + Payne's gray

white of the paper

raw sienna

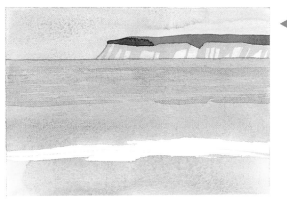

2 Mix a slightly darker version of the wash you used to paint the sea in Step 1. Lay long, flat parallel bands of color, working from the horizon downward as you did before. Leave gaps between your bands to create the effect of ripples in the water. Let dry again.

3 Darken your wash again and continue laying bands of color in the foreground. Make these broader and more widely spaced than the previous ones. This helps you create that vital sense of recession in the picture.

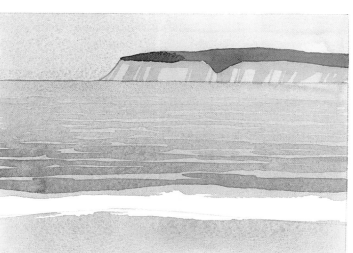

Making waves

Find out how waves work and you will be able to capture all their drama and restless energy.

Understanding how the sea swells to form waves helps you to paint them with assurance. Watch carefully and you will see that they rise to a peak, then curve over and under before breaking into foam. The secret is not to attempt to draw a wave. Instead, use fluid brushstrokes to paint curving, swelling shapes that capture its complex form. Work in the direction in which the wave is flowing—this helps to give momentum and energy to the image.

In the exercise below, the white of the paper stands for the breakers at the shoreline and the whitecaps farther out to sea. Plan the whites at the start.

Try this!

Waves rise and break in a continuous rhythm. Use these studies to help you follow how waves are formed.

◄ **RISING SWELL**
A wave moves toward the shore from afar, starting as a gentle rising swell that gradually builds to a rolling movement.

► **PEAKING**
A breaker forms as the sea becomes shallower and interrupts the wave's circular motion. The wave begins to rise to a peak.

◄ **BREAKING**
As the wave reaches the beach (where the sea floor is at its shallowest) it passes its peak, curls over and crashes down, creating a mass of spray and foam.

In practice Breakers on the shore

Waves breaking on a shore are forceful and vibrant. To capture this, you need the pure white of your paper to contrast with indigo blue under the waves.

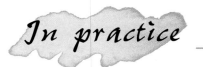

cobalt blue

sap green
Payne's gray

cerulean blue + Payne's gray

white of the paper

raw sienna

◄ **1** Paint the sky, leaving patches of white for the clouds, then start on the sea. Lay long bands of color across the paper, allowing white areas to stand for the whitecaps and the breakers at the foot of the cliff.

► **2** Darken your wash and, using a larger brush than before, apply more color loosely across the sea area, using the brush to "draw" around the wave shapes as you go. Take the wash carefully around the white of the paper in the foreground. This will become the breaker of the wave as it falls onto the beach.

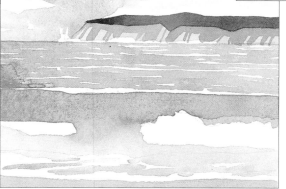

▲ **3** Mix an intense indigo blue wash from a mixture of cerulean blue and Payne's gray and use it to put in the darkest shaded area under the wave. This helps to convey the impression of the curving wave just starting to break.

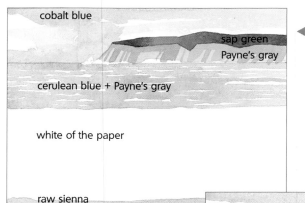

Painting sparkling water

Sunlight on water causes brilliant reflections. The aim is to capture the intensity of the light and convey the translucency of the water.

Light reflected on still water creates a flat, dazzling sheet. If the surface is rippled this is broken into tiny pinpoints of light. The white of the paper is the brightest tone—make it dazzle by surrounding it with darker tones that set up strong contrasts. Paint around the bright areas first or use masking fluid—spatter or stipple it to capture the effect of sunlight glistening on broken water, or use wax resist.

Combine a Rough, highly textured paper with dry-brush work, that is drag the paint across the surface with the bristles of a dry brush—the wash fragments to suggest sparkle. At a later stage, try scraping out to lift the paint—rub with sandpaper for a shimmering surface or scrape linear marks with a blade for light glancing off ripples. Scrape out tiny specks of paint with the tip of a blade to create minute highlights.

Key points

● Reserve the white of the paper at the outset for the brightest reflected lights.

● Use masking fluid or wax resist for broad highlights and broken, sparkling effects.

● Exploit the texture of Rough paper and combine with dry-brush techniques to suggest sparkle.

● Score lines through to the white paper while the paint is wet to suggest light reflected on ripples.

● Scrape off specks of dry paint with the tip of a blade for bright pinpoints of light.

● Use white gouache or soft pastel to add final highlights.

Taking a closer look

The artist has combined delicate nuances of color and darker contrasting tones with whites to create a dazzling sense of intense reflected light bouncing off the water.

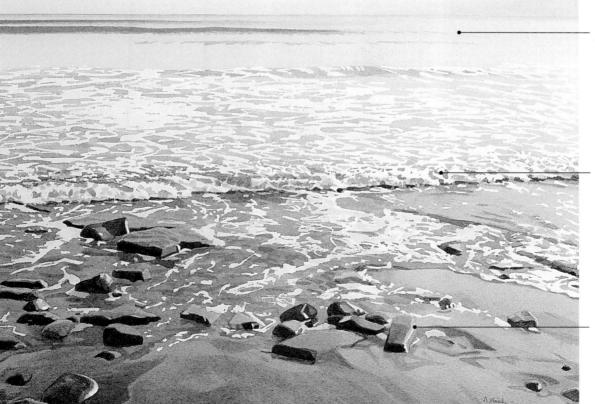

Seascape by Andy Wood

Subtle gradations of tone on the calm sea create a sense of recession. The still surface reflects a sheet of light so bright you almost have to close your eyes against the glare.

The artist used masking fluid to create the complex pattern of light reflected on the water and the wet sand.

Bright highlights on the stones make them glisten wetly.

Capturing light on water

A combination of techniques is often effective for depicting the transient effects of light reflected on water. Keep your painting simple so you retain the freshness and clarity of the subject.

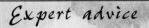

Expert advice

● Look for the direction and the height of the sun, which dictate the position and shapes of the bright reflections. See where the bright highlights occur.

● Lay a loose, bright yellow wash first to establish the overall high key of the painting, that is its pale tones and lack of contrast. Retain areas of this color in the finished painting.

In practice — Sun on a woodland stream

Masking fluid, wet-in-wet and dry-brush techniques combine to create this painting of a sparkling woodland stream.

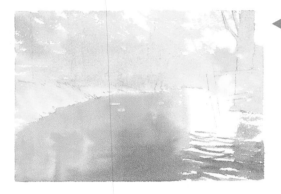

◀ 1 Mask a few river stones. Run cadmium yellow into wetted parts of the woodland. Leave white areas for sky. Wet the river, leaving a dry swathe on the right. Run cadmium yellow into the wet. Add phthalo blue from the bottom and drag some to the right for ripples. Let dry.

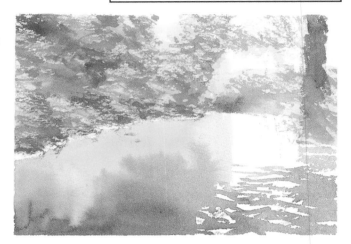

▲ 2 Drag strands of water across the woodland area and use a phthalo green/cadmium yellow mixture to create a dry-brush effect for leaf textures. These diffuse into the wet areas. Add green to the distant bank and the large tree trunk.

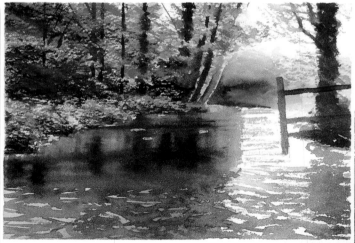

▲ 3 Wash in the darkest foliage in phthalo green/indigo—also the tree trunks, bank, the dark water under the bank and the big tree trunk. Wet foreground reflections and ripples and run in dark green/yellow and Payne's gray/indigo mixtures. Add the fence.

▶ 4 Darken the ripples—add a few in the sky reflection area. Darken the tree trunk reflection on the right. Let dry. Remove the masking fluid and scratch with the point of a knife to create sparkles in the water.

Misty landscapes

The soft lucidity of watercolor is ideal for capturing the veiled light, blurry shapes and muted colors of misty landscapes.

Mist is made up of microscopic droplets of water suspended in the air, creating a fine, gray veil that subdues colors and softens tones. Misty skies and landscapes have a damp luminosity—light is diffused and reflected back, with the mist echoing the colors of the sky.

Mists usually occur in the morning and evening, and over low ground by streams and rivers. Often, on misty days, hills may be seen peeping above vaporous clouds that obscure the valleys beneath them.

Capture the soft light with closely related tones and a limited palette. Use granulation (that is the tendency of some pigments to separate and settle in the indents of the paper) and a variety of brushstrokes. Apply a wash to wet or partially dry paint, creating runs (called backruns) that evoke dampness and suggest the undefined forms of objects seen through a haze.

Key points

● To capture a mist, you need to be equipped to start painting early in the morning or in the evening.

● For the best results, paint wet in wet and exploit backruns; and use the mottled effect of granulation.

● Build up color with transparent washes to suggest veils of mist.

● Use a limited palette of delicate colors and subtle tonal gradations.

● Use complementary color mixtures to create a range of pearly colored neutrals.

Taking a closer look

In this painting, the artist worked wet in wet and exploited granulation effects on rough-textured paper to suggest the soft light of early morning mist over a river.

Early morning, Zayandeh-Rood River, Isfahan, Iran
by *Trevor Chamberlain*

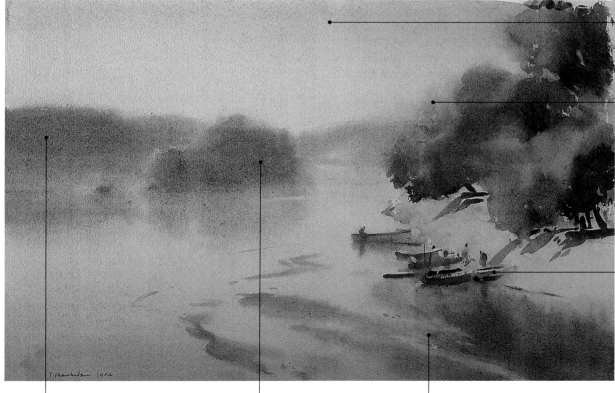

The granulation of the sky suggests the soft glow of misty early morning light.

The artist has applied the washes loosely in one or two layers, keeping the color fresh and light to maintain a luminous quality.

Although the boats have been fairly crisply defined to bring them forward, just one or two brushstrokes are used to suggest their forms.

Features become more indistinct as distance increases —soft-edged areas of tone hint at clumps of trees on the far side of the river.

Tonal contrast has been kept to a minimum, enhancing the sense of diffused light.

Color has been applied using very wet washes. The artist used rough-textured paper, held flat, for extra control and granulation.

Depicting mist

Painting wet in wet and creating deliberate backruns are excellent techniques for achieving an ethereal look.

In practice **Mist over trees**

In this misty landscape, the ridges are marked in pencil over a pinkish gray wash, then strengthened with a series of wet washes.

▶**1** Cover the paper with a wash of Naples yellow/cobalt blue/burnt sienna/ alizarin crimson. Pencil in the ridges. Wet the horizon and run in ultramarine/burnt sienna/alizarin crimson. Wet the far ridge, then bleed in more of the horizon wash. Add water to create backruns.

▲**2** Work downward, wet in wet, painting one ridge at a time, as in Step 1. When each wash is almost dry, brush water just beneath to create feathery backruns, tilting the support if necessary. Allow each ridge to dry before starting the next and vary the color and tone of the blue-gray mixture.

▶**3** Darken the blue-gray mixture with burnt umber and ultramarine. Continue painting the ridges, making them bigger, more widely spaced and looser toward the foreground. For the last ridge, add a little cadmium yellow to the wash. When still damp, drop in water and a little burnt sienna to create a backrun.

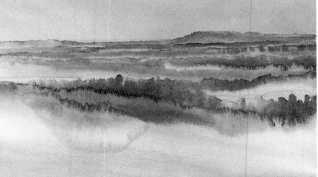

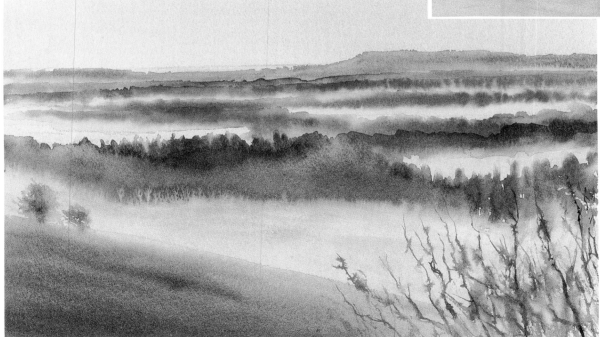

◀**4** Darken the pinkish gray wash with sap green and use this to paint the foreground field and the small trees, working wet in wet from the bottom up. Allow to dry. Feather a damp brush across the foreground on the right. Run a burnt sienna-based gray-brown across, then run in dark branches using the point of the brush loaded with burnt umber/ultramarine.

Painting rain

Rain alters the appearance and mood of a landscape dramatically, presenting different challenges to inspire the landscape painter.

For the artist, rain is not "bad" weather—it offers an opportunity to study the landscape in a different mood. Rain has many aspects, from the light veil of a summer shower to the drama of a thundery cloudburst. Sometimes the landscape is shrouded in gloom. At other times, rain and sun alternate rapidly. Rain can blur outlines, obscure details and horizons, and create muted colors, or it can bring things into sharp focus and intensify colors in the subdued surroundings. Watch rainstorms and make rapid tonal thumbnail sketches. Take photographs to supplement them.

Key points

● Make lots of sketches of the fleeting effects of rain.

● Note the tonal range and look for areas of contrast.

● Control your palette. On an overcast day, use neutrals and muted colors.

● Imply rain with threatening skies and wet ground.

● Use dragging or dry-brush techniques to depict falling rain.

Taking a closer look

In this evocative painting, the artist used several devices to convey the inclement weather conditions. The viewer is left in no doubt about the gloom and utter wetness of the day.

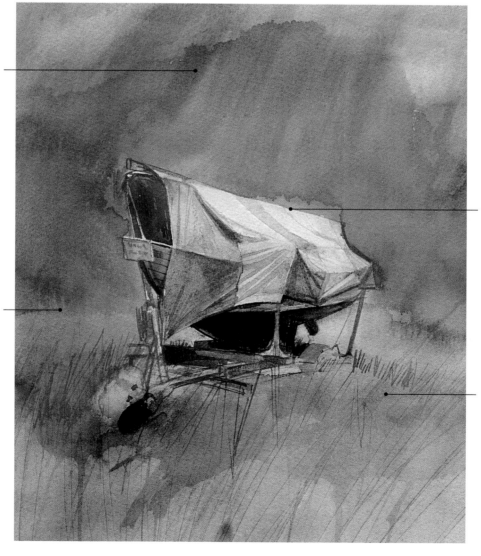

Wrapped boat
by *Michael Whittlesea*

The artist suggested the driving rain with slanting strokes of darker color dragged lightly over the dry background washes with a dry brush.

Sky and background blend murkily in wet-in-wet washes, while the foreground merges into the middle ground in one sodden mass.

The highlight on top of the tarpaulin shines out wetly in the muted surroundings—you can almost see the pouring rain bouncing off it.

Directional brushmarks add texture to the long grass. They seem to follow the trajectory of the rain and increase the impression of a downpour.

Depicting a rainstorm

With watercolor, you can capture the menacing atmosphere of an overcast day and a heavy downpour of rain.

A rainy landscape is never just gray. Colors may be subtle, or there may be areas of heightened color. Note the intensity and direction of the light, and find the lightest and darkest areas. Use your palette carefully —a strong color can destroy the effect. Stroke wet paint downward with a dry brush to suggest falling rain and use directional strokes for added movement.

Tip

You don't need to paint falling rain to suggest a rainy day. You can imply rain with blurred outlines, dark, threatening clouds and puddles on wet ground.

In practice **Countryside in rain**

Wet-in-wet washes are excellent for portraying turbulent clouds and relentless rain, and granulation, i.e. pigment settling in the indents of the paper, adds to the stormy effect.

▶**1** Wet the entire paper, except for the white buildings, and streak in an indigo wash to establish a general background tone. Use vertical brushstrokes in the sky and leave a white area on the horizon.

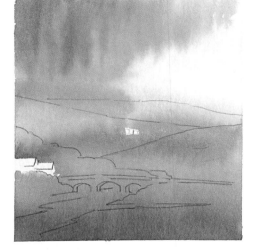

▶**2** While the first wash is still wet, increase the intensity of the sky with a second wash of phthalo blue, taking it down as far as the top of the bridge and painting around the buildings.

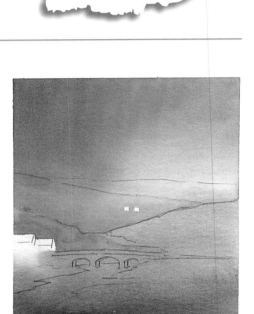

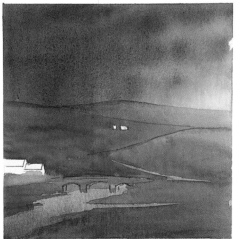

▶**4** Depict the shadows that the cloud casts on the land with streaks of cobalt blue. Paint landscape details with mixtures of cobalt blue, burnt sienna and yellow ocher. Use Payne's gray for shadows and reflections, and light red for the roof. Finally, use a fan brush to stroke water down through the sky. Brush cobalt blue/burnt sienna horizontally for clouds, tilting so that some color bleeds into the hills.

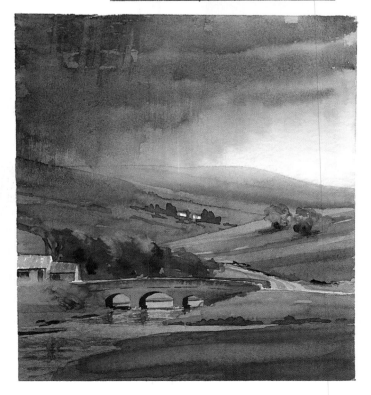

▲**3** Working wet in wet, depict the storm cloud with more indigo. When it's dry, paint the land with yellow ocher, then add cobalt blue to the wash and paint all except the lighter areas of land again.

Looking at rainbows

Lifting out and painting wet in wet are useful techniques for portraying rainbows—the most spectacular light shows on earth.

The translucency of watercolor makes it the perfect medium for painting rainbows. These natural phenomena appear in the sky when there is both rain and sunshine. When you are lucky enough to see one, the sun is always behind you, and the rain is in the direction of the rainbow. When the sun is low, the rainbow forms a steep, dramatic arc. When the sun is higher, the arc is wider and shallower. Rainbows are not seen when the sun is at its highest around midday.

Look carefully next time you see a rainbow—observe how its seven colors start with red at the top and finish with violet at the base. The sky shimmers because of the rain, and parts may be quite dark. Inside the rainbow, the sky is at its brightest.

Key points

● Rainbows have seven colors, starting with red at the top, then orange, yellow, green, blue, indigo and violet.

● The sun is behind you and the rain in front when you look at a rainbow.

● Rainbows have different arc shapes depending on the position of the sun.

● Mix all the colors before starting to paint a rainbow.

Taking a closer look

In this atmospheric painting, the artist has captured the luminous quality of a rainbow set against a dark and stormy sky. The silvery quality of the light suggests a departing rainstorm.

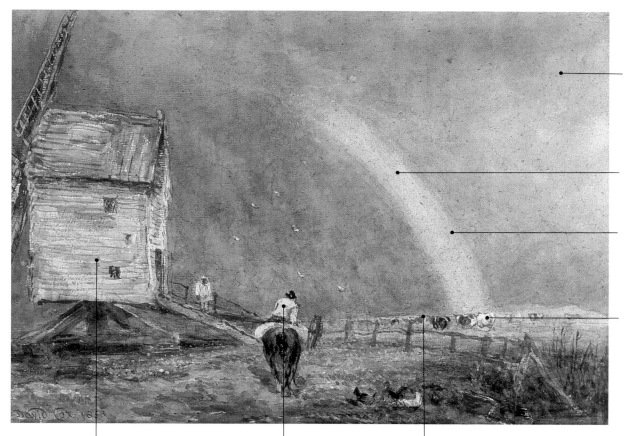

The mill by David Cox

The dark, stormy sky was captured with layers of transparent wash. The effect is uneven, creating a luminous quality.

Only a few light colors are included in the rainbow—the eye fills in the rest.

The artist lifted out an arc of the sky color and worked the rainbow on the scrubbed white paper beneath.

Touches of body color on the cattle and the rider suggest the intensity of the light, shining from somewhere behind the viewer.

The mill creates a sense of place, adding to the drama of the setting.

The pale clothing of the rider is brilliantly lit by the sun.

The low horizon gives the picture an open composition and an optimistic mood.

Convincing breakers

Key aspects of a violent sea can be successfully portrayed with the help of various techniques and special effects.

When you paint a stormy sea, the water must look as if it is moving—blurred edges and marks that suggest the motion of the water help toward this. You can create the white areas in several ways— reserve the white of the paper using masking fluid or wax resist; spatter or stipple with Chinese white or gouache; use soft pastel; or try scratching the dry paint film with the tip of a scalpel or utility knife.

Tip

First-hand observation gives the best painting results, but looking at photographs in books and magazines will also help. Learn from other artists, too—study their work in galleries and examine their techniques to see how they have edited and simplified the subject.

In practice Crashing waves

Use gray masking fluid and scraping-back techniques to depict waves crashing on a jetty. A tinted masking fluid is easier to see.

◄1 Draw the subject lightly, then apply gray masking fluid for the spray. When it's dry, paint the sea with a wash of primary yellow, shaded with cobalt blue at the horizon and foreground. For the sky, drop cobalt into a wet surface.

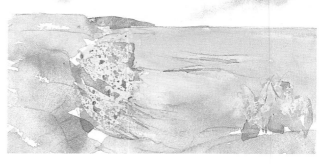

▲2 Paint the jetty and rocks with a stronger cobalt wash, adding a little burnt sienna to make grays in some areas. Keep the tones uneven to add texture to the rough stone surface.

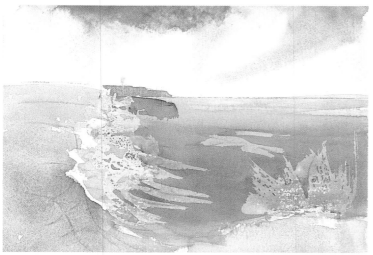

▲3 Rewet the sea with a clean, damp brush and blend a viridian/raw sienna wash into the foreground. Define the distant coastline with cobalt and a touch of burnt sienna. Paint the end of the jetty with a mixture of French ultramarine and burnt sienna. Note how the movement of the sea is beginning to come into focus.

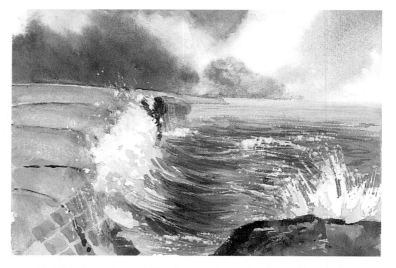

▲4 Paint storm clouds with a French ultramarine/burnt sienna mixture. Add viridian to the same wash for the darkest part of the waves and the foreground wall. Use cobalt/burnt sienna for the top of the wall. Finally, remove the masking fluid and add cobalt blue shadows to the spray. Scrape out flecks of foam with a sharp utility knife.

Painting snowscapes

A snowy, wintery landscape is not an easy option to choose for a watercolor. Planning the picture before you start is essential in order to capture the distinctive brilliance of the scene.

Snow changes the landscape by softening its contours and masking detail. It also makes the land much brighter in tone than the sky—the opposite of the usual situation.

Allow the white of the paper to stand for snow. Make a quick tonal sketch before you start, roughly indicating where you want the white areas to be. Think of them as positive shapes, not negative spaces. When you paint the surrounding darks, you are giving the whites form and shape at the same time. Don't forget the shadows—these indicate a horizontal surface and are vital in snow scenes. Use blues and lilacs for the shadows.

The sky completes the composition and sets the mood for the picture. It can be clear, crisp, cold and sunny, or heavy and brooding, threatening more snowfalls.

Key points

● Use the white of the paper to stand for the snow—plan these areas first.

● Positive shapes are the obects you have painted; negative shapes describe the area between the objects and the edge of the paper.

● A heavy snowfall will make the snow settle in most areas—don't forget the roofs, tops of fence posts and the top side of branches and twigs.

● Use darker surrounding tones to show up the brilliant white of the paper wherever you want to indicate snow.

Taking a closer look

In a snowscape like this, you can see how important it is to plan your whites extremely carefully. Doing this correctly means the sparkling white complements the natural translucency of the paint, giving your rendering extra life and brightness.

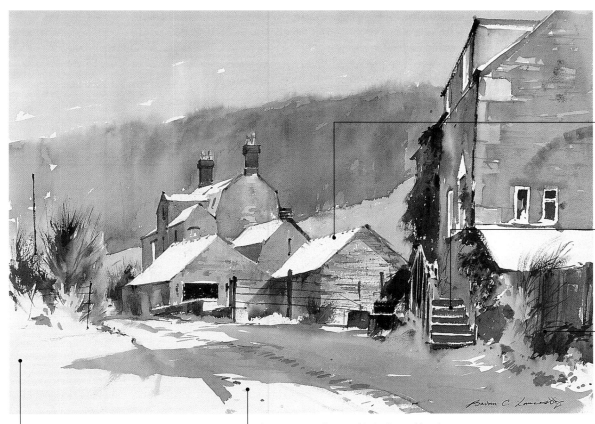

Winter's mantle, farm at Uley, Gloucestershire by *Brian Lancaster*

Crisp straight edges—planned in right at the start—show where the snow has settled on the roofs.

Snow piled up on the treads of the steps has been observed by the artist—again this is represented by the white of the paper.

The artist has used a limited palette of violets, blues and earth colors. You can see how these allow the whites to stand out boldly.

The snow on the ground is much lighter in tone than the sky, which looks as though another snowfall is imminent.

The snow on the road is indicated by the white of the paper. A blue wash indicates deep shadow, and a few dry strokes of color represent the tracks of a vehicle.

Rendering natural textures

When you paint the textures of foliage you must find a way to convey a sense of depth and volume without solidity.

Foliage consists of layer upon layer of leaf forms of different sizes, colors and tones. Since you cannot possibly paint every single leaf, you need to find ways to express the depth and volume of the foliage without producing lifeless, solid-looking shapes.

The transparency of watercolor lets you build up an optical effect of depth and texture by overlaying washes. Try using both warm and cool versions of a color—they mix visually, producing a third tone. If you are painting a detailed study, you can use a variety of appropriate brushmarks—small, leaf-shaped flicks or dabs for little leaves, and long, quick strokes to express waving grass, for example.

For a quick sketch, use broader, more generalized gestures to describe the form and mass of the foliage, and to give clues to the species of plant. Remember that the farther away you are, the less detail you are able to see.

In practice Botanical garden

The gardens in this study contain a variety of exotic shrubs and trees. The varied shapes and textures of the foliage are rendered with different kinds of brushmarks.

Inverewe Gardens, near Poolewe, Scotland
by *Albany Wiseman*

The majestic Scots pines are suggested with horizontal brushstrokes painted outward from the tall trunks in the direction of growth.

The near hedge is painted with a broad, pale wash, its texture hinted at with a few individual leaf outlines.

The snaking curve of the wall draws the eye into the composition. A series of receding curved lines helps to express its rigid form.

Spiky pampas grass is depicted with curved lines painted with a dryish brush. The brushmarks start at the base of the plant and work out to the tip.

Curving brushstrokes are used for the elegant palm fronds here. Start at the base of each leaf and work toward the pointed tip, lightening the pressure on the brush as the leaf gets thinner.

Painting flowers

Flowers are marvelous subjects for watercolor—their beauty, variety and range of colors are perfect for this translucent medium.

When painting flowers, be bold —all too often flowers are rendered in soft, pale washes that have no impact. In nature, flowers come in all hues from pure white to flaming reds, oranges and purples. Flower paintings can range from full flowerbeds to detailed studies of individual blooms. For a whole mass of flowers, overall appearance is more important than detail. Note that on a bush or in a flowerbed, the blooms will all be at different stages of development—some will be in bud, others fully open or already fading. For a flower study, detail is vital. You must get the form and growth habit just right—count the number of petals and the stamens, and study how the leaves spring out from the stem.

Key points

- Work from the general to the particular. Start with outlines and end with details.

- Study individual flowers, checking on the number of petals and leaves.

- Keep your colors fresh—use clean water and wash your brushes often.

- Colors in a border will "blue" and become more indistinct the farther away they are—an effect of aerial perspective.

- White flowers rarely appear pure white —look for reflected color and shadows that influence the local color.

Taking a closer look

When you are tackling a busy subject such as this, the main challenges are to select what you want to keep in and not to get distracted by too much detail.

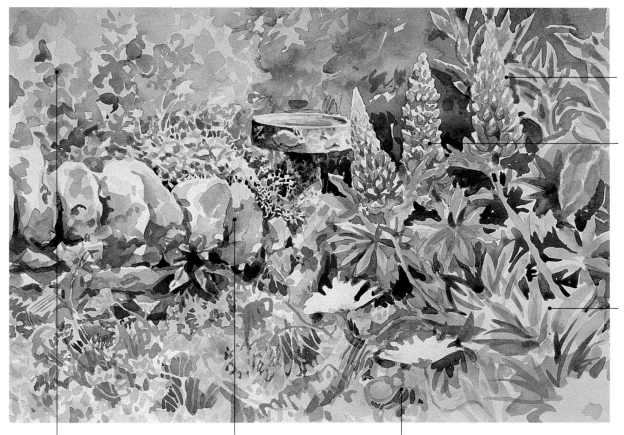

Lupins
by Hazel Soan

Carefully reserved areas of white paper give sparkle and form to the lupines.

The lupines—in the middle ground—are rendered in more detail than the flowers farther back. Their warm color brings them forward.

Wet-on-dry brushwork —a darker green over a lighter wash—gives definition to the spiky leaves of the lupines.

The shape of the delphiniums is only hinted at—their blue color and lack of detail push them back, creating a sense of recession.

The warm brown wall sets off, and contrasts well with, the exuberant colors of the flowers.

The foreground yellow flowers are too small to be picked out individually— touches of paint indicate their mass without too much detail.

Making a flower study

With a garden flowerbed you can be as free as you like with your brushstrokes, but detail and precision are vital for a flower study.

This is not a botanical drawing and need not be as detailed, but it pays to look at individual flower heads closely. Any mistake in the finished painting—the wrong number of petals, for instance—will be glaringly obvious.

Build up your flower bit by bit, starting with a detailed drawing. Continue with layers of washes wet in wet and wet on dry. Allow each wash to dry completely before applying the next—this helps to avoid a muddy, overworked appearance.

Tip

Some artists prefer to leave their pencil lines on the finished painting, thinking they add to the look of the picture. Others prefer to delete them completely. If you do erase the pencil lines, take great care not to abrade the painted surface.

Try this!

An amaryllis is an excellent subject—it has strong form and color. This example has been built up with four successively darker red washes on the blooms.

◀**1** Start by drawing the outline of the amaryllis. Use a soft pencil, noting the basically circular shape of the lower bloom, the conical shape of the upper one and the narrow, elongated bud.

▲**2** Wash cadmium red/light red on the flowers and bud. Leave streaks of white paper in the two main blooms. Apply diluted gamboge yellow to the stalk, then drop in the same color wet in wet on the tip of the bud.

▶**3** Mix a darker wash of cadmium red/light red/alizarin crimson and paint selectively over the petals and bud to build form and tone. Mix gamboge and olive green and apply to the right side of the stalk.

▶**4** Mix an even darker wash of cadmium red/light red/alizarin crimson and apply over the blooms again. Paint very fine hairline streaks over some of the petals. Mix a darker wash of gamboge/olive green and use it to give the stalk more shape. Finally, touch in the center of the lower bloom in ultramarine violet.

Painting spring colors

Watercolor is the perfect medium for capturing the clear light and delicate colors of a burgeoning spring landscape.

In early spring, buds appear and leaves unfurl, soon producing hints of pink, ocher and green, while blossom creates gauzy veils of pink and white. Use broken-color techniques, such as optical mixing, to modify the browns and grays of winter—and to capture the luminous quality of spring light.

When the leaves are fully emerged, the woodland canopy takes on hues of vibrant lime-green, especially in bright sunlight. To convey this, try lemon yellow or cadmium lemon mixed with a cool blue (cerulean) or with cool greens such as phthalo, Winsor or viridian. Alternatively, lay an underwash of lemon yellow. This will shine through and modify the transparent washes on top. You will need a ready-made violet for crocus and lilac—these violets are brighter and cleaner than those you can mix in your palette.

Taking a closer look

In this luminous painting, the artist has captured the moment when a slight plumping of buds lays a delicate glaze of pink and yellow over the leafless winter landscape.

April rain, Bolton Abbey by Lesley Fotherby

Underwashes of pale yellow, green and ocher capture the vibrancy of new foliage caught in a shaft of sunlight.

Washes of pale, acid green are used for the startlingly brilliant green of grass in bright spring sunshine.

Delicate washes of earth colors capture the lattice work of tiny twigs and their swollen leaf buds.

Clusters of snowdrops trembling on a grassy bank were laid in with touches of body color, i.e. watercolor with white added.

Tiny strokes of color suggest a fine mesh of buds in the middle distance.

Optical mixing

A carpet of flowers shimmering in shady woodland is one of the delights of springtime. Optical mixes allow you to capture the iridescent colors.

 Bluebells in a beech wood

Use cobalt blue as a base for the bluebells and cadmium lemon for the foliage, then build up the image with layered washes and spattering.

▶ **2** Apply a loose wash of cadmium lemon across the top of the picture area, and between the drifts of bluebells. Spatter the foreground with water, then with phthalo green. Let dry.

▲ **1** Start with an outline pencil drawing, then dab on masking fluid for the leaves of the main tree. Mix a wash of cobalt blue and apply criss-cross strokes over the foreground. Add a touch of alizarin crimson and brush this on with loose, horizontal strokes in the background.

▶ **3** Spatter phthalo green and cobalt turquoise for the trees and grass—use neutral tint for the shadows. Paint the trees with burnt umber and cerulean blue. When the washes are dry remove the masking fluid—except on the tree trunk.

◀ **4** Paint the trunk with burnt umber, cerulean blue, Naples yellow and cadmium lemon. While damp, add texture with burnt umber and neutral tint, making it darker on the right side. Spatter and dab dark green into the foreground so that the bluebell shapes emerge from the background. Dab the cobalt blue/alizarin crimson mixture over the foreground. Remove the masking fluid from the leaves on the tree trunk, then apply green wash over the leaf shapes.

Painting autumn colors

With vivid reds, golds and russets, landscapes in the latter part of the year offer a glorious subject for the watercolor painter.

In a fall landscape, the browns, reds and yellows of plowed earth, deciduous trees and distant woods are often muted—very different from the fresh, clear colors of spring. Sharp, crisp mornings enhance the bright tones of autumn leaves and deepen contrasts, while the golden light of the late afternoon sun softens and warms the colors but brings intense shadows. The gray light of overcast days cools the colors, reducing the tonal contrasts.

For your autumn palette, concentrate on earth colors such as yellow ocher, raw sienna and Indian red, and complementary shades of violet, blue and green. Bright colors such as cadmium yellow can be softened with a touch of their complementary color. For fiery autumn hues, offsetting hot colors with their complementary colors makes them sing, while paler tints are brightened by strong, dark shadows. For mellow fall scenes, build gradually from the palest wash to the darkest.

Taking a closer look

In this view of autumn woodland, the fiery orange and warm gold foliage glows against the subdued greens and overcast sky.

Autumn, Beaufays Road, Liège, Belgium
by *Izabella Godlewska de Aranda*

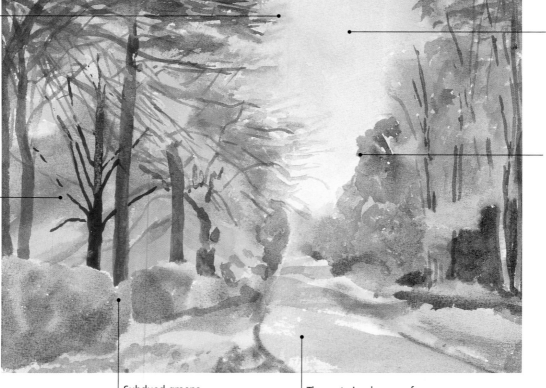

A tracery of lines worked wet in wet suggests the delicate twigs.

The orange wash is laid wet in wet, building slowly from the palest to the hottest tone.

The sky is worked wet in wet, the tones blending subtly for a soft, shimmering effect.

Soft edges help all the elements of the painting to meld into one another, suggesting a hazy fall day.

Subdued greens contrast with the orange, giving it added brilliance.

The restrained grays of the sky and road contrast with the dazzling foliage colors, preventing them from appearing strident.

Ultramarine and its mixtures

As the only reddish blue, ultramarine is a must for any watercolorist's palette. A beautiful color in its own right, it is also useful in mixtures.

Real ultramarine, made from costly lapis lazuli, was used to create the vivid blues found in medieval Books of Hours and in the Madonna's cloak in Renaissance paintings. A method of manufacturing synthetic "French" ultramarine was discovered by the Frenchman J.B. Guimet in 1828, and the new pigment was first used by J.M.W. Turner in 1834. As Reckitt's Blue it was used to whiten laundry. French ultramarine mixes with alizarin to give violet. With cadmium red it gives an earthy terra-cotta, and with raw sienna a useful sludgy green, good for fall and summer landscapes. With a warm yellow, such as cadmium yellow, it gives a surprising mustard. The cadmium lemon mixture gives a sage green, and with viridian it gives a slate blue.

▲ *FRENCH ULTRAMARINE, essential in any palette, is a good all-round color with wonderful transparency and, excellent lightfastness.*

alizarin crimson

cadmium red

burnt umber

raw sienna

cadmium yellow

cadmium lemon

viridian

oxide of chromium

cerulean

20% French ultramarine

ivory black

Chinese white

Using reds

The word "red" conjures up a bright, insistent scarlet—the red of fire engines—but it is in fact a complex color that is remarkably varied in appearance.

As the most dominant color in the spectrum, red is one of the trio of primary colors from which all other colors can be mixed. It can be vibrant and rich—think of the scarlet red of poppies and holly berries, which are represented by colors such as cadmium red, Winsor red and vermilion.

Red can also veer toward purple, burgundy, garnets and rubies—these colors are denoted by magenta and carmine on the artist's palette. Red can be muted, too. Consider brick and terra-cotta—on the palette, earth reds such as Venetian red stand in for these. Delicate and subtle reds are portrayed by rose doré and rose madder.

The origins of red pigments are diverse —rose madder traditionally came from the root of the madder plant, while carmine was made from cochineal beetles from Central America.

Taking a closer look

Bright reds, scarlets, magentas and hot pinks all vie for attention in this sizzling tropical landscape. Touches of green—red's complementary color—enhance the brilliance of the reds, while the blue sky, door and sea startle with their intensity.

**Yialia, Cyprus
by Jenny Wheatley**

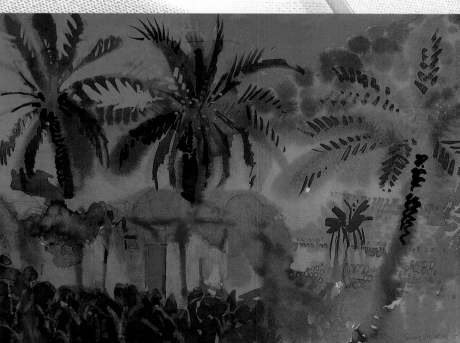

◀ **Carmine**
This red is transparent and highly fugitive, i.e. liable to fade in bright light.

◀ **Rose madder**
This is a light pink color.

◀ **Alizarin**
A synthetic substitute for natural madder, alizarin is a cool red with strong staining properties and is highly transparent.

◀ **Cadmium red**
This is made from the metal cadmium. It is a good, warm, opaque red.

◀ **Magenta**
This is a purple-red color, first synthesized in the 1860s.

◀ **Scarlet lake**
Originally a mix of cochineal lake and vermilion, scarlet lake is now made from various synthetic pigments.

Exploring reds

Alizarin crimson and cadmium red provide a good starting point for a basic palette, but it is worth experimenting with colors such as rose doré and permanent carmine.

There are many new and improved formulations among the reds. Modern organic pigments, the quinacridones for example, have produced new colors such as quinacridone magenta, and traditional colors have been reformulated. Test them for transparency and opacity and see how they mix with yellow and their complementary greens.

Cadmium scarlet
A bright, warm red, this is opaque and mixes to give a good orange. You could substitute it for cadmium red in a limited palette.

Permanent carmine
True carmine, made from cochineal beetles, is costly. Permanent carmine is one of many synthetic substitutes. It is transparent and closely resembles alizarin crimson.

Rose doré
A pretty, old-rose color, this is very transparent and gives delicate flesh tones. It is useful in flower painting.

Permanent rose
This is a bright, pinkish red, much cooler than rose doré, and very transparent. It has good lightfastness.

Mixing reds

These experiments with red mixtures have produced a number of soft browns, oranges and blues. Try out some blue/red mixtures, which give a range of mauves and violets, and red mixed with its complementary green, which produces browns and neutrals.

Two-color mixtures

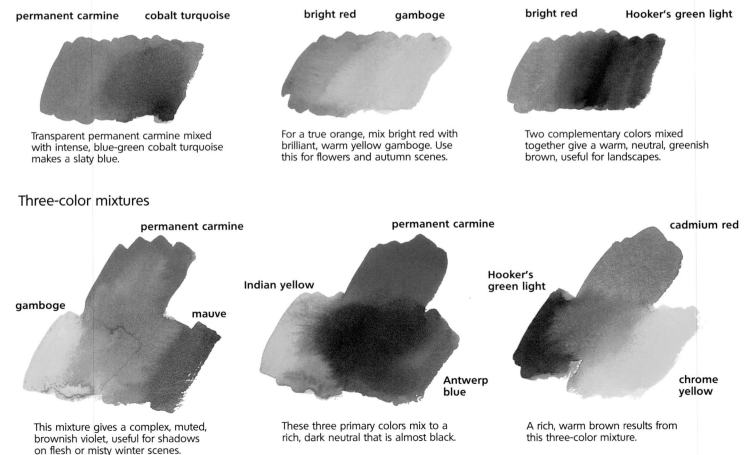

permanent carmine **cobalt turquoise**

Transparent permanent carmine mixed with intense, blue-green cobalt turquoise makes a slaty blue.

bright red **gamboge**

For a true orange, mix bright red with brilliant, warm yellow gamboge. Use this for flowers and autumn scenes.

bright red **Hooker's green light**

Two complementary colors mixed together give a warm, neutral, greenish brown, useful for landscapes.

Three-color mixtures

permanent carmine

gamboge **mauve**

This mixture gives a complex, muted, brownish violet, useful for shadows on flesh or misty winter scenes.

permanent carmine

Indian yellow

Antwerp blue

These three primary colors mix to a rich, dark neutral that is almost black.

cadmium red

Hooker's green light

chrome yellow

A rich, warm brown results from this three-color mixture.

Alizarin crimson and its mixtures

A cool, transparent red, alizarin crimson is a must for every watercolor palette, however limited.

Alizarin was first synthesized in 1868 and is the oldest synthetic lake pigment. A lake is a paint that is made from a soluble dye. It is turned into a pigment by precipitating it onto a base. Alizarin crimson is a useful mixing pigment, but because of its transparency it is at its most beautiful when applied as a pure wash in various strengths or tints. Mix alizarin crimson with French ultramarine for a strong violet. The combination of viridian and alizarin crimson gives a rich gray, useful for cool shadows or foliage. Mixing alizarin crimson with cadmium yellow and cadmium lemon produces muted colors that you can use for warm flesh tones or in an autumn landscape.

▲ ALIZARIN CRIMSON *has good tinting strength—one drop on your brush goes a long way.*

20% alizarin crimson

cadmium red

burnt umber

raw sienna

cadmium yellow

cadmium lemon

viridian

oxide of chromium

cerulean

French ultramarine

ivory black

Chinese white

Cadmium red and its mixtures

Cadmium red is a particularly stable, useful color. It replaces traditional vermilion in the artist's palette.

Throughout history, artists have searched for a good, bright, permanent red color, and this is the one. The cadmium reds range from orange-reds to deep red—the adjectives light, medium and deep are sometimes used in their names, indicating the type of red you can expect. These colors have a high tinting strength and are fairly opaque when first applied, but become less opaque when dry. A warm color, cadmium red combines with cadmium yellow to produce a true orange. Combined with alizarin crimson it makes an earthy terracotta shade. The green mixtures are particularly interesting—with viridian, cadmium red produces a deep brownish green color. The mixture with cerulean blue provides a rich slate gray.

▲ CADMIUM RED *is an intense red that should find a place in your palette.*

alizarin crimson

20% cadmium red

burnt umber

raw sienna

cadmium yellow

cadmium lemon

viridian

oxide of chromium

cerulean

French ultramarine

ivory black

Chinese white

Using yellows

The third primary color—yellow—is bright and vibrant. It comes in many forms, some energizing, others bold and shocking.

Nature has many yellows, ranging from the hot, golden orange of sunflowers and the bright, sharp yellow of lemons to the soft, creamy tinge of primroses. Therefore the artist's palette contains an extensive range, including yellow ocher, which is warm and somewhat greenish; intense, bright cadmium yellow; creamy Naples yellow; and sharp, acidic lemon. Yellow ocher

and raw sienna provide the earth tones in the yellow range. But some yellows have unpleasant origins. The Naples yellow that Rubens loved using for skin tones in the seventeenth century, for example, was based on poisonous lead antimoniate, while Egyptian orpiment was based on arsenic. These pigments are still available, but have mostly been replaced by harmless synthetics.

Taking a closer look

A golden building on a golden afternoon—the artist has used hot cadmium yellows with cooler lemon tones and raw sienna and yellow ocher earth colors. Mixing yellows with blue has given darker tones for shadows, while a warm red gives some strong orange hues.

Ca' d'Oro, Venice
by Jenny Wheatley

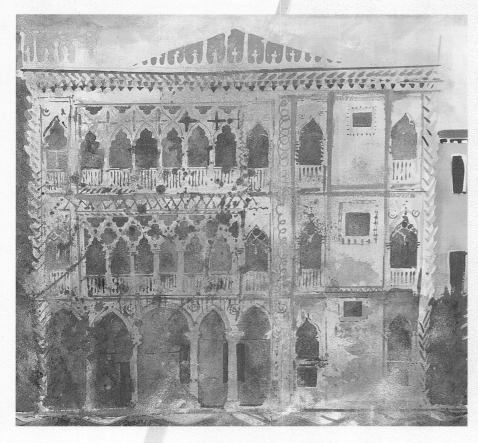

◀ **Strontium yellow**
A cool, light yellow, this has now largely been replaced by other pigments.

◀ **Cadmium yellow pale**
A clean, strong, bright yellow, this has good covering power.

◀ **Chrome yellow middle**
This is a bright yellow, similar to cadmium, but cheaper and quite fugitive, that is liable to fade in bright light.

◀ **Barium**
This cool, greenish yellow is now almost obsolete. It is completely lightfast, but its low tinting strength means it has little effect in a mixture.

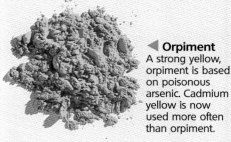

◀ **Orpiment**
A strong yellow, orpiment is based on poisonous arsenic. Cadmium yellow is now used more often than orpiment.

◀ **Realgar**
A reddish orange yellow, similar to orpiment, realgar is also based on poisonous arsenic.

Lemon yellow and its mixtures

Every palette needs a cool as well as a hot yellow, and cadmium lemon fulfills this role admirably.

The term "lemon" describes a pale, sharp, greenish yellow—it is a hue rather than a pigment. The color can be made from different pigments depending on the manufacturer. As a result, each manufacturer gives the paint a different name, such as cadmium yellow lemon, cadmium lemon and chrome yellow.

Lemon yellow creates cooler shades than those made with cadmium yellow. The alizarin crimson mixture looks stronger than the cadmium yellow version, while cadmium red is softened to give a rich terra-cotta. Mixed with ivory black, lemon yellow creates a stunning gunmetal gray, and with French ultramarine you get a beautiful, distinctive blue.

▲ CADMIUM LEMON *based on cadmium yellow medium pigment is reliable and lightfast.*

alizarin crimson

cadmium red

burnt umber

raw sienna

cadmium yellow

20% cadmium lemon

viridian

oxide of chromium

cerulean

French ultramarine

ivory black

Chinese white

Using greens

Green is a secondary color that falls between blue and yellow on the color wheel. It is the color of growth and fertility—but also of mold and decay.

The fresh, bright green of spring is a favorite with artists, but there are a huge number of other shades of this color, ranging from the darker, stronger greens of summer foliage to the golden-greens of mosses, the soft greens of sage leaves and the pale greens of water. The innumerable variety of greens in nature gives artists scope for detailed and imaginative landscape paintings, but be careful because the greens can go disastrously wrong. Sunlight on fresh green foliage or grass creates such a bright and dazzling effect that there is a tendency to make your colors too garish. It takes practice to orchestrate landscape greens satisfactorily.

Taking a closer look

Greens are essential for landscapes and gardens, and they also appear in skies, seascapes and skin tones. The subtleties are endless—from yellow-green to blue-green to nearly black or brown.

**Rough sea at Lyme Regis
by Peter Folkes**

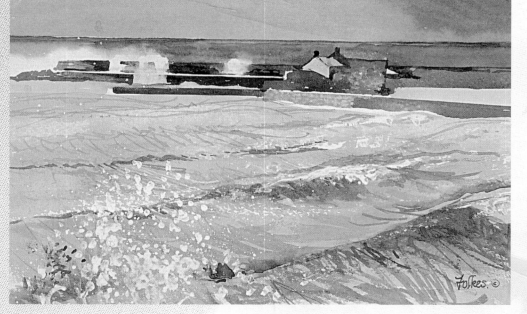

◄ **Verdigris**
This is an antique blue-green pigment based on copper. It was used by the Old Masters, but often blackened over time.

◄ **Cobalt green**
A bright pigment of medium strength, this is reasonably opaque and permanent, but has poor covering power.

◄ **Cadmium green**
This is an artificial mineral pigment based on a mixture of cadmium yellow with either viridian or French ultramarine.

◄ **Viridian**
This is an intense, transparent and distinctive blue-green valued for its opacity and permanence.

◄ **Green jasper**
This crystallized iron silicate gives the natural earth pigment Verona green.

◄ **Chromium oxide green**
This dull, matte, olive green is opaque, permanent and very reliable.

Viridian and its mixtures

This important color was patented in 1859. A brilliant and transparent emerald green, it is valued for its clarity and intensity.

Useful though it is, viridian needs handling with care—even a hint of it on your brush will taint other colors. On its own it can be loud, but in mixtures it can produce some wonderful greens. On your palette, or when thickly applied, it can appear almost black. Lay out your palette in an orderly way so you know exactly where it is.

Viridian mixed with cadmium yellow produces a range of bright spring greens—the colors of newly unfurled beech leaves or the leafy rosettes of primroses. With a cool yellow such as cadmium lemon it produces a bright, chilly green. Mix it with earth colors such as raw sienna and burnt umber for a range of foliage colors, or with reds for some lovely autumnal shades.

▲ VIRIDIAN *is a bright, strong hue that is at its best in glazes, washes and mixtures.*

alizarin crimson

cadmium red

burnt umber

raw sienna

cadmium yellow

cadmium lemon

20% viridian

oxide of chromium

cerulean

French ultramarine

ivory black

Chinese white

Using violets

Mixed from two primary colors—blue and red—violet (or purple) is an extremely rich, vibrant color that appears in many flower hues.

The color violet ranges from the mauves, which have a lot of red in their makeup, to the purples, which hover on the verge of blue. It is a difficult color to define. Individuals differ in their perception of the various different shades—and paint manufacturers don't agree, either.

Although many flowers have given their names to shades of purple—lilac, violet and lavender, for example—nature provides very few good purple pigments. In Roman times, violet was derived from a type of mollusk while in the Middle Ages it was made from inexpensive vegetable dyes. The first synthetic violet was made from coal tar derivatives by William Henry Perkin in 1856. Perkin's violet ushered in a host of synthetic dyes, some still in use today.

◄ Violet quindo
The quinacridone pigments on which this mixed violet is based were first developed in Germany in the 1930s. They are extremely lightfast, i.e. do not fade in the light.

◄ Winsor violet
This—also called dioxazine violet—is a semitransparent, fairly lightfast pigment. It is a good, balanced violet, neither too red nor too blue.

◄ Côte azure violet
This is a bluish-red oxide of iron. It is a naturally occurring earth color.

Taking a closer look

The exact hue of violet is difficult to pin down. This painting includes a beautiful range from deep, dark purples through to pale mauves.

Salvation Jane, Foothills of Mount Lofty Ranges, south of Adelaide, South Australia
by *Roy Hammond*

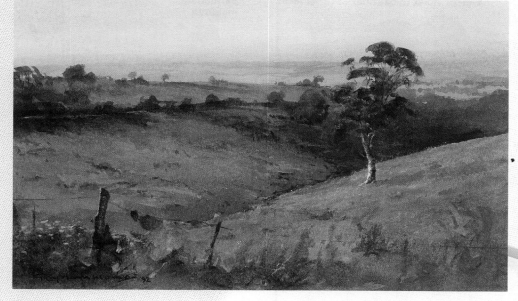

◄ Permanent mauve
This is the first dye distilled from coal tar derivatives and is also known as Perkin's violet, after its creator. It is completely lightfast.

◄ Purpurite
Derived from iron manganese, this violet has an intense hue.

◄ Cobalt violet dark
Cobaltous phosphate was first made in the early 1800s from a natural ore. It is transparent and varies from red-violet to a bluer version.

Permanent magenta and its mixtures

This color is much warmer, pinker and more delicate than permanent mauve, and produces lighter and brighter mixes.

Permanent magenta, a quinacridone violet, enhances the rosy qualities of alizarin crimson to give a bold, lively color, but lightens oxide of chromium to produce a khaki green. The raw sienna and cadmium lemon mixtures are useful for flesh tones. The combinations with blue are interesting —cerulean is slightly muted to produce an intense gray-blue, while the mixture with ultramarine produces an intense blue-violet—the color of some irises.

The addition of Chinese white shows the cool transparency of permanent magenta to its maximum advantage. Mixed with ivory black, permanent magenta produces a slate gray, useful for landscapes and shadows.

▲ *Permanent magenta is a reliable red-violet and a useful addition to your palette. It is lightfast, transparent and gives very smooth washes.*

alizarin crimson

cadmium red

burnt umber

raw sienna

cadmium yellow

cadmium lemon

viridian

oxide of chromium

cerulean

French ultramarine

ivory black

Chinese white

Using oranges

Bright, insistent and showy, orange—mixed from red and yellow—is the warmest of all the secondary colors.

Orange has similarities to both its parent primary colors. Like red, it is strong and bold, yet it is also as cheerful and welcoming as yellow. Orange is always warm, unlike reds such as crimson and yellows such as lemon, which are relatively cool.

The exact hue of any orange depends on the proportions of the mixture—most oranges have a bias toward either red or yellow. Physically, orange is closer to yellow, since both are the brightest of the pure colors.

The complementary partners of orange are the blues and blue-greens. When orange is placed side by side with one of these colors, they enliven each other, but they neutralize each other when mixed.

In nature, orange colors are typical of the summer and autumn months, seen in flamboyant flowers, ripe fruits, leaves and berries. Shrubbery and woodlands abound with orange in autumn, and the color shows its strength in stunning sunsets and stormy skies.

Taking a closer look

In this striking landscape, a range of oranges—pale, yellowish beige darkening to a mid hue and some strong streaks of pure orange—culminates in a few dramatic, fiery bursts of concentrated color of a volcano-like intensity.

Pembrokeshire landscape
by *John Cleal*

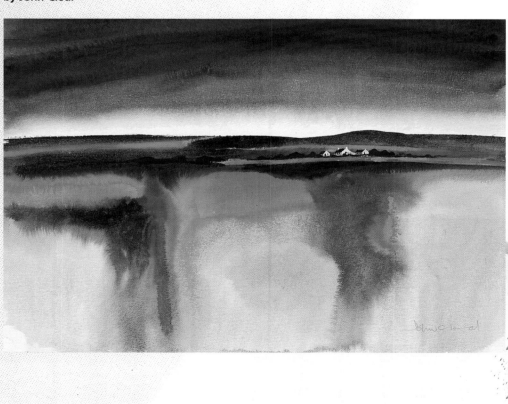

◀ **Chrome orange**
An artificial mineral pigment based on lead chromate, this produces highly saturated colors.

◀ **Cadmium orange vermilion**
Cadmium, a silvery metal, produces colors from pale yellow to warm orange. This pigment has good lightfastness, i.e. it does not fade in the light.

◀ **Titanium orange**
This pigment is strong and quite opaque. It is slightly muted and leans toward yellow.

◀ **Isoindolinone orange**
A synthetic orange pigment, this is a reliable, strong mid-orange with a high tinting strength. Its transparency makes it good for glazes.

◀ **Iron oxide orange**
Synthetic iron oxide is a good substitute for the natural earth colors. It produces quite a good brown-orange.

◀ **Cadmium orange light**
A variation of cadmium orange, this slightly paler pigment is bright and strong.

Cadmium orange and its mixtures

Some cadmium orange paints are made from the pigment cadmium orange. For others, such as the one shown here, manufacturers mix yellow and red pigments.

This cadmium orange—mixed from cadmium yellow and cadmium red —is bright, strong and glowing. Mixed with raw sienna and cadmium yellow, it creates a range of golden and marigold shades. It neutralizes greens to create leaf and sage shades, ideal for spring and summer landscapes.

With French ultramarine, cadmium orange gives a range of greenish browns, while the cerulean mixture is a bluish green. The black and cadmium orange mixture gives a warm, earth brown, and this has a wide variety of applications, ranging from landscapes and interiors to skin tones.

▲ CADMIUM ORANGE, *like all cadmiums, is very warm and strong. It is also opaque, but it can be thinned to create very even, consistent washes.*

alizarin crimson

cadmium red

burnt umber

raw sienna

cadmium yellow

cadmium lemon

viridian

oxide of chromium

cerulean

French ultramarine

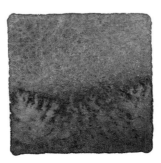

ivory black

Chinese white

Using browns

Brown has a varied character: it can be intense, strong, solid, even somber—but it can also be mellow, smooth and comforting.

In the natural world, brown is the color of the earth—rich, dark, wet mud or the milky cocoa of turned fields. Cool gray-browns and pinkish browns create a backdrop to woods and shrubbery. The autumn landscape provides the richest range, with russets, golden ochers and chocolate browns. Winter's palette is more subtle—delicate browns and pearly neutral browns are set off by others so dark they look black. There are many lovely browns to choose from among the earth pigments, including burnt umber, burnt sienna, sepia and Indian red.

Technically, brown is a colored neutral—the warm equivalent of the cool grays. It can be created by darkening yellow, orange or red with black or their complementary colors. Mixtures of yellow and violet, orange and blue and green will give you a range of beautiful browns—yellow-brown, red-brown, orange-brown or browns with a red-violet tinge. The three primary colors can mix to a neutral brown or gray.

Taking a closer look

An almost inexhaustible range of muted browns and earth colors have been used in this painting of a small country town in the rain on an autumn evening—all blending together to create a gentle, harmonious image.

**Autumn evening, Elton
by Keith Noble**

◀ **Raw sienna**
This golden-brown pigment is derived from a natural clay containing iron and manganese.

◀ **Burnt sienna**
A bright golden-brown, burnt sienna is created by heating raw sienna in a furnace.

◀ **Raw umber**
Umber pigment originally came from Umbria in Italy. The tones of this deep brown pigment range from green-yellow to violet.

◀ **Burnt umber**
This also came from Umbria and, along with raw umber, it is the most widely used brown pigment.

◀ **Burnt green earth**
Also called terre verte, this semitransparent brown is derived from clay stained green by manganese and iron in the earth.

◀ **Yellow iron oxide ocher**
This is a yellow earth pigment.

Burnt umber and its mixtures

Heating raw umber—an earth pigment—in a furnace produces burnt umber, which is a decidedly reddish brown with a slight but attractive underlying pink tone.

The final color of burnt umber depends on the temperature of the furnace and the length of roasting, but it ranges from a muted, burnt orange to a rich ginger. An intense, stable color, it may darken with age if the underlayers are not completely dry. In washes and glazes it gives a delicate pinkish tint. Used more solidly, it has the burnished richness of a seedpod. Burnt umber gives many colored neutrals—terra-cotta with cadmium red, dull khaki green with oxide of chromium. The blue mixtures are useful—with cerulean it makes a subtle gray, with ultramarine a dark, rich purple. With the yellows—raw sienna, cadmium yellow and cadmium lemon—it gives pinkish yellows.

▲ BURNT UMBER *has high tinting strength combined with good covering power. Try using it instead of black to soften a mixture.*

alizarin crimson

cadmium red

20% burnt umber

raw sienna

cadmium yellow

cadmium lemon

viridian

oxide of chromium

cerulean

French ultramarine

ivory black

Chinese white

Using black and white

Black represents the negation of color—and yet in theory it is achieved by mixing all three primary colors. White is its opposite.

For the artist, black can be warm or cool, matte or glossy, opaque or transparent. The Dutch artist Frans Hals (1581–1666), who painted "The Laughing Cavalier," created 27 different shades of black! Although you can mix black from the three primary colors, the best you can get is a very dark neutral. A good black in the palette is useful when you want a true black and for graying other colors. No blacks are perfect—they all have either a blue or a red bias.

A pure white is difficult to find. Most are warm or cool although whites have to be laid side by side for you to see this properly. It is the most responsive pigment to adjacent colors and the ambient light, and generally betrays a hint of another color. When white paint is mixed with other colors it gives a range of lighter tones, or tints. In watercolor, the white used most often is Chinese white—for highlights and making corrections, and to paint in items that have white as their local color.

◄ **Vine black**
This is a blue-black made from burned vine twigs or wood.

◄ **Bone black**
Produced from charred bones, this is a light black with a brownish tinge. It is denser than lamp black.

◄ **Manganese black**
Also known as manganese brown, this artificial color is a useful neutral.

Taking a closer look

The great simplicity of this image—painted in just three colors—gives it drama and impact. The rooster is painted in a rich, black watercolor wash, with his comb in brilliant red, while the white hen is represented by the pure white of the paper itself.

Coq et poule, 1991 by Patrick Procktor

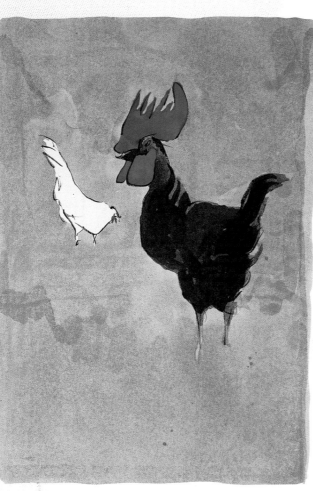

◄ **Ivory black**
Originally produced by burning ivory, this is actually a high-grade bone black. It is a deep black with a brownish tinge.

◄ **Mars black**
Like all Mars colors, this is an artificial oxide of iron. Dense, heavy, opaque and permanent, it has a brownish tinge.

◄ **Lamp black**
This deep, velvety black is made from the soot of oil, tar, pitch and resins. It is used in printing inks and in Chinese ink sticks.

Exploring blacks

Black can give some wonderfully subtle shades—the secret is to use it sparingly.

A cool black, such as blue-black, can be mixed with a cool yellow to give a range of acid greens—ideal for foliage and landscapes. Black can be used to give some pleasing slate grays and neutrals —look, for example, at the ivory black/cobalt blue mixture, which resembles Payne's gray.

If you choose more than one black for your palette, go for a warm black (such as ivory black) plus a cooler one (such as lamp black). Lamp black tends to be more opaque than ivory black.

Neutral tint
This varies between manufacturers. This version is semi-opaque and very dark with a bluish-purple undertone.

Payne's gray
Originally made from slate, Payne's gray is now mixed from several pigments. This version is distinctly blue.

Davy's gray
Like Payne's gray, this was based on a pigment made from slate. Now it is mixed from several pigments. It is opaque with a smoky greenish cast.

Lamp black
This is a dense, sooty black with high tinting strength and covering power. It is ideal for areas of solid black, but can be diluted to create washes.

Mixing blacks

There is a limited range of ready-mixed blacks available in watercolor. One should be enough for most purposes, since black can be modified by mixing with other colors.

Two-color mixes

blue-black	cadmium lemon

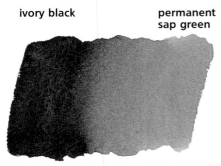

This combination gives an acid green, suitable for spring landscapes—especially the color of new beech leaves.

ivory black	yellow ocher

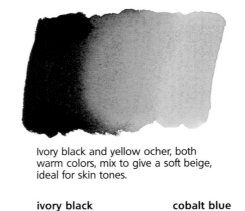

Ivory black and yellow ocher, both warm colors, mix to give a soft beige, ideal for skin tones.

neutral tint	cadmium yellow deep

Neutral tint softens and lightens cadmium yellow deep, giving a brownish neutral.

ivory black	permanent sap green

This mixture gives some interesting sage and khaki greens—excellent for landscapes.

ivory black	cobalt blue

Black and blue make for some subtle, soft, slaty blues, good for stormy skies or shadowy water.

neutral tint	alizarin crimson

This mixture creates a warm, pinkish, terra-cotta color, useful for garden scenes and interiors.

Ivory black and its mixtures

Black can be used to create an interesting range of tones, but if you use too much you will find your colors begin to look dead—so always handle it with care.

As you can see from the chart below, ivory black gives some pleasing results in mixtures. For example, look at the lovely midnight blue it makes with ultramarine, and at the dark, air-force blue you get with cerulean. With cadmium lemon, it gives a sharp, mossy green, and with cadmium yellow you get a rich, old gold.

The red mixes are interesting, with alizarin crimson producing a deep claret red, cadmium red an intense terra-cotta, and burnt umber a rich brown. Bear in mind that some versions of ivory black have a more obviously brown cast than the one shown here. As always, remember that the colors vary from one manufacturer to another.

▲ *IVORY BLACK is no longer made from ivory, but is produced by burning animal bones from which the fat and gristle have been removed by boiling.*

alizarin crimson

cadmium red

burnt umber

raw sienna

cadmium yellow

cadmium lemon

viridian

oxide of chromium

cerulean

French ultramarine

20% ivory black

Chinese white

Chinese white and its mixtures

Chinese white is a cold, zinc white with excellent covering power. It is the white commonly used to add "body" to transparent watercolor.

If you look at the reds mixed with white in the chart below, you will see that the alizarin tint is a cool fuchsia while cadmium red turns salmon-orange. Chinese white mixed with viridian and with oxide of chromium provides an interesting comparison. Viridian retains its transparency to give the color of the deep sea or colored glass, but oxide of chromium is rendered more solid and opaque.

Cerulean blue mixed with white produces a cool, sea-blue tint, while ultramarine and white give a pretty bluebell blue—the addition of white seems to emphasize the difference between the two.

The earth colors burnt umber and raw sienna demonstrate surprising delicacy and transparency with white, producing tints that are excellent for a range of flesh tones.

▲ CHINESE WHITE *has long been the white of choice for watercolorists, but titanium white, which surpasses zinc white in whiteness and covering power, is increasingly popular.*

alizarin crimson

cadmium red

burnt umber

raw sienna

cadmium yellow

cadmium lemon

viridian

oxide of chromium

cerulean

French ultramarine

ivory black

20% Chinese white

CHAPTER 3
PROJECTS

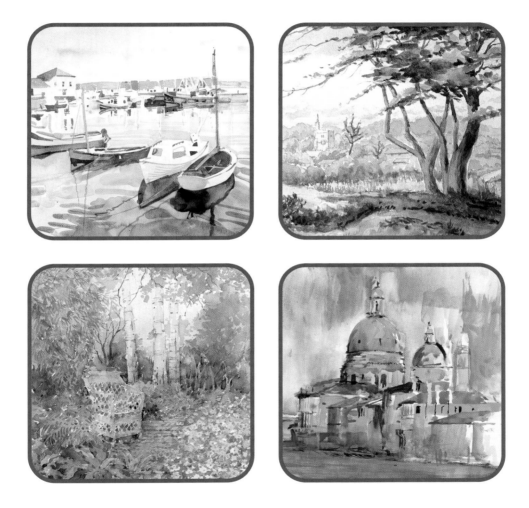

What you need

- A 21 x 15in (50 x 38cm) sheet of stretched cold-press watercolor paper—Whatman 200lb (425gsm) has a strong, soft surface
- Staples and staple gun
- Masking tape
- Drawing board
- B pencil
- Masking fluid
- Paint shaper for applying masking fluid
- Nine paints: Winsor red, Winsor blue, Winsor green, ultramarine, cadmium lemon, burnt sienna, Naples yellow, Venetian red, indigo
- Three brushes: No.8 and No.4 round; a 2in (50mm) soft flat
- Two jars of water
- Palettes
- Tissues

▲**1** Staple the paper to the board and define the picture area with masking tape to ensure a clean, crisp edge to the finished painting. Make an outline drawing of the subject using the well-sharpened B pencil. Paint the foreground fence with masking fluid, using a paint shaper to spread the fluid smoothly and quickly (inset). Add a few streaks of masking fluid with the tip of the shaper to indicate blades of grass in the foreground.

▲**2** Wet the sky area with clean water, using the 2in (50mm) soft flat brush. Apply a wash of Winsor red to the lower half of the wet sky with the No.8 round brush, then strengthen the red along the horizon. Allow the painting to dry.

Expert opinion

Q How can I achieve clean, white shapes when lifting out wet color from the paper?

A Start lifting wet color as soon as possible after application—before the pigment has had time to sink into the paper, and certainly before the paint starts to dry. In this painting, the artist used a clean tissue to lift each white shape for the clouds. Avoid using dirty tissues because this can spread smudges of color.

▲**3** Wet the top of the paper and paint a broad band of a Winsor blue/Winsor green mixture across the top of the sky. Wet the lower half of the sky, taking the water precisely to the horizon line. Drop the blue/green mixture onto the wet paper, letting it find its own way along the wet horizon.

blue-green sky color

Winsor blue

Winsor green

▶ **4** While the sky is still wet, darken the area just above the horizon with ultramarine. The red underpainting should show through as a rosy glow. Dab the wet sky with a crumpled tissue, lifting the color to reveal white clouds. Change to the No.4 brush and soften the lower edge of the clouds with clean water (inset). Drop dilute mixtures of Naples yellow, Winsor red and ultramarine into the wet areas. Let dry.

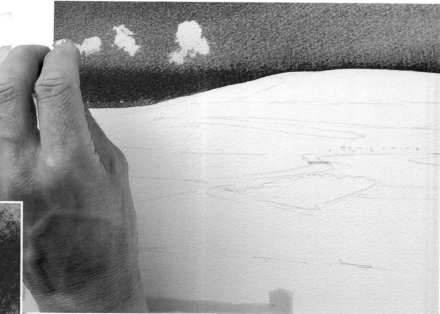

▶ **5** Block in the foreground with diluted burnt sienna and a touch of Winsor blue, using the No.8 brush. Paint the sunlit fields in cadmium lemon and burnt sienna. Add a touch of ultramarine to the mixture and paint the distant water and background hill, taking the color up to and along the horizon line.

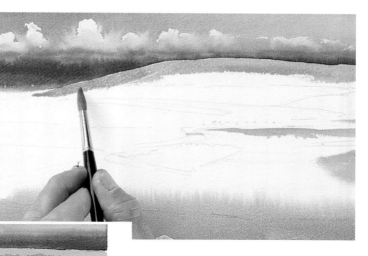

cadmium lemon

Venetian red

warm autumnal yellow

◀ **6** Flood mixtures of cadmium lemon and Venetian red into the remaining landscape, leaving the road, chalk cliff and distant trees as patches of unpainted paper. Overpaint the far hill in a washy green mixed from cadmium lemon and Winsor blue.

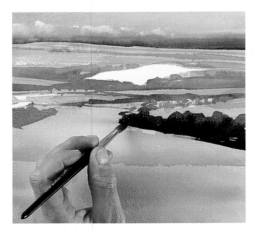

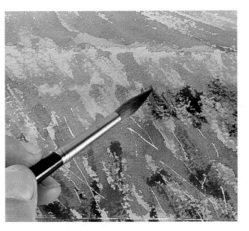

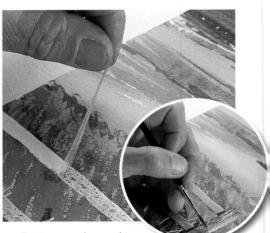

▲**7** Paint the distant shadows in washes of cadmium lemon, Venetian red and indigo. Bring these forward to define the white cliff. Use a strong mixture of indigo/Venetian red/cadmium lemon for the central hedges. Paint the plowed field in Venetian red/Winsor blue. Let the yellowish underpainting show through.

▲**8** Lightly paint the cliff texture in dry strokes of indigo/burnt sienna. Put in reflections on the river in indigo. Rub off the masking fluid in the foreground and paint the grass in bold, diagonal strokes of burnt sienna. Overpaint this in a very dark mixture of burnt sienna/indigo, using short, textural strokes.

▲**9** Remove the masking fluid on the fence, lifting one end of the rubbery mask and carefully pulling upward. Paint the fence in a pale wash of cadmium lemon/indigo/burnt sienna. Paint the wood grain in burnt sienna/indigo with the tip of the No.4 brush (inset).

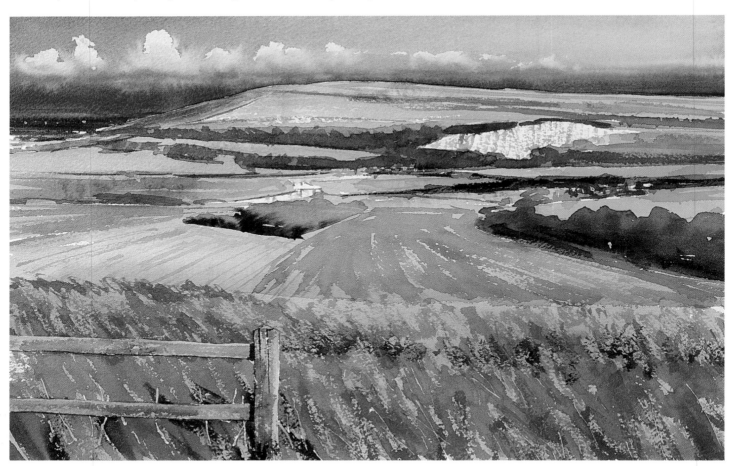

▲**10** Stand back and review the painting, comparing it with the reference photograph. It is important to ensure the illusion of recession from foreground to background is successfully achieved. To bring the foreground forward, add more texture on the wooden fence using the burnt sienna/indigo mixture, and apply touches of unmixed burnt sienna to the foreground vegetation.

FINISHED PICTURE
Various compositional devices draw the viewer into and around the painting. The converging furrows of the plowed field and the diagonal of the bushes provide a route from the foreground into the distance, while the gleaming white crescent of the chalk pit is an important focal point, echoed in the river and clouds.

Bury Hill in autumn
by *Joe Francis Dowden*

Old mill and stream

This peaceful scene with verdant trees, a gently flowing stream and a distant building provides the opportunity to develop the technique of painting reflections in water.

The first thing to remember here is a rule of perspective: parallel lines converge on the horizon—or your river will appear to flow uphill. Notice how the river narrows sharply as it flows into the distance, and how the ripples become smaller and denser as they recede. Don't include every ripple and reflection. The more simply you paint water, the wetter it looks. The artist used a large brush to make broad washes, letting his colors spread softly on the damp paper and merge wet in wet. Right at the end, he put in a few dark ripples and shadows. The contrast between light and dark tones gives the effect of brilliant light reflecting from the water's surface.

Tip

When you are painting skies and water, it's a good idea to prepare your washes in advance, each in a separate well of the palette. This way you can paint quickly and confidently, without having to stop in mid-flow to mix a color.

The setup

The white clapboard walls of this old restored mill, lit by a shaft of sunlight, make a strong focal point that is attractively framed by the surrounding trees.

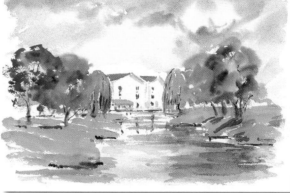

◀ **WATERCOLOR SKETCH**
This will familiarize you with the subject so that you aren't approaching it "cold." It will also help you plan the tonal key of the picture.

◀ **PENCIL SKETCH**
Use a soft pencil with a blunt point to make your initial sketches of the scene; this glides easily over the paper and will give you a full range of tones from silver-gray to black.

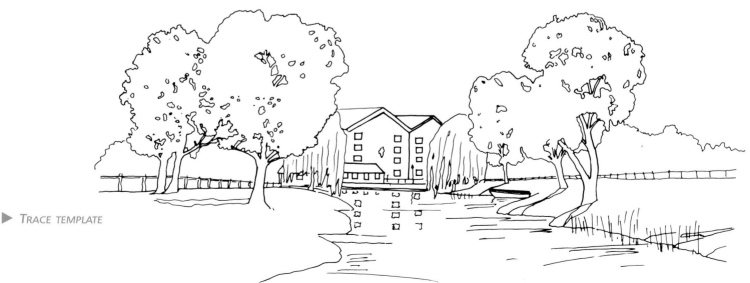

▶ *TRACE TEMPLATE*

What you need

- A 22 x 15in (56 x 38cm) sheet of 300lb (640gsm) Saunders Waterford Rough watercolor paper
- Drawing board
- HB pencil
- 10 watercolor paints: French ultramarine, raw sienna, burnt sienna, burnt umber, alizarin crimson, light red, cadmium yellow, Winsor red, Winsor blue (red shade), Payne's gray
- Four brushes: No.16 and No.8 round; a No.3 sable script liner; and a 2in (50mm) flat
- Two jars of water
- Palette
- Tissues

1 Draw the mill in simple lines, using the well-sharpened HB pencil. Indicate the surrounding trees and the stream, but avoid putting in too much detail.

2 In separate wells of the palette, prepare washes of raw sienna and French ultramarine with a touch of alizarin crimson, and a dark blue mixed from French ultramarine/burnt umber. Dampen the lightest part of the sky and touch in some raw sienna with the edge of the flat brush.

French ultramarine and alizarin crimson

raw sienna

French ultramarine and burnt umber

3 While the underwash is still damp, start the clouds with the ultramarine/alizarin mix. Apply the paint with random strokes of the No.16 round brush and let it bleed wet in wet to create soft shapes. Use a tissue to lighten some of the clouds and to blot unwanted runs (inset).

4 Add a little burnt umber to the mix and put in the darker cumulus clouds. To give the effect of moving, broken cloud, hold the brush horizontal to the paper and roll it between your fingers while moving it from left to right.

Tip

To tackle reflections, a good rule of thumb is simply to dilute the mixtures you used for the features themselves —a slightly diluted foliage mixture for reflections of trees, for example. Where the reflections are in shadow, use slightly darker, stronger mixtures.

5 Mix a dilute, grayish green from ultramarine and raw sienna and put in the line of trees in the far distance. Warm the mixture with more raw sienna for the nearer row of distant trees. Then mix cadmium yellow, raw sienna and a little ultramarine for the farthest of the grassy banks.

6 Continue to paint the grassy banks. As you work from distance to foreground, make the washes progressively stronger in tone and the greens warmer by adding more cadmium yellow to the mixture. Let dry.

▲**7** Mix stronger, warmer greens with cadmium yellow and ultramarine or Winsor blue (red shade). Suggest the rough contours of the nearer grassy banks with overlaid washes, using less water than before. Paint the dark shadows where the banks meet the water with a dark, dry mixture of burnt umber/ultramarine (inset).

▲**8** Paint the reflections of the sky on the water's surface using the same colors mixed for the sky (raw sienna applied to damp paper, overlaid with ultramarine and a hint of burnt umber). This time apply the colors with smooth, flat strokes, making them smaller and narrower in the distance.

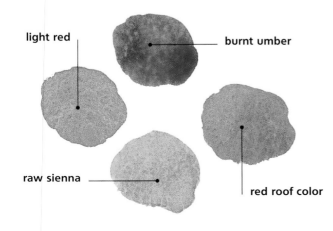

light red

burnt umber

raw sienna

red roof color

▲**9** Use the No.8 brush with light red/raw sienna/burnt umber for the red roofs and the wooden walkway. Add more burnt umber/ultramarine for the darker parts. Paint the shadows of the eaves and the windows with ultramarine/burnt umber.

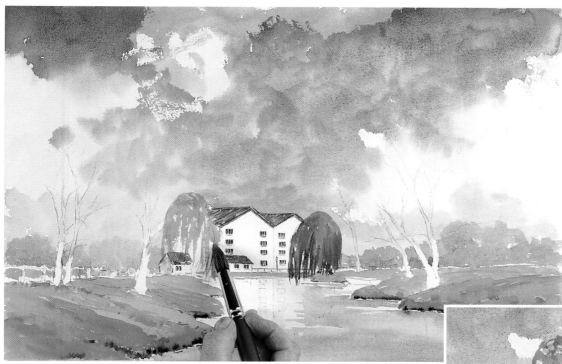

◄10 Mix cadmium yellow with a hint of Winsor blue (red shade) and paint the two willow trees with downward-sweeping dry-brush strokes. Add Payne's gray to the mixture and put in the darker foliage.

Winsor blue (red shade)

cadmium yellow

ultramarine

foliage color

►11 Paint the reflection of the willow tree on the right and break it up with ripples of dark blue. Then use mixtures of cadmium yellow, Winsor blue (red shade) and ultramarine for the foliage of the foreground trees. Push the brush upward to create broken strokes that suggest clumps of foliage moving in the breeze.

◄12 Paint the foliage of the trees on the left in a little more detail to show that they are nearer than the other trees. Use raw sienna for the trunks, overlaid with ultramarine and burnt umber on the shadow side. Paint the shadows down into the grass to "anchor" the trees to the ground.

Expert opinion

Q I always seem to overwork my paintings. How can I overcome this problem?

A Try using bigger brushes. Small brushes tend to encourage small, messy brushwork, and also they don't hold much paint. One large watercolor brush (anything from a No.12 upward) is more useful than three small ones. A good-quality brush —a pure sable or a sable/synthetic mix—holds plenty of paint for covering large areas and also comes to a point fine enough for the smallest details.

▲**13** Use the sable script liner for the small branches and the tree trunk shadows. Paint the boat shadows and the red trim. Use the No.8 brush for the tree reflections with diluted tree colors. Use ultramarine/burnt umber for the window reflections and a few ripples.

▲**14** Paint the wooden fence on the left with raw sienna/burnt sienna/burnt umber. Use the sable script liner brush for the weatherboarding under the mill roof. Jot in a couple of figures sitting on the railings, and their reflections in the water below.

▲**15** Mix a near-black from burnt umber/ultramarine and use the sable script liner brush to put in a few cattails plants on the riverbanks. Use the tip of the brush for the stalks, then press lightly with the side for the seedheads.

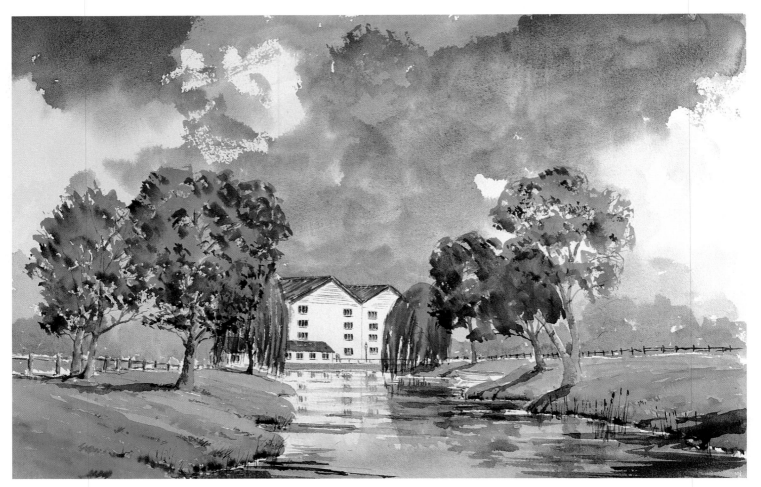

▲**16** Using the dark blue mixture, add the shadows cast by the trees and suggest a few clumps of grass in the foreground. Add some dark reflections to the foreground water. This brings the foreground forward and stops the eye from dropping out of the bottom of the picture.

FINISHED PICTURE
This simple but effective study uses a traditional division of the picture, with the sky occupying two-thirds of the area. The low horizon ensures that the trees and the mill are dramatically silhouetted against the blustery sky.

The old mill
by *Frank Halliday*

Harbor view

This bird's-eye view of a quiet harbor emphasizes both the haziness of the morning light and the sharp silhouettes of a church and a ruined abbey on the clifftop in the distance.

The artist wanted to convey the misty quality of the sunlight in this scene, yet at the same time to capture the silhouette effect of the buildings. He decided to work in loose washes, building up the color in transparent layers. In this way, he kept his picture in a fluid state until the very last stages. He then used a sable script liner brush and a small round brush to define some of the buildings and the bridge.

It is important not to overdo the finishing touches in a scene such as this. A few dots and lines using the tip of the brush are enough to suggest architectural details and to show the bridge. These sharp definitions bring selected parts of the painting into focus, leaving the surrounding areas—sky, sea and cliff—as spontaneous washes of color.

Tilt the drawing board at a slight angle to allow diluted washes to run and form bands of darker color along the lower edge of the brushstrokes. The tonal variations create natural-looking rock strata on the cliff face and lend depth to the shadows on the grass.

Tip

Avoid using a board with a laminated surface. Washes and very wet color can cause the surface to buckle and disintegrate, resulting in a very lumpy support for the paper.

The setup

To capture the quality of the morning light, the artist took a series of photographs of the harbor. However, he didn't want the photos to determine the shape and proportion of the painting, so he mounted his chosen view on a card and extended the scene in paint, thus giving himself a wider vista from which to select his composition.

▲ WATERCOLOR SKETCH
There was no preliminary pencil sketch for this painting. Instead, the artist made this rapid watercolor sketch to establish broad blocks of color in the composition.

What you need

- An 11 x 8in (28 x 20cm) sheet of acid-free board
- 13 paints: cadmium yellow, permanent rose, cerulean, ultramarine, cobalt green, burnt sienna, cadmium red, Winsor violet, lemon yellow, viridian, raw umber, alizarin crimson, yellow ocher
- Three brushes: No.4 and No.14 rounds; a sable script liner
- Two jars of water
- Mixing palettes

► **1** Loosely wash in the lower sky area with the No.14 round brush and some diluted cadmium yellow. While the paint is still wet, drop a little permanent rose into the yellow wash.

◄ **2** Working in broad, sweeping strokes, paint the rest of the sky in a dilute mixture of cerulean and ultramarine.

► **3** Define the horizontal waves on the left side of the cliff with a mixture of cerulean and cobalt green. Block in the top part of the cliff with diluted burnt sienna, allowing the color to run slightly down the tilted paper to suggest the rock strata.

Tip

Acid-free board makes an excellent support for watercolors. A cream-colored surface rather than pure white gives an attractive overall warmth to the finished painting.

▶ **4** Using the tip of the brush, draw the edge of the cliff in a mixture of cobalt green and burnt sienna. Paint the grass on the top of the cliff and on the ledges in a mixture of cadmium yellow and cobalt green. Wash in the sandy beach in a dilute mixture of cadmium yellow and burnt sienna.

cadmium yellow

sandy beach color

burnt sienna

◀ **5** Working in broad, sweeping strokes, add a few streaks of ultramarine to the sky. Paint the horizon line in ultramarine and burnt sienna. Add more water to the mixture and block in the rest of the sea, working down in overlapping horizontal strokes.

◀ **6** Change to the No.4 round brush and paint the edge of the cliff and the strata on the cliff face in ultramarine/burnt sienna. Take the color around the houses, leaving these as unpainted white shapes.

cliff strata color

burnt sienna

ultramarine

▶ **7** Using the tip of the brush, lightly suggest the outline of the houses in burnt sienna/ultramarine. Block in the houses in diluted burnt sienna with a touch of ultramarine.

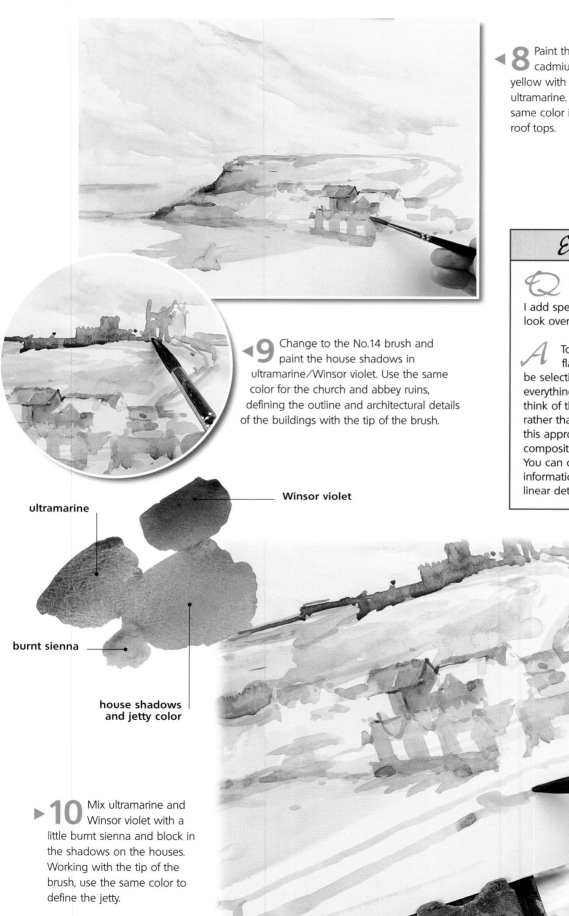

◄**8** Paint the rooftops in cadmium red/cadmium yellow with a touch of ultramarine. Take a little of the same color into the sand and roof tops.

◄**9** Change to the No.14 brush and paint the house shadows in ultramarine/Winsor violet. Use the same color for the church and abbey ruins, defining the outline and architectural details of the buildings with the tip of the brush.

Expert opinion

Q I enjoy painting buildings and architectural subjects, but when I add specific details my pictures tend to look overworked. How can I prevent this?

A Too much detail can have a flattening effect on buildings, so be selective and don't try to paint everything you see. From the outset, think of the subject in terms of mass rather than line. Watercolor lends itself to this approach, so start by establishing the composition in blocks of color and tone. You can convey a surprising amount of information without any drawing or linear detail.

ultramarine

Winsor violet

burnt sienna

house shadows and jetty color

►**10** Mix ultramarine and Winsor violet with a little burnt sienna and block in the shadows on the houses. Working with the tip of the brush, use the same color to define the jetty.

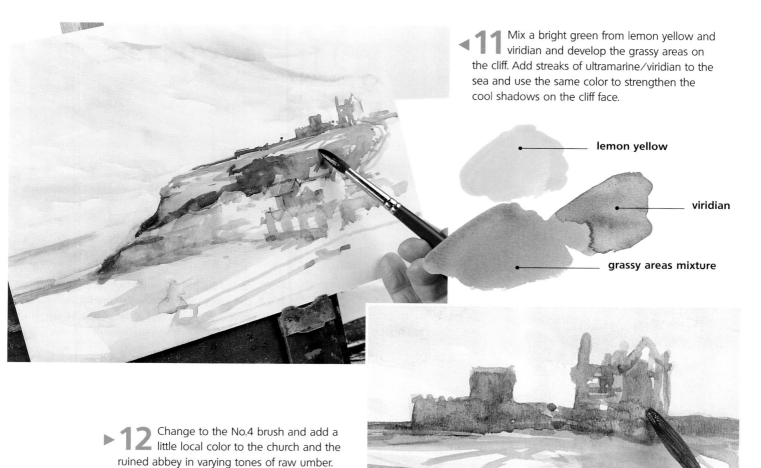

11 Mix a bright green from lemon yellow and viridian and develop the grassy areas on the cliff. Add streaks of ultramarine/viridian to the sea and use the same color to strengthen the cool shadows on the cliff face.

lemon yellow

viridian

grassy areas mixture

12 Change to the No.4 brush and add a little local color to the church and the ruined abbey in varying tones of raw umber.

13 Using the sable script liner brush, paint the construction lines of the harbor bridge in a mixture of burnt sienna/ultramarine.

14 Following the curved line of the tide mark on the beach, add streaks of diluted permanent rose to the sand to echo the warm tones of the sky.

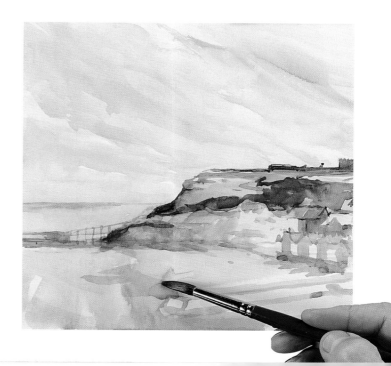

What you need

- A 22 x 16in (56 x 41cm) sheet of 140lb (300gsm) cold-press watercolor paper, stretched onto a board
- HB pencil and ruler
- Four brushes: No.1 and No.6 rounds; a ¾in (20mm) flat; and a hake (Japanese pony hair brush)
- Three watercolor paints: yellow ocher, cerulean, ultramarine
- Six gouache paints: Bengal rose, cerulean, yellow ocher, ultramarine, lemon yellow, white
- Two jars of water
- Two mixing palettes

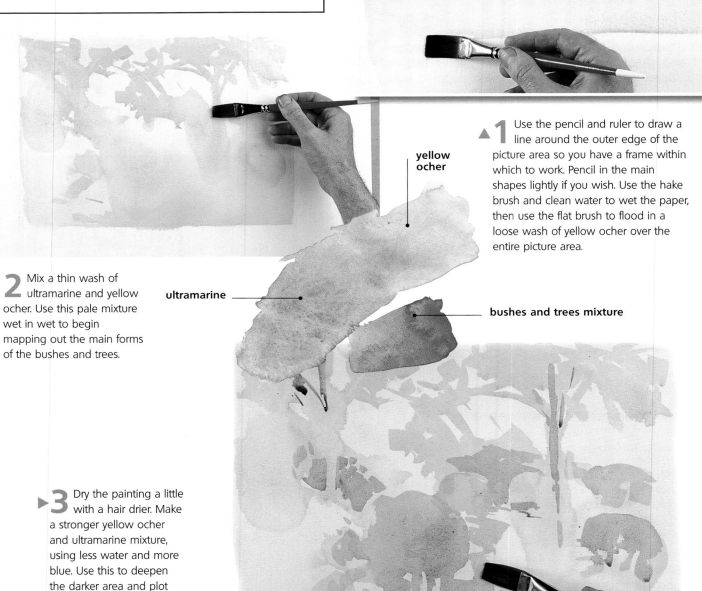

▲1 Use the pencil and ruler to draw a line around the outer edge of the picture area so you have a frame within which to work. Pencil in the main shapes lightly if you wish. Use the hake brush and clean water to wet the paper, then use the flat brush to flood in a loose wash of yellow ocher over the entire picture area.

yellow ocher

ultramarine

bushes and trees mixture

▲2 Mix a thin wash of ultramarine and yellow ocher. Use this pale mixture wet in wet to begin mapping out the main forms of the bushes and trees.

▶3 Dry the painting a little with a hair drier. Make a stronger yellow ocher and ultramarine mixture, using less water and more blue. Use this to deepen the darker area and plot the shadows. Use unmixed yellow ocher to block in the brightest areas of foliage.

◄ **4** Continue building up the watercolor underpainting, using stronger ultramarine tones for the deepest shadows. Vary the foliage tints with cerulean. Move around the picture, assessing and balancing the tones, pushing back some areas and bringing forward others.

Bengal rose

▶ **5** Now change to gouache for the rest of the painting. Make a washy Bengal rose/ultramarine mixture and use the No.6 round brush to block in the purple foliage.

ultramarine purple foliage

◄ **6** Still using the gouache quite thinly, mix yellow ocher and ultramarine to work up the shadows and begin to hint at forms and foliage. Add more ultramarine to the mixture to deepen the shadows and textures. Use lemon yellow for the brightest foliage on the clipped tree in the center.

ultramarine

leaf textures

yellow ocher

► **7** Build up tones and textures across the painting in thin washes. Use the darker yellow ocher and ultramarine mixture to add depth and form to the trees and shrubs. Introduce balancing touches of lemon yellow in the middle ground and on the tree canopy. Echo the purple foliage with touches of the Bengal rose/ultramarine mixture in the foreground. Introduce textural dabbing marks in the foreground.

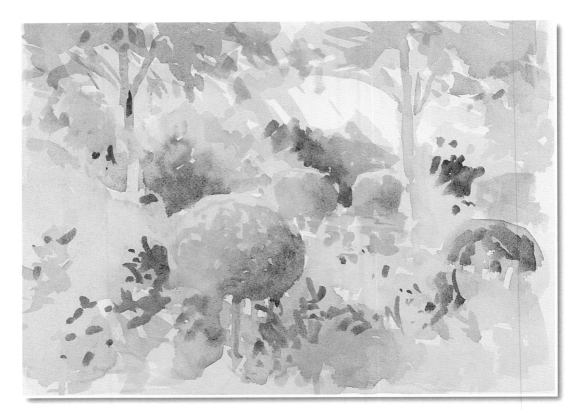

◄ **8** Start to thicken your washes. Use darker yellow ocher and ultramarine mixtures to deepen the shadow textures. Continue using dabbing brushmarks to express foliage surfaces. Move around the image without dwelling too long on any single area, and stand back from time to time to assess the tonal balance.

Tip

Palettes that keep gouache paint moist and workable are available. The plastic tray contains "reservoir" paper that you dampen before squeezing your colors onto it. The moisture prevents the paint from drying out, so you can continue to use it and none is wasted.

► **9** Let the painting dry a little so you can make crisper brushmarks. Strengthen the tree canopy with the darker ultramarine mixture. Use the same mixture to intensify the background bushes. Strengthen the Bengal rose/ultramarine mixture and add small textural marks to the purple shrub. Use the same mixture to paint the shadows on the back wall.

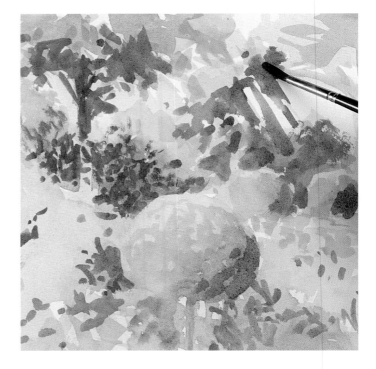

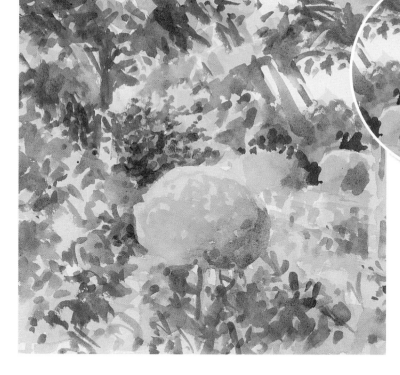

◄10 Develop the foreground and left side with more dabbed leaf marks. Vary yellow ocher/ultramarine and cerulean/lemon yellow mixtures and build up layers to suggest foliage textures. Use Bengal rose/ultramarine to deepen the purple foliage—use a dry brush for texture. Add dark leaf detail to the tree canopy (inset). Use longer brushmarks in the right foreground to suggest flower stems and leaves.

cerulean

lemon yellow

brighter green foliage mixture

►11 Intensify the leaf textures on the left side of the central tree with more leaf-shaped marks, using ultramarine/yellow ocher mixtures. Introduce touches of lemon yellow to suggest sunlit grass through the leaves.

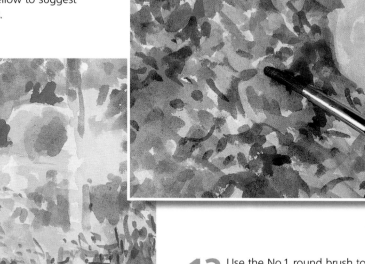

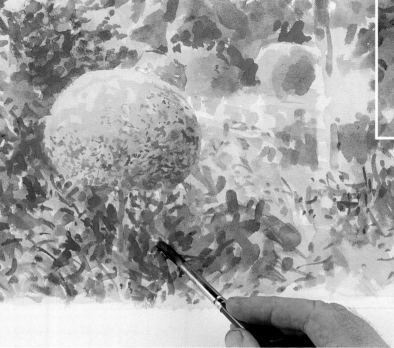

◄12 Use the No.1 round brush to add more detail to the central round tree, bringing it into focus so it advances into the foreground. Suggest the clipped foliage with small dabs of broken color, using mixtures of lemon yellow/yellow ocher. Work up the leaf area beneath the tree with more ultramarine mixtures.

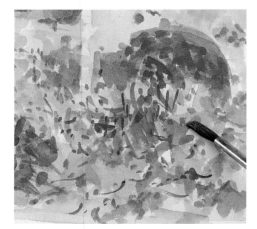

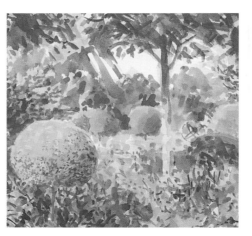

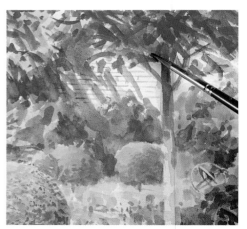

▲**13** Keep the foliage textures open in the right foreground and add small touches of Bengal rose here and there to suggest flowers. Dab echoes of the same color among the dense foliage in the foreground on the left.

▲**14** Use the No.1 round to "draw" the sundial in dark ultramarine/yellow ocher. Use the No.6 round to deepen foliage texture. Use ultramarine mixtures for the tree canopy and lemon yellow/yellow ocher for the trimmed light green trees.

▲**15** Use light Bengal rose/ultramarine for the brickwork. Soften with clean water and blot with tissue. In the center and foreground suggest sunlight with lemon yellow. Put in highlights on the sundial with the No.1 round brush and white gouache.

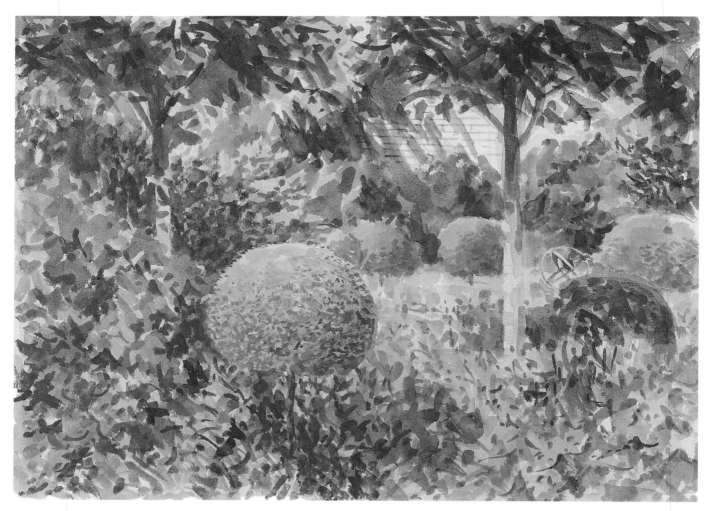

▲**16** Add more leaf detail to the central trimmed tree with lemon yellow/yellow ocher mixtures. Use a darker mixture to add generalized texture to the distant round trees.

FINISHED PICTURE
A combination of transparent watercolor and gouache was used to build up the complex shapes and textures, and dappled light and shade in this study. Touches of complementary red and pink enliven the predominant greens.

A Gloucestershire garden by *Derek Daniells*

Rocky coastline

The sea in all its ever-changing moods makes a compelling subject for a painting. Apart from the test of capturing the restless energy of the waves, it is important to get the composition right.

Views looking straight out to sea can appear flat and monotonous, and it may be better to look along the shoreline. Cliffs give a picture a vertical, rather than a horizontal, emphasis, which helps strengthen the sense of recession as the eye is led along the coast.

In this painting, the artist has given his composition a strong vertical emphasis by using the promontory, which juts into

the sea dividing the picture roughly in half. This allows him to contrast the two different styles used for the sea and the land. For the sea, he worked loosely, applying washes wet in wet and using a sponge to soften edges. For the cliffs, on the other hand, he worked exclusively with crisp-edged washes, overlaying washes applied wet on dry to build up depth of color and emphasize the solidity of the rock face.

Tip

Flat brushes are also known as one-stroke brushes, but the name is misleading. You can make a broad flat mark with the side of the brush, and also a narrow vertical mark with the tip. Flats can be exploited for a range of graphic textural effects. Here two flats of different sizes have been used for the cliff faces.

The setup

This sea view has cliffs and promontories marching away into the distance, set off by waves crashing into the cliff face in a mass of churning white water.

◀ **OUTLINE DRAWING**
All that's needed before starting to paint is an outline of the main composition to use as an underdrawing, lightly indicated in HB pencil.

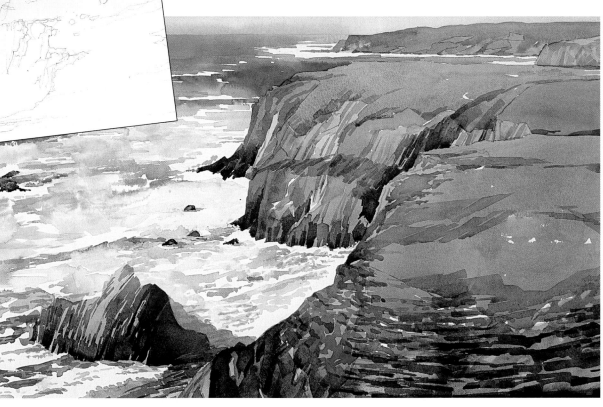

▶ **FINISHED PICTURE**
The high horizon line gives dramatic emphasis to the sweep of the cliffs, and the overlapping headlands strengthen the sense of recession.

What you need

- A 22½ x 15in (57 x 38cm) sheet of 140lb (300gsm) cold-press watercolor paper
- HB pencil and eraser
- Small natural sponge
- 12 watercolors: raw sienna, burnt sienna, purple madder alizarin, cerulean, cobalt blue, French ultramarine, Winsor blue, indigo, sap green, Winsor green, Vandyke brown, ivory black
- Permanent white gouache
- Four brushes: No.2 and No.8 rounds; ½in (13mm) and ¾in (20mm) flats
- Two jars of water
- Deep-welled palette

► **1** Mix separate washes of cerulean, indigo and Winsor blue. Using the ¾in (20mm) brush, apply a narrow band of cerulean at the top of the paper for sky. While still wet, sweep in washes of indigo and Winsor blue for the distant sea. Leave strips of white paper for the wave crests.

► **2** Mix ivory black and indigo for the sea in the middle ground. Use short strokes for the choppy waves, leaving white paper for highlights and sea spray. Use the sponge to lift out wet paint and soften the washes. Add Winsor green to the earlier mixture for the dark water around the foreground rock on the left.

▲ **3** Start the distant promontory, using the No.8 brush and a light wash of raw sienna/sap green/cobalt blue. Vary the mixture with indigo for the cool shadows at the tip of the promontory, and purple madder alizarin/ ivory black for the reddish rock face.

◄ **4** Paint the grassy promontory in raw sienna/cerulean/ivory black. For the near promontory, mix Winsor green/raw sienna/ivory black. Paint the bright, grassy patch in Winsor green/raw sienna. Use the ¾in (20mm) brush and Vandyke brown/Winsor green/ivory black for the exposed rock face in the bottom right corner.

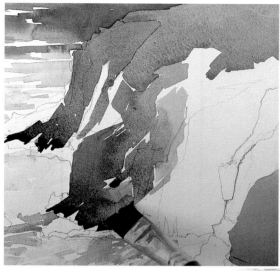

5 Paint the edges of the cliff in shades of gray mixed from ivory black/cobalt blue/raw sienna. Use the tip of the ¾in (20mm) brush. Use a pale, neutral version of this wash to paint over the smaller rock on the left (see Step 6).

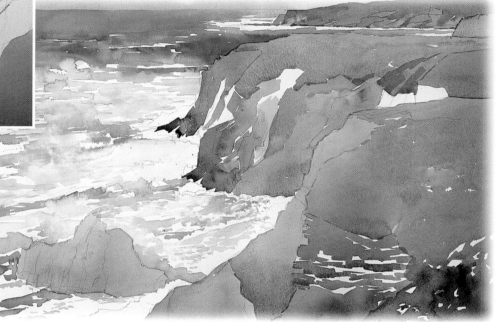

6 Put in the horizontal layers of the foreground cliff face with the ¾in (20mm) brush and Vandyke brown/Winsor green/ivory black. Use Winsor green for the bright grass and a thin wash of burnt sienna for the rock's left-hand side, where the sunlight gives it a golden glow.

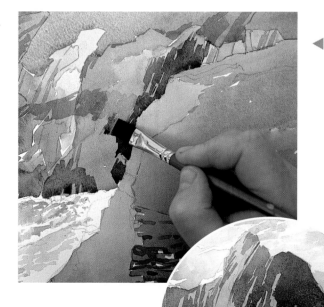

7 Once the washes on the cliffs and rocks are dry, switch to the ½in (13mm) brush and paint the crags with thin glazes. Use a warm gray mixed from burnt sienna/indigo/ivory black and a cool gray mixed from ivory black/indigo.

8 Model the small rock on the left with the same colors used for the cliff. Feel free to use very dark tones—you want a good contrast to do justice to the sunny day.

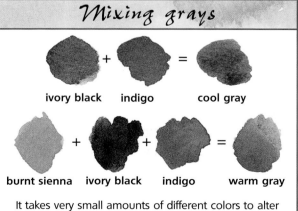

Mixing grays

ivory black + indigo = cool gray

burnt sienna + ivory black + indigo = warm gray

It takes very small amounts of different colors to alter a mixture. To mix the two grays used for the craggy cliffs, start with indigo—but make one gray cool by adding ivory black, and the other warm by adding ivory black and burnt sienna.

▶ **9** Use the No.2 brush to apply dabs of the gray mixtures to the tips of the rocks jutting through the water. Mix indigo and French ultramarine for the shadows of the rocks in the water. Let dry. Suggest the foam around the rocks with permanent white gouache.

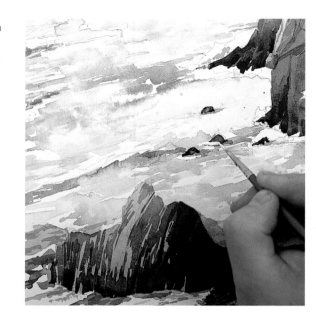

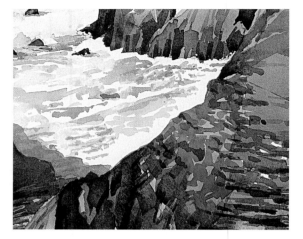

▲ **10** For the earthy red area on the left of the foreground cliff, use burnt sienna/purple madder alizarin/ivory black. Suggest the rugged texture of the rock face by working horizontally with both the No.8 and the ½in (13mm) brushes.

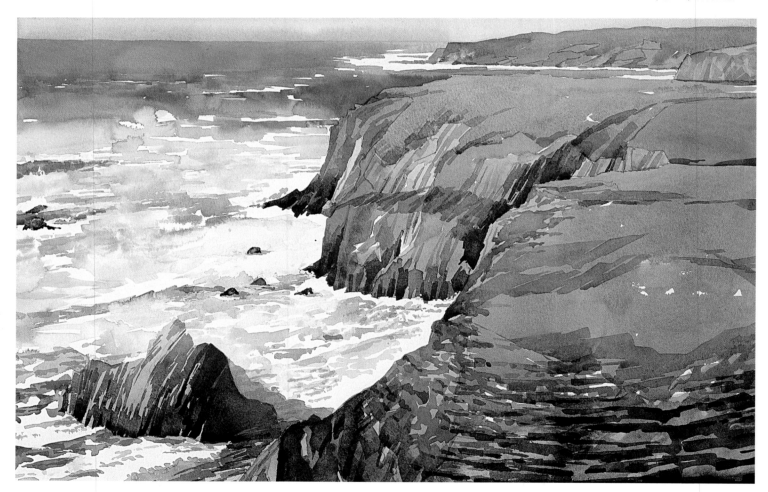

▲ **11** Finish the cliffs by adding the cast shadows on the grass with the ½in (13mm) brush and two mixtures— ivory black/indigo and raw sienna/Winsor green/cobalt blue. For the near cliff, use mixtures of ivory black/burnt sienna/ Winsor green/purple madder alizarin for the gray areas.

FINISHED PICTURE
The drama of the subject matter is matched by the drama of the composition with its high viewpoint, and by the contrast between the calm water and the white foam, and the grassy cliff tops against the rugged cliff face.

A rocky coastline
by Adrian Smith

Mountain hamlet

A combination of very wet washes and extremely detailed pen work is necessary to capture the character and charm of a small rural community such as this.

The difficulty in painting landscapes from life is that, as you paint, the light often changes. This can present problems in setting the tonal scale, but there are some practical ways around it—the secret is to be prepared. Spend some time familiarizing yourself with the landscape, taking in the view, before you start. It helps to take some photographs for color reference and to start with some quick preliminary sketches with written notes on light source, shadows, color, tones and textures. This preparation covers you in the event of a sudden change in the weather, and allows you to continue your painting later, using your sketches and photos for reference.

Tip

Use a palette knife to scrape out sections of paint. This technique has been used on the drystone wall in this painting (Step 3 on page 128), and it gives just the right effect for the characteristic stone slabs. Thin, vertical strokes with the palette knife suggest tall blades of grass in the foreground (Step 4 on page 129).

The setup

This detailed view has a rambling cluster of crooked houses, bright roofs, a bell tower and distant cypress trees.

▲ **FINISHED PICTURE**
Good preparation, careful portrayal of light and shade, and painting quickly with confident strokes resulted in this fresh view of a mountain hamlet.

▲ **ANNOTATED PENCIL SKETCH**
Several of these help you to recognize the distinctive characteristics of a view.

▶ **TRACE TEMPLATE**

▶ **7** Wash in the left side walls of the foreground houses in pale yellow/orange. Paint the sides in shadow in contrasting mixtures of orange/ultramarine, adding red and terre verte. Continue over the central foreground grass with the same mixture, using vertical brushstrokes for fine blades of grass. Leave some background houses unpainted to enhance the contrast of light and shade.

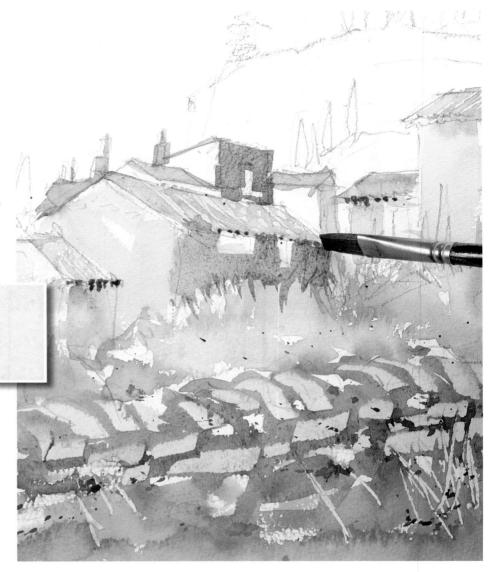

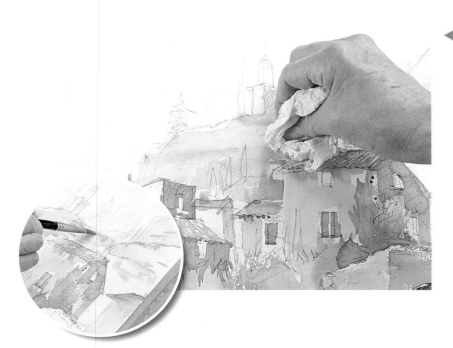

▲ **8** Paint shadows under the roofs in a mixture of crimson/ultramarine/burnt umber. Use the edge of the ½in (13mm) brush to apply small dabs of paint to emphasize the undulating shape of the roof. Detail the windows and shutters in a wet wash of ultramarine in single, flat brushstrokes.

◀ **9** Mix a wash of lemon yellow/ocher for the background hill. Scrub in the wash, keeping it pale to suggest the effect of bright sunlight (inset). Drag out strong colors with a paper towel in a sweeping movement, working horizontally across the page.

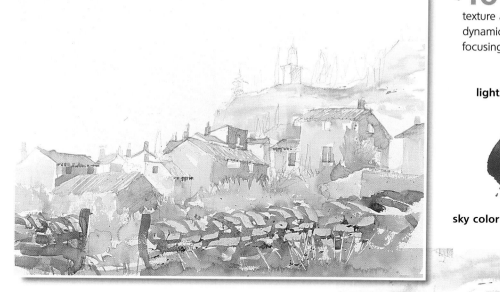

◀ **10** Step back and take an overview of the painting. The contrast of light and shade, texture and loose painting creates a harmonious dynamic that works throughout the composition, focusing the eye in and around the landscape.

light red

purple

sky color

ultramarine

▶ **11** Mix ultramarine/purple/light red for the sky. Turn the support upside down and, using very wet paint, wash in the sky with the ⅜in (9.5mm) brush. Keep adding water to maintain a pale tone. Paint around the rooftops. When the whole sky is blocked in, tip the paper and let the paint drip down for a vertical sweeping effect. Wipe off excess with a paper towel.

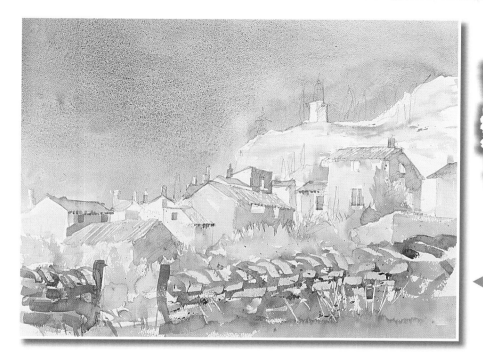

Tip

When a very watery wash is necessary for the sky, turn the paper upside down to avoid the paint dripping down along the horizon. Tilting the paper at an angle allows the excess to run off the edge and it can then be blotted dry with a paper towel. The result is a soft, even sky sweeping up and emphasizing the gradient of the hill.

◀ **12** This is a good time to stand back again and assess your work. The color of the sky will have added a lot to the character of the composition, which now needs some fine details to sharpen the contrasts of tone.

▲ **13** Use the sky mixture and the ½in (13mm) brush for shadows in the shutters. Paint the pines and cypress trees with ultramarine/ terre verte/brown. Vary the mixture and strokes for the other hillside trees and their shadows.

▲ **14** Continue the trees on the hill and behind the houses in a dilute version of the mixture used in Step 13. Use the pen to define brick shapes and roof details, filling the nib with a mixture of burnt umber/ raw sienna/ultramarine/terre verte/olive (inset).

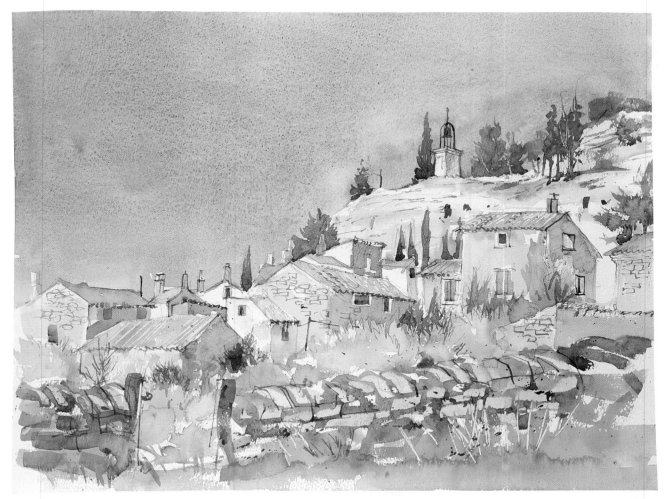

▲ **15** Add details and spattered texture to the hilltop trees. Use pen and paint to draw rooftop antennae, the church tower and bell, and to add definition to the shadows around the windows.

FINISHED PICTURE
Old buildings cascading down a hillside have been rendered with delicate wet-in-wet washes. Foreground textures were added by scraping into wet paint with a painting knife, while the rough-hewn masonry was sketched in with a pen loaded with paint.

Mountain village
by Kay Ohsten

Beach at low tide

The white of the paper shining through layers of transparent watercolor wash gives a luminous quality that is ideal for seascapes. Use a Rough paper and a dry-brush technique to add sparkle to the water.

This project is built up using a series of washes. The secret is to break the subject down into a series of overlapping planes: sky, land and sea. The clouds and the highlights on the water and sand are light in tone, so make sure you reserve both those areas. Begin by laying in the sky—this will set the mood for the rest of the painting. The foreground consists of the beach at low tide—water, sand and seaweed are rendered in horizontal bands of wash. The sky and the shore are separated by three rocky promontories. For these you need to emphasize the spatial relationships: pale blue for the most distant headland and a warm violet for the nearest.

▼ PENCIL SKETCH
Use a pencil to make quick sketches on the spot. Here the artist has focused on the areas of light and dark tone. Notice how simply the figures have been introduced.

The setup

This summer coastal scene was painted at low tide. The sand is glazed with a film of water that acts as a mirror to the sky, giving the entire view a lively, light-filled quality.

▶ WATERCOLOR SKETCH
Watercolor is a sympathetic medium for depicting skies and water. Here the sky is painted in a variegated wash while the white of the paper is reserved to stand for the clouds.

What you need

- A 21 x 15in (50 x 38cm) sheet of Rough watercolor paper. Arches 300lb (640gsm) moldmade paper (used here) does not need stretching
- Masking tape
- Drawing board
- 2B pencil
- 11 paints: Naples yellow, ultramarine, cerulean, raw umber, yellow ocher, lemon yellow, sepia, Winsor violet, cobalt, alizarin crimson, cadmium yellow
- Three brushes: No.9 and No.6 synthetic fiber round; ½in (13mm) flat
- Two jars of water
- Mixing palette

▲**1** Fix the paper to the board with tape. Draw the sky, the promontory and the light and dark tones on the sand with the 2B pencil. The water's edge falls less than halfway down the picture area. This division allows your eye to travel across the sand and the water, yet leaves room for the sky, which is vital to the composition.

▲**2** Wet the sky area with the ½in (13mm) flat brush. The sky will be laid on the wet paper with several washes (see Step 3).

Mixing sky blues

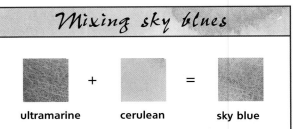

ultramarine + cerulean = sky blue

Ultramarine is a warm blue, while cerulean has a cool undertone. Both are suitable for skies. Every artist has a favorite, and it is worth experimenting to see which one you find most pleasing. A mix of the two blues often gives the best result. For this project, the artist felt a mixture of ultramarine and cerulean gave a good, summer-sky blue. Test the color on some spare paper, and remember it will be lighter in tone when dry.

◀**3** Mix a pale wash of Naples yellow and, with the No.9 brush, apply touches of it to the wet sky area. Then lay three swathes of wash across the sea and sand with a darker mixture of the same color. Load the No.9 brush with a sky blue wash mixed from ultramarine and cerulean (see above) and apply loosely, leaving areas of white paper for clouds. Let dry.

▶ **4** Lay a horizontal band of color in the area of the sea using the flat brush and the same ultramarine and cerulean mixture you used in Step 3. Hold the brush lightly and drag it briskly so it glances off the uneven paper, leaving some speckles of white paper showing through. Lay a band of paler wash beneath the first. Let dry.

◀ **5** Apply a loose wash of Naples yellow over the land on the horizon. Mix raw umber and yellow ocher for the wet sand. Dragging the tip of the flat brush sideways, start with narrow bands, broadening out as you get closer to the picture plane. Mix a dark brown wash for the seaweed.

warm sandy brown mixture

raw umber

yellow ocher

Expert opinion

Q How can I create a sense of space when there are so few clues to perspective?

A If your painting is looking a little flat, you can create a sense of recession by using larger brushmarks and bolder textures in the foreground. Here various techniques are used to pull the foreground to the front of the picture. Broad brushmarks contrast with the narrower marks farther back, while speckles of white paper showing through the washes and spatters of dark color suggest that this area is nearer to the front of the picture.

◀ **6** To suggest a sense of recession—distance—lay broader bands of the same dark brown wash in the foreground. Use the full width of the brush for these swathes of color. Hold the brush loosely and at an acute angle to the paper so it dances over the surface, letting the white of the Rough paper show through in places.

What you need

- A 14 x 21in (35 x 53cm) sheet of stretched 140lb (300gsm) cold-press watercolor paper
- 2B pencil
- Kneaded eraser
- 13 paints: French ultramarine, cobalt blue, cerulean, Winsor green, sap green, yellow ocher, Indian yellow, lemon yellow, Winsor violet, permanent magenta, scarlet lake, burnt sienna, sepia
- Two round brushes: No.3 and No.10 sable or sable/synthetic
- Two jars of water
- Mixing palette

1 Start by lightly drawing in the main elements of the composition. Apply a wash of ultramarine with a little cobalt blue to the sky, working quickly and loosely with the No.10 brush. To create a sense of recession, gradually weaken the wash as you work down the paper. Leave white shapes to suggest the high cumulus clouds.

2 Add a touch of cerulean to the sky wash and paint the lake with three broad, horizontal brushstrokes. Leave streaks and patches of white paper to suggest highlights on the surface. While this is drying, paint the grassy bank on the right with a pale wash of Winsor green. Then mix yellow ocher, Indian yellow, lemon yellow and Winsor green in different proportions and paint the grasses and ferns (inset) at the water's edge, still using the No.10 brush.

3 At this stage, stand back and view the whole painting. You can see the value of using a large brush for the initial stages: it encourages you to make broad, sweeping strokes that keep the painting fresh and lively.

burnt sienna

soft orange mixture

Indian yellow

Expert opinion

Q How can I make reflections in still water look realistic?

A In still water, reflections appear directly below the object causing them—but you should paint the reflected colors in slightly muted tones to allow for the effect of the water.

4 Put in the shadow areas on the bank with more Winsor green washes. Now change to the No.3 brush until Step 7. Paint the dead foliage in the center of the fern with a mixture of burnt sienna and Indian yellow. Allow the paint to form pools—these dry darker than a thin, flat wash, and provide interesting tonal contrasts and crisp edges.

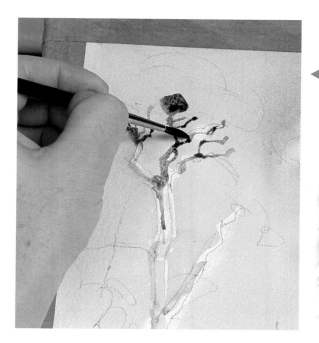

◀ **5** Paint the trunks of the tall Scots pines with a light yellow ocher wash. Add shadows on the left sides of the trunks with a light wash of Winsor violet. Paint the branches under the tree canopies with a mixture of sepia and Winsor violet. The sepia will give the wash a darker tone.

▶ **6** Paint the canopies with a wash of sap green, then add touches of a stronger mixture to parts of the foliage. Lighten the wash and paint the trees in the distance (inset) with loose, scrubby strokes. Before the canopies dry, touch in a few hints of sepia to give form and volume— notice how the paint spreads, making dark pools in some places and transparent, pale shapes in others, perfectly describing the clumps of foliage (inset far right). Use sepia for the dark left sides of the trunks.

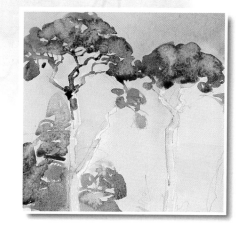

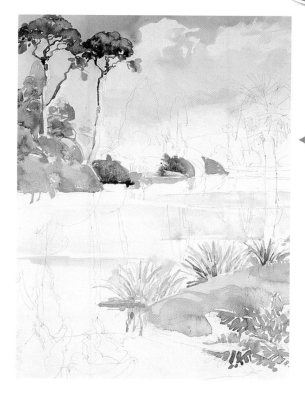

◀ **7** Mix a range of greens with Winsor green, sap green, Indian yellow and yellow ocher. Use these to paint the green shrubs on the far bank of the lake, varying the tones as you work. Paint the reddish shrubs with a dusky red mixture of permanent magenta and scarlet lake. Paint the tall conifer in the center with a wash of sap green, overlaid with a darker wash of sap green and Winsor green, capturing the natural shape and rhythm of the tree with your brushstrokes.

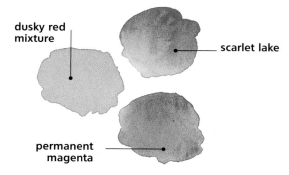

dusky red mixture

scarlet lake

permanent magenta

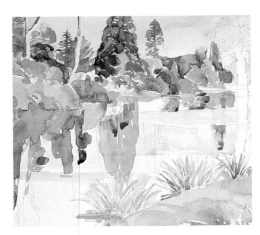

9 Use the No.3 brush to paint the palm tree on the right. Apply a thin wash of yellow ocher and Winsor violet to the trunk. Paint the palm fronds wet on dry with mixtures of sap green and Winsor green. Use the tip of the brush and work from the center of the branch outward. Let dry.

8 Lighten the green mixtures from Step 6 and block in the reflections in the water with the No.10 brush. The washes spread wet in wet, suggesting the smooth surface of the water. Add a touch of sepia to the greens for a more neutral tone.

10 Mix ultramarine and cobalt blue and apply wet in wet with the No.10 brush for the dark water. Paint the dark reflections of the foreground pines in a mixture of sap green, Winsor violet and sepia. With the No.3 brush make rapid lines and squiggles to capture the water's light and movement.

11 Paint the foreground grass in sap green. Allow to dry slightly, then add more washes of sap green and Winsor green, leaving patches of lighter tone to show through.

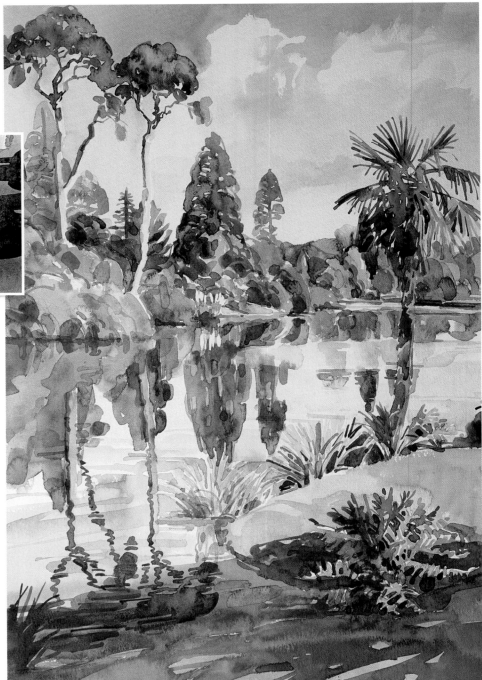

FINISHED PICTURE
The picture is full of color and texture, the calm, glassy surface of the water contrasting with the exuberant shapes of the trees and shrubs. See how the reflections get darker and the ripples more emphatic the closer they come to the foreground.

**Lakeside garden
by *Polly Raynes***

Bustling harbor

With so many boats bobbing around in this colorful harbor scene, the challenge was to create an overall impression of the busy background by simplifying the subject into blocks of tone and color.

The background appears realistic and convincing, but look more closely at the harbor and jetty. The buildings and one or two boats are shown in some detail, but the rest of the background and most of the boats are painted simply as flat, colored shapes. Because a few selected areas have been painted more specifically, the viewer is deceived into seeing detail in the rest of the scene.

The composition is divided into two: foreground and background. The artist developed the picture as a whole, working simultaneously in both areas. The tall mast and the blue water provide important links between the foreground boats and the distant harbor. The artist made the most of these connecting elements, leaving the mast of the nearest boat as a strong pale shape against the darker background.

▼ **FINISHED PICTURE**
The contrast between light and dark areas is central to this composition. The darkest tones are the foreground shadows, which reflect the curved forms of the boats. Light areas include the white on the boats.

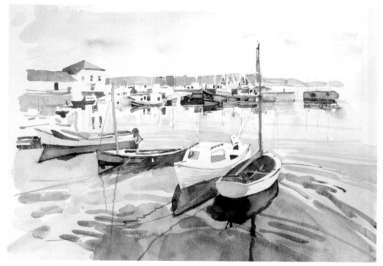

The setup

A few boats reflected in the water and, in the distance, a small, crowded harbor provide an interesting test for the artist.

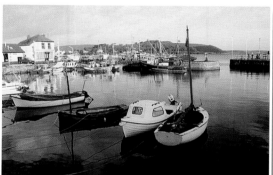

▲ **REFERENCE PHOTOGRAPH**
Several of these help with decisions on the composition of the painting, and a photograph makes a good color reference.

▶ **TRACE TEMPLATE**

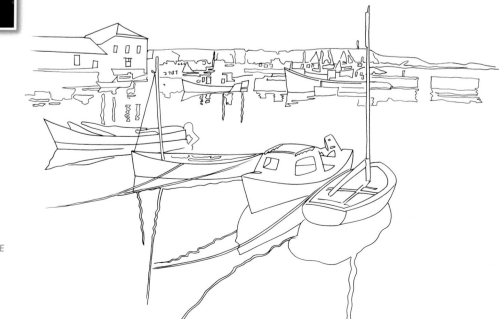

What you need

- A sheet of 30 x 22in (75 x 55cm) stretched good-quality watercolor paper
- Drawing board
- Masking fluid
- Three brushes: a Chinese brush; a 1in (25mm) flat brush; and an old brush for masking fluid
- 17 watercolor paints: cobalt blue, gamboge yellow, cadmium red, cadmium yellow, violet, black, burnt sienna, alizarin crimson, ultramarine blue, Winsor blue, Winsor green, cadmium orange, cerulean, raw sienna, sap green, yellow ocher, Naples yellow
- Two jars of water
- Mixing palette

▲**1** Using the Chinese brush, lightly sketch in the composition in diluted cobalt blue. Keep the tone pale so you can move easily from one area to another, making any necessary adjustments and corrections by overpainting the lines.

▲**2** Apply masking fluid to any small areas that will be white in the finished painting. These include the masts and details on the harbor and houses. Don't try to paint every mast in exactly the right place. Get one or two right, then add the rest.

gamboge yellow

cobalt blue

background greenery mixture

▲**3** Let the masking fluid dry. Then use the Chinese brush to paint the distant hills and background greenery in a mixture of gamboge yellow and cobalt blue. Take the color over the masked-out masts.

▶ **4** Start to block in the background, beginning with the largest boat on the jetty. Paint the patches of bright color in pure cadmium red, cadmium yellow and cobalt blue. Add the shadows in a mixture of violet and black.

Tip

Crisp, clean lights and highlights are essential if you are to capture the sparkling quality of light on water. To retain the contrast between important light and dark tones, masking fluid was used to block out all the smaller areas that were to be white or light in the finished painting.

◀ **5** Develop the background with small areas of dark tone in black and black/violet washes. In the foreground, paint the main mast in diluted burnt sienna/black. Define the foreground boats in black/violet. Use the same mixture to block in the reflections. Leave the rope as an unpainted white line.

Expert opinion

Q I have always found the curved shapes of boats difficult to draw. Is there a simple way of doing this?

A The curves must be free and unrestrained. Hold the pencil or brush loosely and draw from the wrist rather than the fingers. This gives you a sweeping line rather than a cramped shape. In addition, look carefully for the point of contact between the bottom of the boat and the water. If your eye level is close to the water, this will be a straight line.

▲**12** Develop the dark tones in the background, adding small areas of color. Paint the rooftops in mixtures of raw sienna/yellow ocher/Winsor blue. Block in the colors to the right of the main mast in raw sienna with burnt sienna or cadmium orange.

▲**13** Extend the distant landscape in gamboge yellow/sap green. Paint the beach in gamboge yellow. Add details to the background, and dab in doors in violet and windows in burnt sienna/black. Change to the 1in (25mm) brush and develop the reflections in the foreground water with Winsor blue/black.

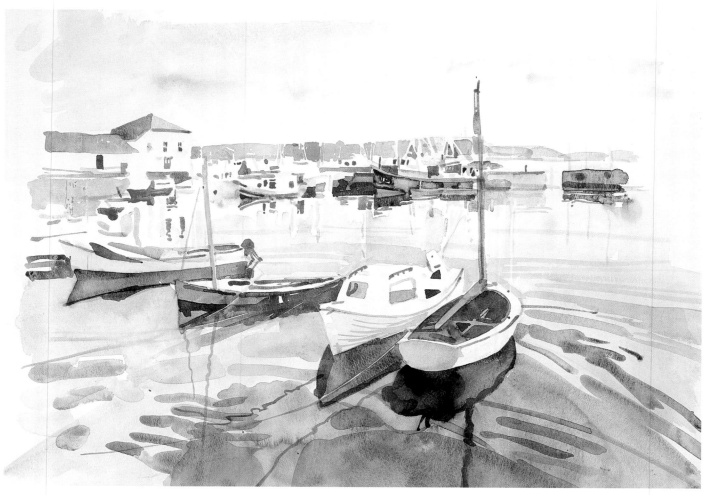

▲**14** Add splashes of bright red and yellow to the distant boats, use burnt sienna/raw sienna for the roofs, and lay in the sky with Naples yellow with touches of cerulean/black. Paint the ropes and masts.

FINISHED PICTURE
Wet-on-dry applications of wash capture the shimmering surface of the sea. The cluster of boats and buildings around the harbor are laid down very simply as patches of flat color, a few deft details pulling the image into focus.

Cornish harbour
by *John Raynes*

Sheep in the snow

How do you paint white sheep in the snow? The answer is that neither the sheep nor the snow is actually pure white. The sheep look yellowish gray against the snow, while the snow itself is tinted by shadows.

Animals lend scale as well as life and interest to your landscape paintings. But painting them in the field is not always practical—sheep, for instance, have a habit of wandering off. This is where sketchbook studies come in useful—if you make sketches of individual animals, you can transpose them to an otherwise empty landscape.

Arrange the animals in groups rather than stringing them out. Position them in the scene at varying distances and overlap some to encourage the eye to move through the picture. Vary their positions, placing them so they face in different directions or with their heads at different levels. In this picture (see page 152), the group of three sheep have similar poses but their heads are turned at different angles. They form a unified shape and because they overlap they introduce perspective. Variety is added by the fourth sheep, set slightly apart and staring out inquisitively.

Tip

If you are worried about painting animals' feet accurately—horses' hoofs or sheep's feet, for instance—don't spend time struggling. Just ensure that your subject is standing in long grass, tufty turf or, as here, snow. It looks very natural to see the animal's legs disappearing into the grass or snow—it "grounds" them securely.

The setup

An imaginary winter landscape can be put together with the help of a selection of watercolor sketches and photographs, which provide both inspiration and practical reference.

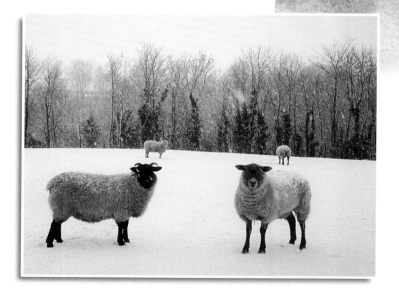

▲ REFERENCE PHOTOGRAPH
You can borrow different elements from several photos like this one, and combine them to make a composite image.

▲▼ WATERCOLOR SKETCHES
A couple of thumbnail watercolor sketches help you loosen up before you start work on your painting. It's a good idea to make some sketches of the sheep since they never stay in one position for very long.

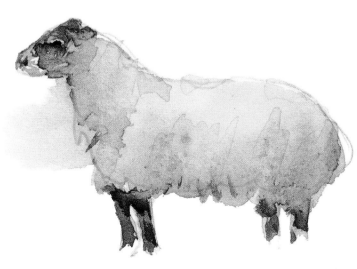

French ultramarine

raw sienna

yellowish-gray sheep color

7 Mix a pale wash of raw sienna, adding a hint of ultramarine to make a dirty yellow. Use this to fill in the shapes of the sheep with the No.6 brush. Sheep are not white—their wool looks yellowish gray against the snow.

8 While the yellow wash is still damp, use the tip of the brush to touch in some diluted French ultramarine on the faces, necks and underbellies of the sheep. This creates shadows that define their rounded bodies. Notice how the paint granulates as it dries, suggesting the woolly texture of the sheep's coats perfectly.

Expert opinion

Q When I try to paint winter trees, they look stiff and clumsy. How can I make them more graceful?

A Don't attempt to paint every last twig. Accentuate the main limbs and branches and merely suggest the smaller branches—the viewer's imagination will fill in the rest. Always work from the base of the trunk or branch upward, gradually taking the pressure off the brush as you near the end of the stroke so it tapers off naturally and becomes paler at the tip.

French ultramarine

light red

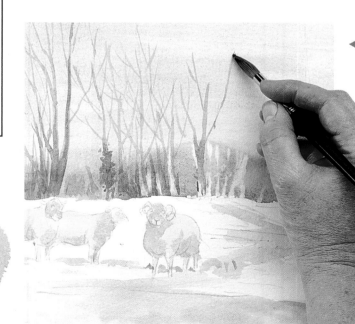

9 Jot in the shadows cast by the sheep with diluted ultramarine. Then paint the trees: mix ultramarine and a touch of light red for the cool, bluish trees, and raw sienna with a hint of Winsor blue for the warmer-colored trees. Vary the strength of tone to indicate how some trees are nearer than others, and how some are partially obscured by mist.

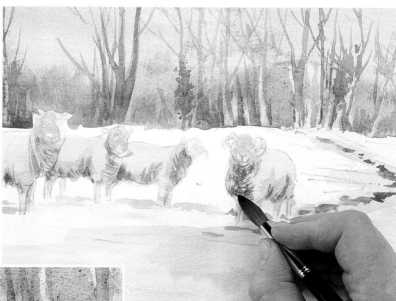

foreground tree mixture

Winsor blue

raw sienna

▶ **10** Use a dry brush to suggest remnants of foliage on some trees. Splay the brush (inset), then press and lift, leaving soft, broken marks. Paint the two trees on the right. Use raw sienna and a touch of Winsor blue for the left tree, and ultramarine for the right tree and the shadows on the left one.

▶ **11** Use a fairly concentrated wash of ultramarine, Winsor blue and raw sienna to suggest the tracks in the snow with small, broken strokes. Then mix a purple-gray from light red and ultramarine and dry-brush some more texture and shadow onto the sheep's coats.

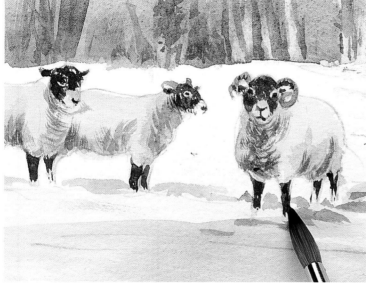

◀ **12** Paint the rams' horns with raw sienna warmed with a touch of cadmium red. Paint all the legs with ultramarine, finishing with ragged ends to suggest that the feet are lost in the snow. Then use the tip of the brush to touch in some burnt umber and let it settle. Use the same method to paint the black parts of the sheep's faces and their eyes, noses and mouths.

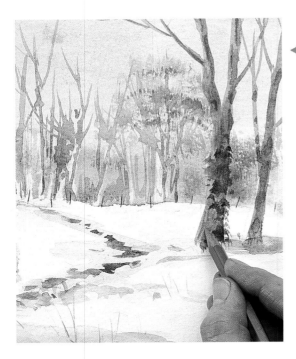

◄**13** Apply the ultramarine, Winsor blue and raw sienna mixture on your palette to paint the ivy twining up the tree on the right. Then use the bright, leafy green colored pencil to suggest lichen on the tree trunk and to introduce a touch of warmer color to the picture. Let dry.

▲**14** Use a scalpel or utility knife to scrape into the paper surface to suggest falling snowflakes. Use the tip of the blunt edge of the blade and scrape very quickly with a light, flicking movement—enough to scrape off the paint without digging into the paper.

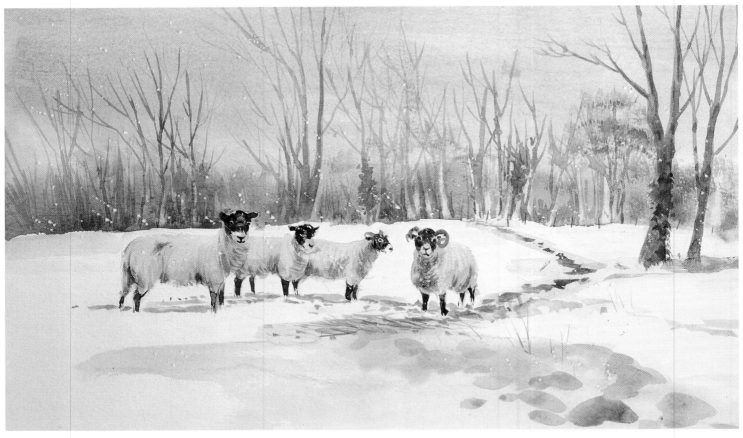

▲**15** To finish the picture, add a few more shadows on the snow with quick, light strokes of diluted ultramarine. Then paint the straw in the foreground with raw sienna and a little gray from the palette.

FINISHED PICTURE
The small touches of warm color in the painting nicely offset the cool, neutral colors that capture the atmosphere of a snowy winter's day.

Sheep in the snow
by *Linda Birch*

Harbor wall

Ingenuity is needed to convey the texture of the stones in this dramatic painting. Use several different sponges, among other things, to build up variety and interest.

Brushes are by no means the only items you can use to apply paint to paper. There is a vast range of other objects available for creating texture, and a variety of informative, descriptive marks that give liveliness and interest to your painting. A subject such as this harbor wall is perfect for trying out different ways of applying paint. The scene has lots of craggy texture—the weathered stones from which the harbor wall is built, for instance, the path on top, the sand and the surrounding cliffs, the boat shed and other buildings.

To depict these textures, use several different sponges, both natural and synthethic, plus masking fluid and masking tape, some small pieces of cardboard—even an old credit card!

The setup

Find the position that gives the most interesting view. Here, from the far end of the harbor wall, the cliffs rise up majestically from the sea, and the scene offers many different textures and vital contrasts between the path, cliffs, sea and sky.

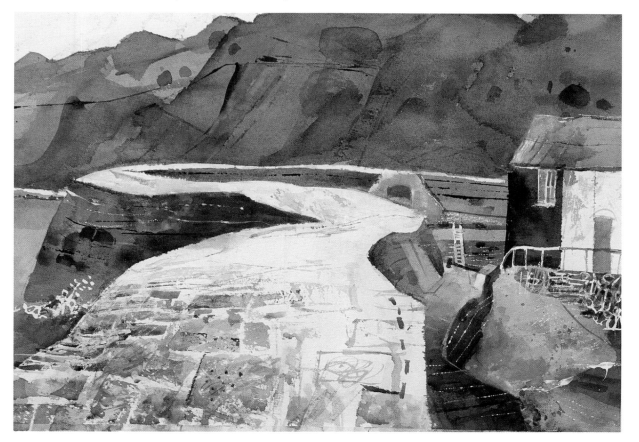

◄ FINISHED PICTURE
The sinuous, twisting line of this harbor wall is a naturally picturesque feature —the patchwork pathway leads the eye into the painting and entertains the viewer with its rugged textures and patterns.

What you need

- A 20 x 14in (50 x 36cm) sheet of stretched 140lb (300gsm) cold-press watercolor paper
- Large and small natural sponges and wedges of synthetic sponge
- Masking fluid, masking tape
- HB pencil
- Scissors and small pieces of cardboard
- Seven watercolors: Payne's gray, alizarin crimson, cadmium yellow, cobalt blue, Hooker's green, raw sienna, Chinese white
- Two brushes: No.6 to apply the masking fluid and No.12, both round synthetic
- Two jars of water
- Mixing palette

▲1 Draw your subject with the HB pencil on the stretched paper. The artist made very sketchy outlines to give the main shapes and structure of the composition. Then use masking tape to mask off the path, boat shed and sky. Apply masking fluid with the No.6 brush to protect the finer details such as the sea splashing against the lower wall, the ladder, the railings and the grout in the wall. Let dry.

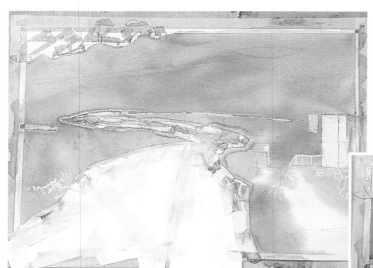

▲2 Wet the paper with the dampened natural sponge. Using the same sponge, apply a wash of Payne's gray to the wet paper. Cover all the paper, including the masked sky, leaving only the path and the sandy area on the right. Let the paint seep under the masking tape—it all helps to create texture. Let dry.

Expert opinion

Q If I find at a fairly late stage that I want a couple of extra light or white areas in my painting and I've forgotten to mask them off, what can I do?

A You can—carefully—scratch in highlights with the tip of a utility knife or scalpel. This works particularly well with linear highlights. Don't dig into the paper too much or you will ruin the surface; and don't overdo the scratching or the result will not look fresh.

▲3 Mix some rich, neutral colors with Payne's gray, alizarin crimson and cadmium yellow, and dab them onto the wall with the small natural sponge to create a softly mottled effect (inset). Mix a variety of blues, greens and golden yellows from combinations of cobalt blue, Hooker's green, raw sienna, alizarin crimson and cadmium yellow, and apply them to the sky, hill, wall and right side of the wall. Allow the colors to melt into one another to create a variety of tones and textures. Let dry.

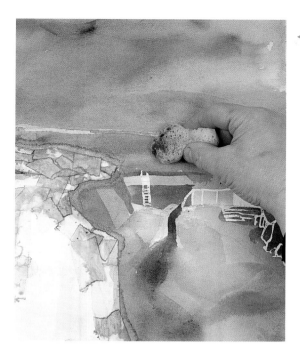

4 Using the small, natural sponge, apply rich, golden tones to the sand area. Mix Payne's gray and cobalt blue, and use to add darker neutral tones and textures to the hill and cliff by dragging the sponge across the paper and dabbing paint on to produce a slightly mottled effect.

Payne's gray

cobalt blue

neutral gray tone mixture

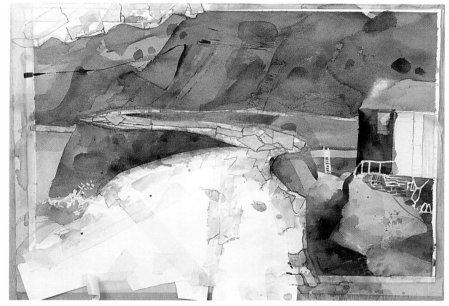

5 Now sponge in the darker tones on the hills, the wall and the clifftops with the blue and green mixtures from Step 3. Squeeze color onto the paper and work with the sponge wet in wet. Let dry. For extra texture, spatter paint onto the lower right area. Add linear details onto the hills and cliffs with the edge of a piece of cardboard dipped in paint.

6 Remove the masking tape (inset). Lift it without tugging, so you don't tear the paper. Rub off the masking fluid with your fingers. Paint seeping underneath the tape has produced jagged lines of color and texture on the path and sky. Tone these down with a little Chinese white and the No.12 brush. Use the Chinese white to add texture and highlights here and there, using a piece of cardboard rolled up and dipped in the paint.

▲**7** Use various wedges of synthetic sponge to print different colors and textures on the stone path with the greens, ochers and blues you mixed earlier. Either dip the sponge into a single color wash or, for a more mottled effect, select several colors and apply them to the sponge with the No.12 brush.

▲**8** Stand back to assess your work so far, then add details as necessary. Notice how the squares of color get smaller as the eye travels into the scene, creating an accurate sense of perspective. The sponge markings help to offset the flat surface of the path, adding contrast and providing depth.

▲**9** Use a piece of synthetic sponge loaded with cadmium yellow to add linear effects and smudged blobs to the sandy area to create light patches. Then, working wet on dry, use small wedges of synthetic sponge to add detail to the wall—and also to lift off color from it.

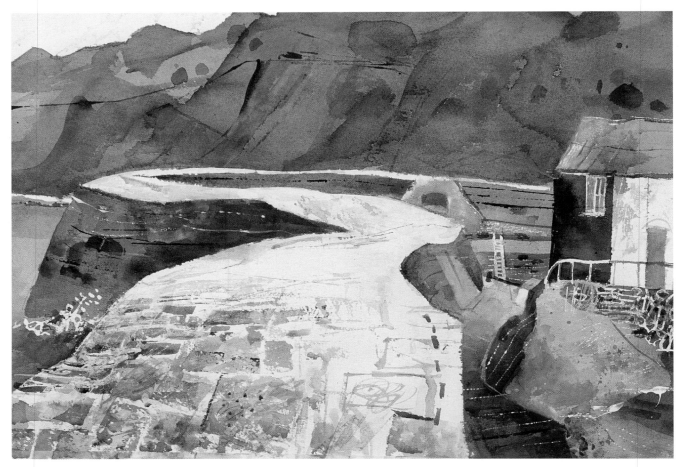

▲**10** Continue developing the textures on the harbor wall using combinations of sponging, printing, scratching and spattering techniques.

FINISHED PICTURE
The dark background emphasizes the wall's light serpentine shape, which pushes forward, seemingly coming out of the picture, and creates a jigsaw of shapes and patterns.

The Cobb
by *Stan Smith*

Summer landscape

This peaceful rural scene is a joy to paint. It relies for its effect on subtle color, carefully observed details and meticulous handling of the watercolor washes.

This complex composition aims to fit a lot of detail into a small space. It calls for good organization and for the use of a wide range of different watercolor techniques.

To create the illusion of depth, the artist used small variations of colors. He mixed a range of warm and cool tones to pull some elements forward and push others back, and made the tiniest of color adjustments to his washes in order to give objects form. He softened some colors by lifting them out to create a sense of distance, and also used dry-brush, wet-on-dry, scratching out and overlaying wash techniques to achieve plenty of texture and tone in the painting.

Tip

Clean all your brushes regularly as you go along so your color stays pure. Use two jars of water—one for cleaning brushes, the other for mixing washes. Change the water frequently. Keep spare paper nearby for testing different mixtures. Remember that for landscapes, you start with pale misty colors in the far distance and gradually mix stronger colors as you come forward.

The setup

On-the-spot sketches are especially useful for a painting with this much detail. Here, the artist used a 2B pencil to make one detailed and one rough sketch, annotating the rough one with notes on colors and weather conditions. He worked directly onto the detailed sketch, using the rough one for reference.

◀ FINISHED PICTURE
The focal point of the church (inset) draws the eye with two tiny touches of cerulean— on the clockface and the spire—the only places in the entire picture where this color is used.

What you need

- A 14 x 10in (35 x 25cm) sketchbook with 140lb (300gsm) cold-press acid-free watercolor paper
- 2B pencil
- Utility knife
- White scrap paper
- Sheet of blotting paper
- 13 paints: cadmium yellow, yellow ocher, raw sienna, burnt sienna, cadmium red, light red, alizarin crimson, Payne's gray, viridian, cerulean, ultramarine, cobalt blue, Prussian blue
- Three round brushes: No.4, No.6, No.10
- Two jars of water
- Large mixing palette

▲**1** Make a watery mixture of cobalt blue/ultramarine and use to sweep in the sky, starting a third of the way down the page and moving up toward the top right. Use the tip of the No.10 brush and make the blue stronger at the top of the page.

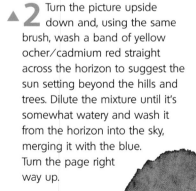

▲**2** Turn the picture upside down and, using the same brush, wash a band of yellow ocher/cadmium red straight across the horizon to suggest the sun setting beyond the hills and trees. Dilute the mixture until it's somewhat watery and wash it from the horizon into the sky, merging it with the blue. Turn the page right way up.

Payne's gray ——

ultramarine ——

pale blue-gray mixture

▲**3** Mix a pale blue-gray with ultramarine/Payne's gray for the silhouettes of the distant hills and trees—use the No.4 brush. Wash the gray up and down the tree trunk to avoid sharp edges. Blot excess paint to keep the area pale and misty.

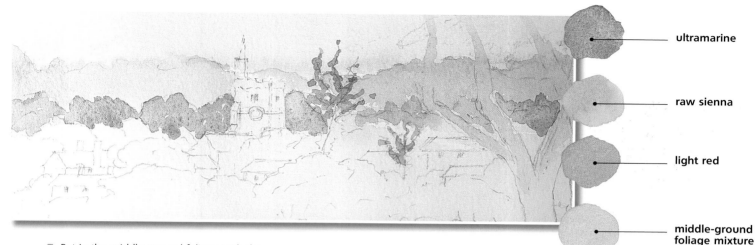

ultramarine

raw sienna

light red

middle-ground foliage mixture

▲ **4** Put in the middle-ground foliage with the No.4 brush and a mixture of ultramarine/ raw sienna/light red. Add other washes for variety—blue-gray, green-blue and yellow-green. Fill in the different trees, however small, with the point of the brush. Paint the lower parts of the foliage darker, so the tops appear to catch the light.

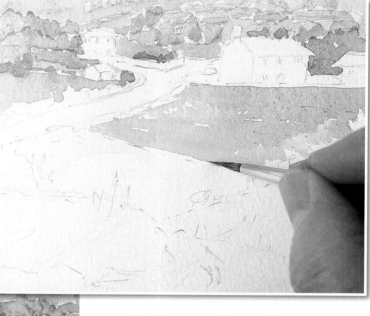

▲ **5** Work on the fields and foliage in front of the trees you just put in. Use the green-blue washes, adding warmer colors in the foreground. Paint the brown field on the right with cadmium red/yellow ocher. Leave a little white paper showing around a few shapes to suggest space and form.

alizarin crimson

ultramarine

plum mixture

burnt sienna

▲ **6** Paint the gray roofs, the church, its buttress and spire in diluted cobalt blue/Payne's gray. Apply the same wash for shadows in the trees in front. Use a warmer gray mixture of yellow ocher/burnt sienna/ultramarine on the church front. Make a plum mixture with burnt sienna/alizarin crimson/ultramarine for the roofs of the other houses. Add more diluted alizarin and yellow ocher for the walls and road next to the fields.

◄ **7** Mix cadmium yellow/yellow ocher/cobalt blue for the lightest tones near the top of the line of trees in front of the houses. Add viridian and more cobalt blue for a stronger green in the center of the trees. Add raw sienna and lay your wash over the gray for the deepest shadows at the bottom.

► **8** Mix yellow ocher/raw sienna for furrows on the brown field. Dilute this wash and add cadmium yellow for the cornfield. Paint the purple field with alizarin crimson/cobalt blue, then deepen the mixture for furrow texture. Apply this wash in places in the foreground. Mix cadmium yellow/yellow ocher/cadmium red/viridian and use with the No.6 brush for the leaves against the sky.

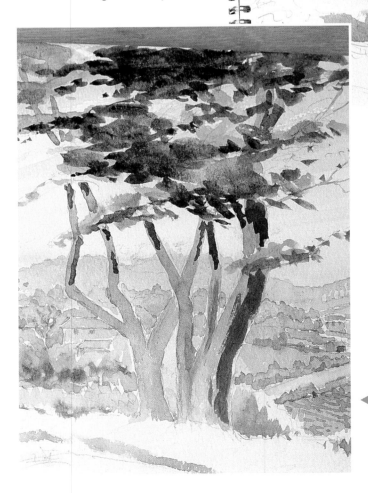

Tip

The artist used tubes of paint, squeezing yellow through red, brown and green to blue onto a large palette. This paint order is important. If you raise your palette at a slight angle as you mix the colors, the excess paint runs down into three compartments, making a blue/gray mixture, a plum mixture and a green/brown/yellow mixture.

◄ **9** Use the plum mixture from Step 6 for the gnarled tree trunk. Dilute it for the lighter left side. Build up the shadows on the right to a dense plum color. Mix burnt sienna/viridian for the darker clumps of leaves. Add cadmium yellow and cobalt blue here and there to build up strong, leafy clusters full of light and shade.

yellow ocher

burnt sienna

Prussian blue

mixture for dark green bush

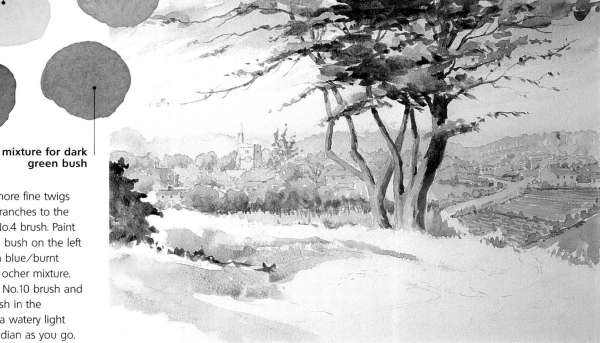

▶ **10** Add more fine twigs and branches to the tree with the No.4 brush. Paint the dark green bush on the left with a Prussian blue/burnt sienna/yellow ocher mixture. Change to the No.10 brush and lay a loose wash in the foreground of a watery light red, adding viridian as you go.

◀ **11** Splash a greenish yellow mixture across the foreground, then break it up with touches of Prussian blue and burnt sienna. The artist invented a path winding up past the tree. Use a damp brush to lift out some of the color you just put on. Mix a strong wash of ultramarine/alizarin crimson/ burnt sienna and sweep it over the foreground with the No.10 brush. Use blotting paper (inset) to lift out paint so some of the underlying colors reappear. Redefine the path in this way.

▶ **12** Put in clouds on the horizon with a wash of ultramarine/Payne's gray and a dry brush. Use the same wash to strengthen the trees on the horizon and put shadows on the sides of the houses on the right. Use the No.4 brush to add a touch of cerulean to the clockface and spire on the church to make them stand out.

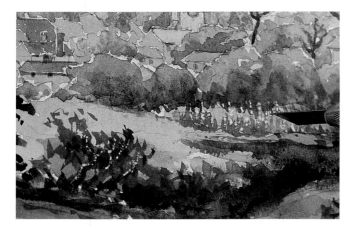

▲ **13** Use the utility knife to scratch off some color carefully from the middle-ground trees and bushes to add texture. This also puts more white back in the picture without the need for too much white paint.

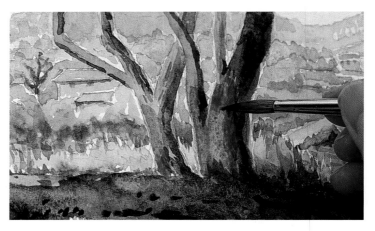

▲ **14** Put a wash of light red on the tree trunk, then dab on a few patches of the plum mixture to give the bark texture. Add more layers of dense plum and cobalt blue to the trunk under the leaves for the strongest shadows.

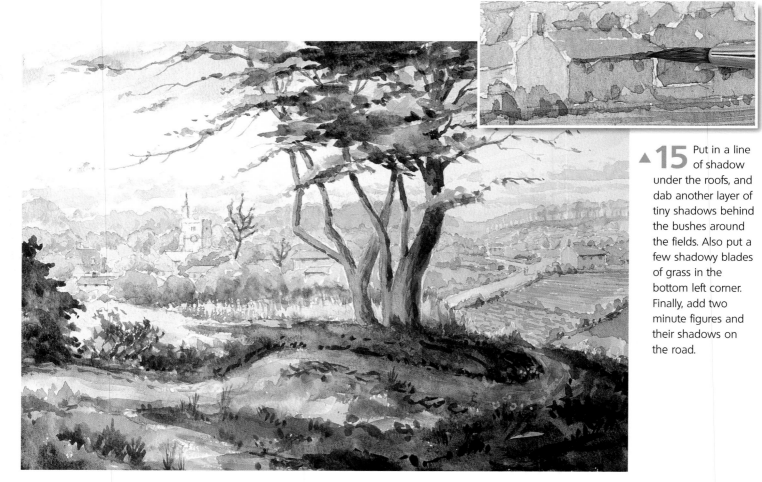

▲ **15** Put in a line of shadow under the roofs, and dab another layer of tiny shadows behind the bushes around the fields. Also put a few shadowy blades of grass in the bottom left corner. Finally, add two minute figures and their shadows on the road.

FINISHED PICTURE
The final painting shows that every detail has been carefully observed. You can tell the time of day by the shadows, and the season of the year by the flowers and crops. It is *this combination of attention to tiny details and controlled handling of watercolor that captures the calm atmosphere of a tiny hamlet nestling in a sunlit valley.*

Summer landscape
by *Dennis Gilbert*

Grand museum

For any large and complex building such as this, an accurate sketch is a prerequisite for capturing its character and texture.

The first stage in producing a likeness of a building is to study the structure carefully and record it as precisely as you can. Once you have put the structure down on paper, you have more freedom to think about other matters—conveying color and form, bringing out different textures within the building, and contrasting it with the textures of any surrounding buildings or vegetation.

In order to capture the character of the lovely golden stone of this gallery, the artist chose a slightly textured neutral gray cold-press paper. He brought out the warmth of the stone by playing up the violet of the road—this is the complementary color of the yellow stone and has the effect of enhancing it. Finally, he contrasted loose washes in the trees with tighter work on the building itself to help draw the eye.

Tip

If you choose to work on small sheets of paper such as the one used for this painting —it measures 12 x 9in (305 x 230mm)—some precise work is necessary when it comes to details. Try using a large goat-hair hake brush for general washes, and a No.3 round brush for putting in the small, but telling, details.

The setup

The building with its beautiful classical embellishments is the focus of this painting. It has been given a slightly old-fashioned appearance by ignoring most of the paraphernalia of modern life such as cars and trucks, as well as the crowds of people.

▼ FINISHED PICTURE

▲ REFERENCE PHOTOGRAPH
This will help you make an initial sketch for your painting. Remember that you need to reproduce the structure of the building, but there's no need to copy all the details. What you are after is an accurate impression, not an architect's drawing.

What you need

- A 12 x 9in (30 x 23cm) sheet of neutral gray cold-press watercolor paper
- 2B pencil
- Seven paints: yellow ocher, vermilion, cobalt blue, Hooker's green medium, permanent violet, burnt sienna, Vandyke brown
- Chinese white
- Three brushes: a hake (very large goat-hair flat); No.3 and No.6 rounds
- Two jars of water
- Mixing palette

burnt sienna

Vandyke brown

soft warm brown mixture

▲ **1** Loosely plot the scene with the 2B pencil, working very lightly over the paper so the marks won't stand out too much in the finished painting.

Now warm up the buildings, steps and street with thin washes of yellow ocher and burnt sienna. These help to give an initial impression of the bulk of the building.

▲ **2** Model the pillars and indicate the hollows in the windows and door arches with a darker wash of burnt sienna with a touch of Vandyke brown. Use the No.6 brush, switching to the small round for tiny touches of color.

The colored paper means you can't leave areas blank for whites. Instead, apply a little Chinese white for the brightest whites.

▲ **3** Wash in the sky with cobalt blue and the hake brush, switching to the round brushes to work neatly around the buildings. You don't need to skirt around the tree canopies since the green washes can be worked on top of the blue.

Hooker's green medium

cobalt blue

Vandyke brown

=

green for foliage

▶ **4** Sweep in the road in permanent violet. Then use the No.6 brush and a wash of Hooker's green medium tinged with Vandyke brown and cobalt blue for the trees on either side of the building and the grassy area on the right. Wet the paper first so the color spreads. Strengthen the wash for the darker undersides of the tree canopies.

◀ **5** Lightly indicate some of the people nearby. Put in the darker shadows on the road with more permanent violet, working wet on dry to give crisp edges. Add a more brightly clad figure with a little vermilion. Touch in the figure at the front entrance in a mixture of cobalt and white (inset).

permanent violet

▶ **6** Stand back and assess your progress. Notice how the trees frame the building and enclose the composition to hold the viewer's gaze.

▲**7** Use Vandyke brown mixed with cobalt for the railings, the steps and the shadows on the road, applying the color fairly dry with the very tip of the No.6 brush to give additional texture.

◄**8** Enrich the shadows in the portal of the main building with vermilion, then add a little Vandyke brown to shade the right side of the building.

Now darken some of the shadows on the building and steps by applying a second wash of the same color. This produces more subtle tonal variations than mixing a darker wash.

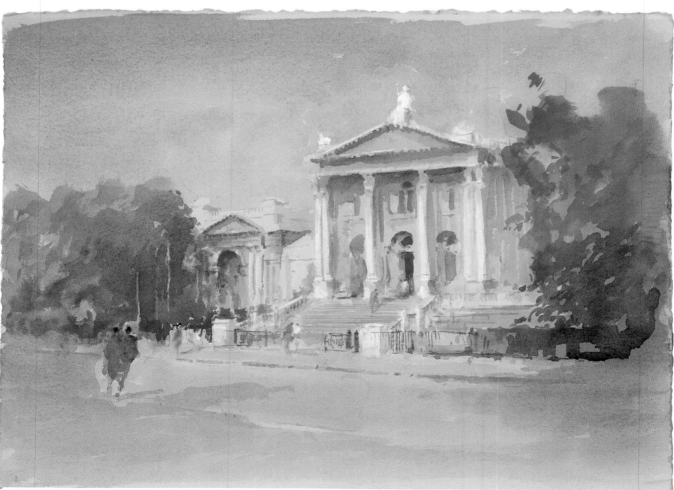

▲**9** To finish the painting, add more highlights and deep shadows to bring out the contrasts of tone typical of a sunny day—to the main entrance, for example, and under the arch of the second building. Add a few extra figures, or develop the existing ones as necessary.

FINISHED PICTURE
Note how the building attracts and holds the attention. The dark trees enclose the scene, while the violet shadows seem to make the building glow with an inviting warmth.

The Tate Gallery, London
by Roy Hammond

Coastal town

In order to paint a misty seascape, a number of variegated washes are used. The secret is to control the different colors in the fluid washes.

In order to convey the atmosphere of this coastal town, the broad plan is to work in very wet washes in the early stages, allow the washes to dry, then build up structure by working wet on dry. The key to this approach lies in the washes. You need to apply them quickly but thoughtfully—be ready to respond immediately if a new color suggests itself, and apply it while the paper is still wet enough to move the paint around easily. It pays to prepare all your washes in advance.

As the paper starts to dry, the paint becomes harder to manipulate—so, in a sense, water is your ally. But if the paper becomes too waterlogged, you will find the paint almost impossible to control. It's all a matter of striking the right balance.

Tip

Although you can mix a great range of greens from the colors on your palette, it is sometimes helpful to keep a few palette greens handy. For this painting, for example, you could use viridian as a short cut to a clean, blue-green.

The setup

A small town in the shadow of rugged cliffs, with the sun just breaking through, presents an interesting prospect for the painter, and a chance to practice technique with washes.

▶ REFERENCE PHOTOGRAPH
In this case, a view from above is an excellent aid for color and composition.

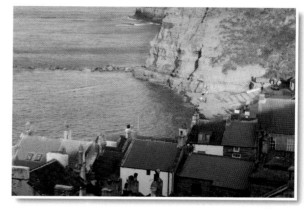

▼TRACE TEMPLATE

▲ FINISHED PICTURE
Flat areas, such as the sea, and large expanses, such as the cliffs, are obvious candidates for rendering wet in wet, but the more definite, precise forms of the buildings may also be successfully depicted using this technique.

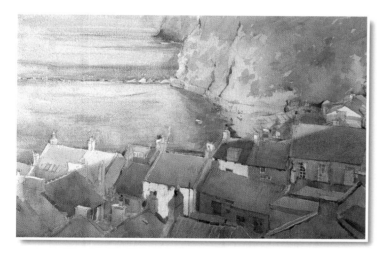

What you need

- A 40 x 20in (100 x 50cm) sheet of 300lb (640gsm) cold-press watercolor paper
- 3B pencil
- Sponge
- Masking fluid
- Four brushes: No.12, No.8, No.5 rounds; old brush for applying masking fluid
- Nine paints: cerulean, cobalt blue, cobalt violet, yellow ocher, raw sienna, permanent magenta, light red, Indian yellow, cadmium red
- Two jars of water
- Mixing palette

▲**1** Make a pencil drawing of the scene. Mask out the areas you want to keep white—a few of the walls, chimney stacks, window frames, distant figures and boats and flecks of rock along the waterline. Keep the edges straight and crisp. Let dry completely.

yellow ocher

beach color mixture

cerulean

▲**2** Wet the paper with the sponge. Prepare your washes, then use the No.12 brush to apply them, working from the top. For the sea, use cerulean/cobalt violet. For the cliffs and beach, use yellow ocher/cerulean. For the warm shadow in the sea, drop in a little raw sienna.

▶**3** For the tiles on the roofs, apply yellow ocher/cerulean (the roof on the left), and raw sienna/permanent magenta (the roof in the middle). For the cool shadow, dip in a little cobalt blue here and there.

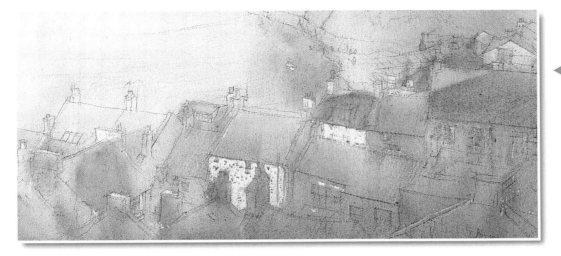

◄ **4** As the paint dries, revisit some areas with another wash—a blue green (either mixed or viridian) on the roof on the right, for example. You can already see the shadow starting to develop across the foreground. Let dry.

▲ **5** Rub off the masking fluid. You'll see that your washes have dried a much lighter color. The pencil drawing still appears satisfyingly crisp and light enough to hold together the washes (right).

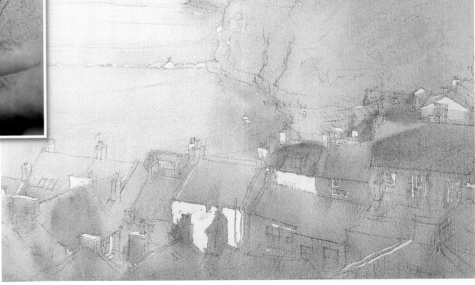

Expert opinion

Q How can I achieve a good balance between wet-in-wet and wet-on-dry work in my painting?

A Try the following exercise. Use good-quality, heavy watercolor paper (as here, 300lb/640gsm) and prepare all your washes beforehand— you need to paint your washes as quickly as possible. In the early stages, apply the paint with reckless abandon. For this you have to be mobile and you might find it helpful to stand up. For the wet-on-dry stages, you can move at a much sedater pace, and since you need a steady hand, it may be better to sit down.

▶ **6** Using the cerulean and cobalt violet mixture, work back into the sea with the No.12 brush. Grade the tone from light at the top to dark at the bottom, leaving a few breaks so the first wash shows through. These provide crisp shapes for the waves. Drop in some raw sienna for the warm reflection of the cliffs.

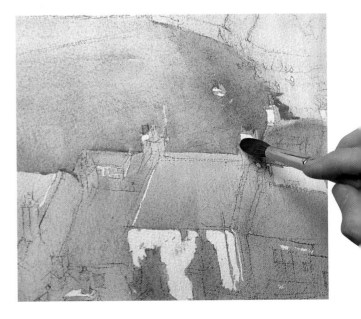

◄**7** Let your previous wash dry completely. Change to the No.8 brush and stroke a little cobalt violet on to the sea—this is dry-brush work.

►**8** Mix a natural-looking green from yellow ocher/cerulean and apply it for the grass on the crumbling rocks. Apply a blue-green mixture plus raw sienna for the darker areas on the cliffs. Accentuate the crevices in the rocks with a plummy mixture of raw sienna/permanent magenta/cobalt blue.

raw sienna

cobalt blue

permanent magenta

plummy mixture for rock crevices

◄**9** Apply a steely blue wash right across the foreground diagonal shadow—use a mixture of cobalt blue/raw sienna/light red. Crisp up the edges of the roofs by painting in the ridge tiles and gable ends in a mixture of cobalt blue/raw sienna/permanent magenta—use the No.5 brush for this. Also paint in a few of the windows.

Tip

The mixtures used by the artist for this painting are almost all variations on a theme —often containing one or more of the same colors. This means that the colors blend together naturally, none of them jumping out —something to bear in mind when you are mixing washes for your own subjects.

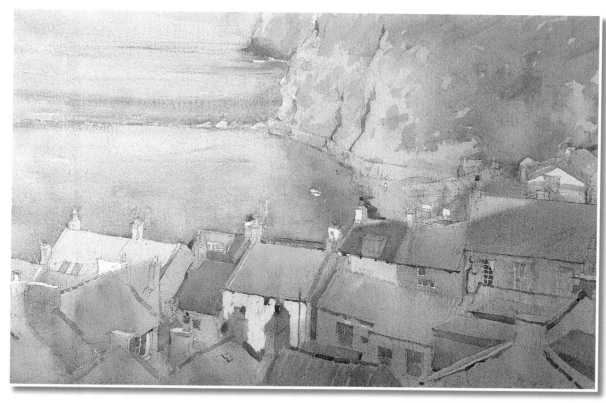

◀ **10** Stand back to get an overview. The tones have darkened, but the darks in the buildings in the foreground are stronger than those in the sea and cliffs. The lightest tone—the wall of the house—is also in the foreground. The greatest tonal contrasts are in the foreground.

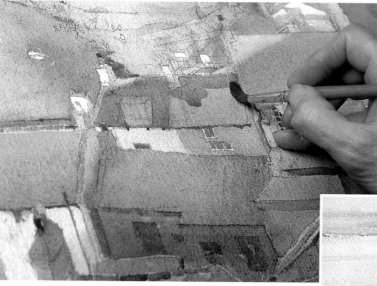

mixture for amber roof

cobalt blue

◀ **11** For the amber roof, mix Indian yellow, cadmium red and a tiny touch of cobalt. For the roof behind, add more cadmium red and a little more cobalt blue to the same mixture.

cadmium red

Indian yellow

▶ **12** Paint the roof next to the amber roof in raw sienna/permanent magenta. Then paint the roof next to it—which is the same color, but in shadow—in the same mixture, adding a little cobalt blue to darken and cool it.

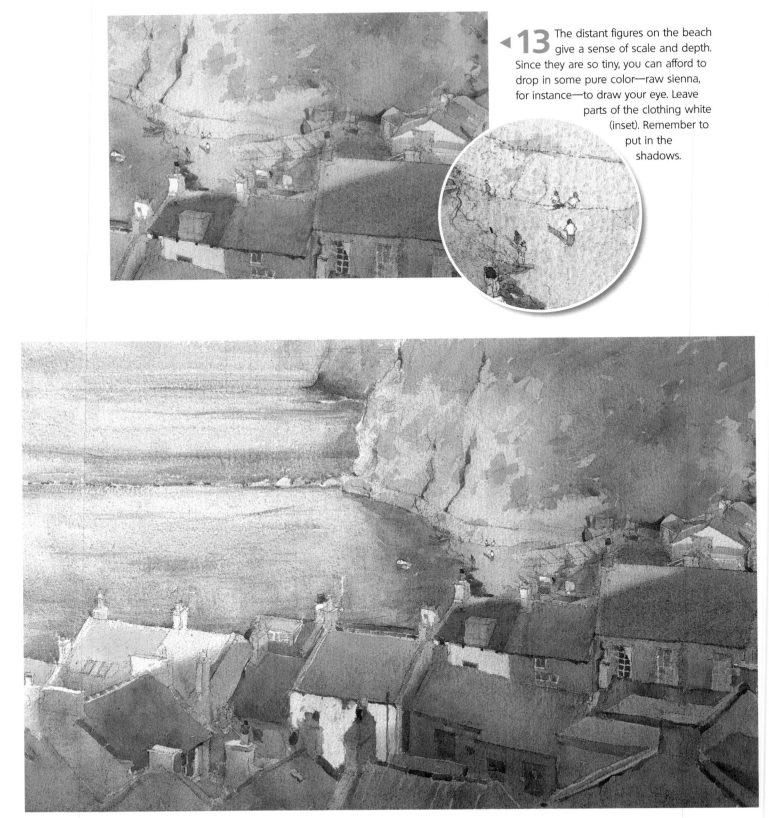

◄ **13** The distant figures on the beach give a sense of scale and depth. Since they are so tiny, you can afford to drop in some pure color—raw sienna, for instance—to draw your eye. Leave parts of the clothing white (inset). Remember to put in the shadows.

▲ **14** To complete the painting, use cobalt blue to put on another glaze—a transparent wash—over the shadow in the foreground. Cobalt is fairly transparent, so it cools the colors underneath without muddying them.

FINISHED PICTURE
By using variations of a few basic mixtures all over the picture, the painting has inherent harmony, all the colors blending and merging in a pleasing way. The wet-in-wet approach conveys a soft, misty atmosphere typical of a coastal area.

Fishing village
by David Curtis

Leafy garden

The flowers and foliage in this shady corner give an overall impression of minute detail, but you don't have to paint every leaf and petal to achieve this realistic effect. Skillful technique is required.

Gardens are a glorious subject to paint, but the details often cause dilemmas. What should you leave in and what should you leave out? The secret is to concentrate on the overall effect and not get bogged down in minute detail.

Start with a pencil drawing of the main shapes. Then approach each plant or cluster of foliage by painting the spaces between them in dark green, so the leaves themselves remain as unpainted white shapes. When this dark tone is almost dry, apply water or a wash of very diluted color over the entire plant. This lifts some of the dark green, causing it to run into the wet shapes, creating paler green leaves with soft, natural-looking edges.

Watercolor becomes lighter as it dries, so as the painting progresses, you must keep going back to strengthen the darkest tones. Paint the foliage rapidly— a single brushstroke can represent a leaf. Suggest stalks, branches and other linear shapes equally quickly, using the tip of a No.4 brush.

With deft brushwork, you can create effective flower and leaf shapes. Also, by building up the color in small strokes, you can leave small flecks of white paper showing between the brushmarks, giving an overall effect of dappled light and shade.

The setup

A quiet corner of the garden is the inspiration for the painting, but artistic license can be taken with the flowers and plants.

▼ *WATERCOLOR SKETCH*
Before embarking on the painting, try out the light and dark foliage tones on a pencil sketch (see inset bottom left).

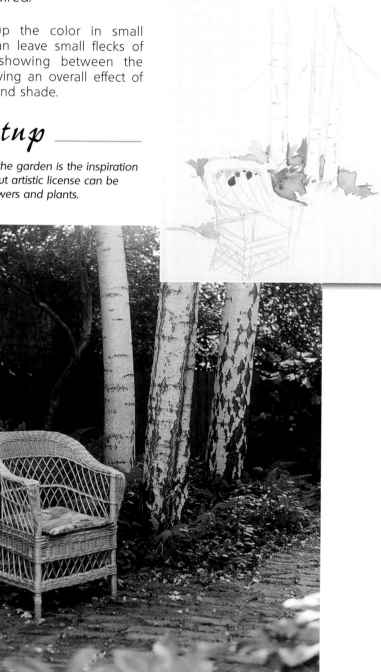

▶ *PENCIL SKETCH*
A preliminary pencil sketch, made on the spot, helps you to decide the final composition of a painting. Here, three silver birch trees are central and a wicker chair is placed just left of center.

▲ *REFERENCE PHOTOGRAPH*
A photo provides the detailed information needed to paint the shapes and tones of the flowers and foliage.

What you need

- An 11 x 15in (28 x 38cm) sheet of 300lb (640gsm) cold-press watercolor paper
- Drawing board
- Masking tape to fix paper to board
- 2B pencil
- 10 paints: sap green, cadmium yellow pale, cadmium orange, Winsor blue, ultramarine, cadmium red, alizarin crimson, Vandyke brown, burnt sienna, Winsor violet
- Two brushes: No.4 and No.6 round
- Two jars of water
- Mixing palette

1 Make a light outline drawing of the subject with the 2B pencil. Using the No.4 brush, start to paint the spaces between the trees in diluted sap green. Add tiny amounts of burnt sienna and ultramarine to create patches of warmer and cooler color.

sap green

sap green + burnt sienna

sap green + ultramarine

sap green + cadmium yellow pale

2 Paint the background plants in sap green, varying the mixture with small amounts of cadmium yellow pale, burnt sienna or ultramarine. First paint the spaces between the leaves in strong color. When dry, wash over each plant with dilute green mixtures to create pale green leaf shapes.

3 Continue painting the foliage spaces around the chair in sap green, ultramarine and Vandyke brown. Paint the spaces in the wickerwork in sap green. When dry, paint the wickerwork in mixtures of cadmium yellow pale, burnt sienna and alizarin crimson. Add Winsor violet to these for the shadow on the chair back.

Expert opinion

Q Every plant and tree is a different green. How can I use so many greens yet retain an overall sense of harmony in a painting?

A Use just one green and add small amounts of other colors to this to get different color variations. Add touches of yellow for bright spring foliage; burnt sienna or red for a warmer green; and blue or purple for a cooler color. This simple technique gives infinite variety but, because the basic green is the same, your painting retains a sense of integrated color.

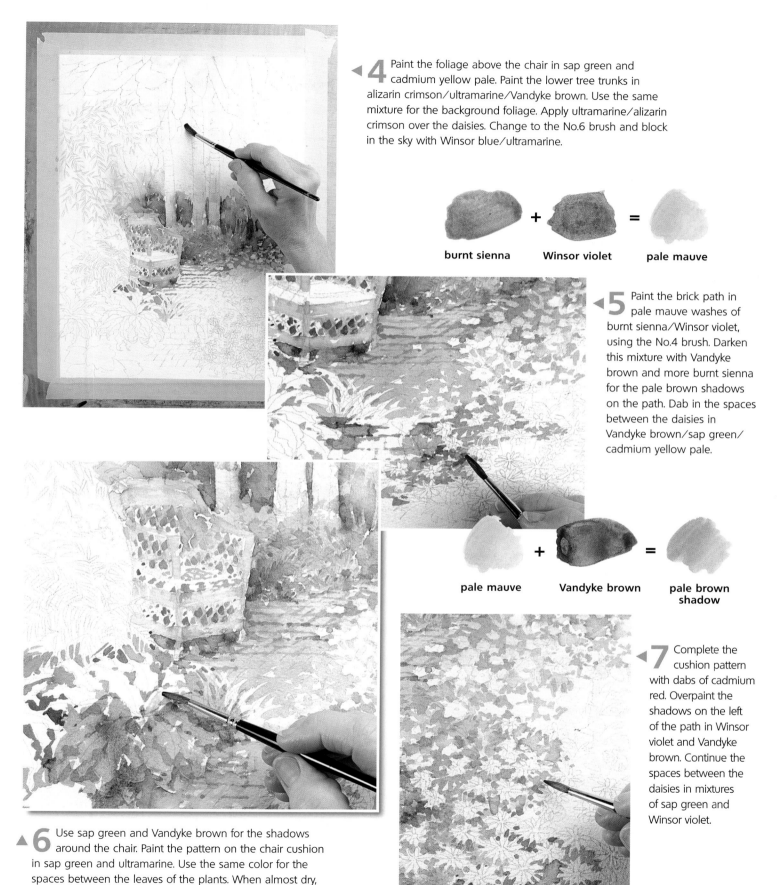

4 Paint the foliage above the chair in sap green and cadmium yellow pale. Paint the lower tree trunks in alizarin crimson/ultramarine/Vandyke brown. Use the same mixture for the background foliage. Apply ultramarine/alizarin crimson over the daisies. Change to the No.6 brush and block in the sky with Winsor blue/ultramarine.

burnt sienna + **Winsor violet** = **pale mauve**

5 Paint the brick path in pale mauve washes of burnt sienna/Winsor violet, using the No.4 brush. Darken this mixture with Vandyke brown and more burnt sienna for the pale brown shadows on the path. Dab in the spaces between the daisies in Vandyke brown/sap green/ cadmium yellow pale.

pale mauve + **Vandyke brown** = **pale brown shadow**

7 Complete the cushion pattern with dabs of cadmium red. Overpaint the shadows on the left of the path in Winsor violet and Vandyke brown. Continue the spaces between the daisies in mixtures of sap green and Winsor violet.

6 Use sap green and Vandyke brown for the shadows around the chair. Paint the pattern on the chair cushion in sap green and ultramarine. Use the same color for the spaces between the leaves of the plants. When almost dry, wash over the plants in a diluted mixture of the same color to establish the paler green leaves.

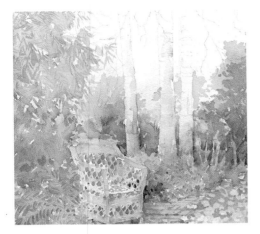

▶ **9** Paint the branches behind the chair in Vandyke brown. Paint the tree foliage in loose dabs of sap green and ultramarine. Allow flecks of white to show between the strokes to convey an impression of sunlight and dappled shade.

▲ **8** Paint the tree trunk shadows in diluted Vandyke brown/ultramarine, then wash burnt sienna/cadmium yellow pale into the base of each tree. When dry, apply diluted sap green/ultramarine on the background shrubs. Let dry. Use the same colors for the leaves on the left shrub.

▲ **10** Use alizarin crimson/cadmium red for the red flowers. Dab in the centers of the daisies with cadmium orange/cadmium yellow pale mixture. Strengthen the dark tones and paint a wash of ultramarine/Winsor violet over the farthest daisies.

▶ **11** Paint the branches and the markings on the tree trunks in Vandyke brown. Curve the lines around the trunks to suggest their solidity and cylindrical form.

FINISHED PICTURE
The many greens are mixed from sap green with the addition of small amounts of other colors. Splashes of bright red and yellow bring the painting to life.

The artist's garden
by *Shirley Felts*

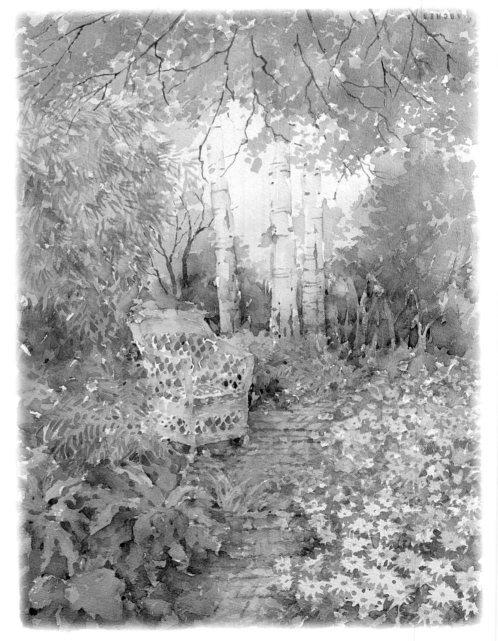

Meandering river

In this glowing woodland scene, layers of spattered paint contrast with blended wet-in-wet colors to produce an almost photographic image—but without the fuss of painting every detail.

To achieve a natural-looking scene, you must paint what you see rather than what you think is there. In this painting, the artist used spattering for a highly textured surface, creating the illusion of foliage layers in perspective. Starting with the palest color, overlay darker tones—contrasting denser areas of color with lightly spattered areas—letting the paper shine through to give the impression of dappled sunlight.

In contrast, the water is painted wet in wet to continue the natural look. To achieve reflections in the shadow areas, work the paint quickly into wet paper coated with gum arabic, which slows the drying process, depicting the reflections with vertical strokes and lines overlaid with horizontals. This produces wet, blurred, color blends; the horizontals give the effect of surface interruptions in a stream of moving water.

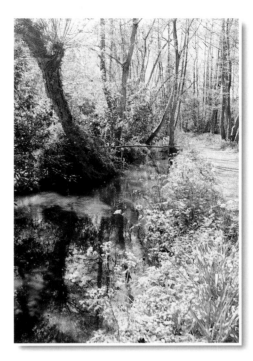

The setup

A slow stream winding through woodland is a popular subject and provides the opportunity to use several different techniques in the same painting.

▲ ▶ PENCIL SKETCH AND OUTLINE DRAWING
For a scene like this, start by making an energetic rough composition drawing (right). Overlay the sketch with tracing paper and, refining the lines, transfer it to the painting support within a ruled pencil border (above).

▲ REFERENCE PHOTOGRAPH
When composing a scenic painting in the studio, spend time studying your chosen landscape from photos taken at different angles. Becoming familiar with the various elements of the scene helps you determine composition, technique and color range.

◀ TRACE TEMPLATE

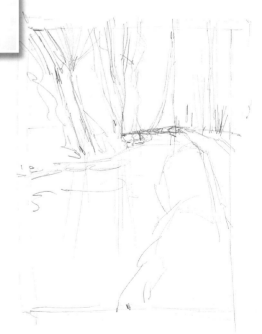

What you need

- A 20 x 14½in (51 x 37cm) sheet of Whatman 200lb (425gsm) cold-press watercolor paper
- Cartridge paper for masking
- Tracing paper
- Staple gun and staples
- Drawing board
- 2B pencil
- 14 paints: cadmium yellow, lemon yellow, Naples yellow, light red, alizarin crimson, cobalt blue, cerulean, indigo, turquoise, cobalt green, phthalo green, burnt sienna, burnt umber, titanium white
- Five brushes: No.2, No.4, No.8, No.10, No.16 sable or sable/synthetic
- Masking fluid plus paint shaper and toothbrush
- Gum arabic, saucer and brush
- Two jars of water
- Mixing palette
- Hair drier
- Paper towel

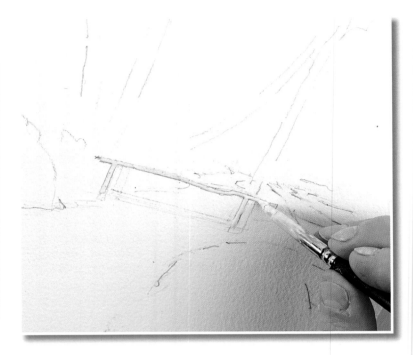

▲ **1** Apply masking fluid to selected areas, using both the paint shaper (shown) and the toothbrush. Contrast strong lines for the bridge and trees with clusters of small dabs and flicks for the wildflowers on the right bank of the river and the sunlight glistening through the trees on the opposite bank.

▲ **2** Wet the woodland area on the left bank with a spattering of clear water, protecting the rest with a paper mask. Spatter a mixture of cadmium lemon/burnt sienna/phthalo green across the wet area with the No.2 brush (inset). Overlay dense patches of the same color with the No.8 brush on the edges of the river bank.

▶ **3** Continue spattering with the same mixture on the right bank, alternating brushes for variety of tone and texture. Adjust the paper mask as necessary and blend the colors by spattering clear water over them. Use the No.8 brush to describe the edge of the riverbank. Let dry.

◄ **4** Add cobalt green to the mixture and mask off the foreground. Then, interchanging the No.16 and the No.8 brushes, intensify the texture and tones of the foliage. Blend with spatterings of clean water.

▶ **5** Mask the top area. Then use the No.8 brush to spatter an open, ragged texture on the right bank, flicking clean water in criss-cross movements. Work from the bottom up, making the drops smaller and denser toward the back. Use the same action to overlay greens already mixed on your palette.

▲ **6** Return to the wooded area on the left. Mix burnt umber with your greens, and spatter in dark shaded tones with the No.8 brush, varying the density and allowing the background color to show through in places. Use the No.4 brush to drag out a few foliage shapes.

Expert opinion

Q How can I create a variety of different marks using spattering techniques?

A Always use brushes with a fine point. To create a sense of perspective, start with the biggest brush and scale downward, testing the paint load on a piece of spare paper first. For tiny droplets, spatter from a small brush onto dry paper with a sharp tap of your hand. Larger marks can be achieved with a watery solution on a bigger brush. Spatter onto wet paper to create soft blends. To preserve highlights, spatter masking fluid onto a dry surface, as in Step 1.

▶**7** The illusion of thick, deep woodland is created by the overall variety of spattered and blended paint. Highlights of spattered light red and turquoise add texture, while a small patch of phthalo green brushed on a wet surface at the far end of the river suggests a grassy glade.

▲**8** Wet the river area to help the color spread. Mix phthalo green/indigo and paint the reflection of the sky in the water with the No.10 brush, laying vertical strokes over horizontal. Work the brushstroke from the bottom upward. Let dry.

 Tip

Stapling the paper to the board along each edge provides a good support and avoids the need to stretch the paper in advance.

▶**9** Working quickly into a wet surface and allowing the paint to blend creates the impression of a quivering reflection on water. The illusion of depth is enhanced by intensity of tone against the tiny dots of masking fluid.

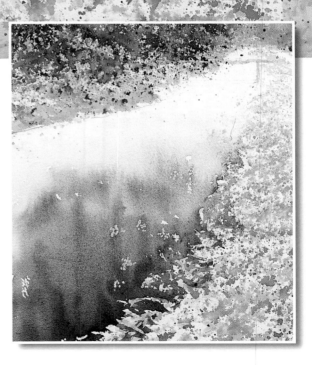

▶ **10** Use a mixture of greens and alizarin crimson and the No.4 brush to darken the foliage, adding bright marks in pure turquoise and light red. Define the river edge in palette colors overpainted with turquoise and cadmium yellow. Use dark palette mixtures for the main tree trunk (inset), wetting the paper first. Then drag out the color of the branches with the tip of the brush.

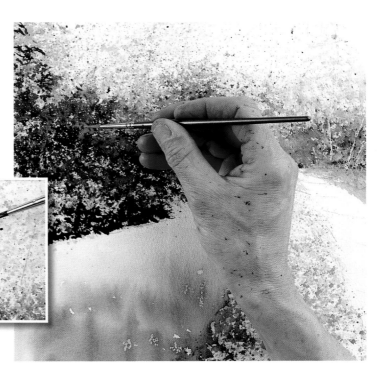

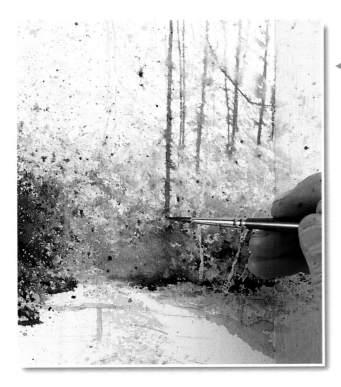

◀ **11** Paint the thinner tree trunks right at the back with the No.4 brush and a mixture of cobalt green, light red and cobalt blue, working the color from the bottom upward. Blend the trunks into the foliage with a wash of clear water. Indicate the branches with fine, sweeping strokes.

▶ **12** Paint in the tall, thin trees in front of the background ones, adding shadows to the trunks with the No.4 brush and a mixture of light red and cobalt green. Dilute the mixture to wash in the path, adding in darker palette tones for the shadows. Darken the riverbank with a spattering of green.

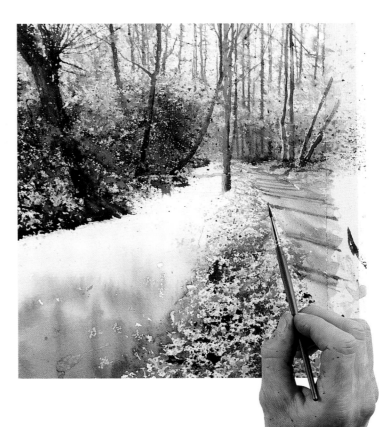

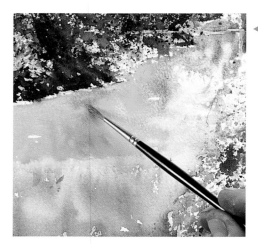

13 Make a strong mixture of cerulean for the water by the bridge. Wet the paper first and apply gum arabic—pour a little in a saucer and brush on with a clean brush. Use vertical strokes of the No.4 brush to paint the water. Now paint in the water by the left bank in cadmium lemon/Naples yellow, letting the background color show through. Add in strong contrasting lines of crimson and green.

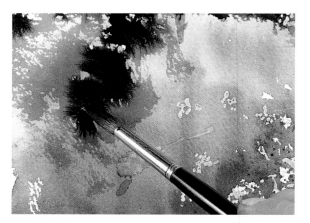

14 Alternating the No.4 and No.16 brushes, paint in tree reflections with a mixture of crimson and green, keeping the paper wet. Accentuate bands of color under the bridge, and paint vertical zigzag lines in Naples yellow. Use a dark palette mixture to create horizontal shimmer lines.

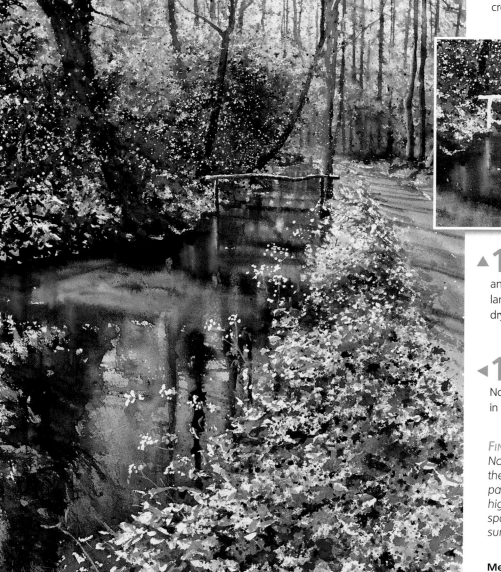

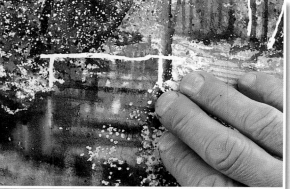

15 Lift out flashes of light reflections in the water with the clean No.4 brush and water. Adjust the color tones in the landscape as required. When the painting is dry, rub off the masking fluid with your fingers.

16 Stand back and assess your work for tone and contrasts. Then, using the No.4 brush, lightly paint in the wildflower stems in a mixture of lemon yellow/titanium white.

FINISHED PICTURE
Notice how effective the contrast is between the crisp spattered areas and the parts painted softly wet in wet. The bright highlights left by the masking fluid give sparkle and create the appearance of sunlight filtering through the trees.

Meandering river
by Joe Francis Dowden

Farmyard scene

To paint a scene like this successfully requires careful observation of the landscape, the farm buildings and the animals—all of which require different skills to portray convincingly.

When faced with a composite scene with several different elements under constantly changing light, it pays to reduce the features to their essentials, and to use simple painting techniques. For example, a piece of farm machinery can be painted using just a few economical brushstrokes. Here the artist used the traditional watercolor method of working from light to dark, and from the broad to the detailed. The result of working methodically in this way is a painting that seems both effortless and exhilarating (see page 188).

The cows and chickens were not actually there but were added to bring life and character to the picture. The artist used his imagination, plus existing sketches as reference, and took care to draw the animals in correct proportion to their surroundings.

(see page 188).

Tip

French ultramarine and raw sienna are good colors for painting cloudy skies. Interestingly, the two colors don't turn green—as you might expect—even when applied wet in wet.

The setup

This project provides the opportunity to explore the contrasts between the organic forms of the sky and trees and the hard-edged shapes of the man-made structures.

▼ TRACE TEMPLATE

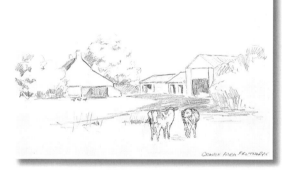

▲ PENCIL SKETCH
The finished painting is loosely based on this sketch, but the cows have been moved back into the middle ground in order to present a more cohesive design.

6 Mix a cool green from ultramarine/raw sienna and lay in the line of distant trees on the left of the picture, using the tip of the No.16 brush (inset). Mix a warm olive green from cadmium yellow/ultramarine and start to paint the nearer trees. Use the tip of the brush to make small, ragged marks that resemble clumps of foliage.

warm olive green for trees

cadmium yellow

ultramarine

7 To suggest shadows and darker clumps of foliage, add touches of Payne's gray wet in wet, using the tip of the brush. Make the middle tree slightly paler and bluer to push it farther into the distance. Put in the smaller trees, adding some cadmium yellow to the mixture for the golden foliage and some Winsor blue for the dark, warm greens.

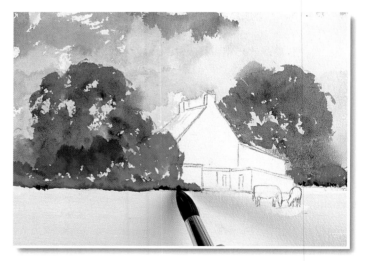

8 The tree on the right is nearest, so paint it with a stronger, richer green mixture of cadmium yellow/Winsor blue. Add Payne's gray for the darks, particularly near the base of the canopy. Let the sky peek through the foliage, especially around the top. When the trees are dry, mix a dark brown from ultramarine/burnt umber and add a few branches with the No.3 sable script liner brush (inset).

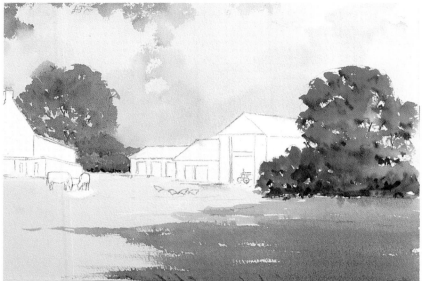

9 Mix a warm green from cadmium yellow and Winsor blue and dilute it to a thin wash. Put in the shadow on the grass in the foreground with the edge of the flat brush. To give the effect of perspective, make the wash weaker in the distance and strengthen it with a little ultramarine/burnt umber in the front.

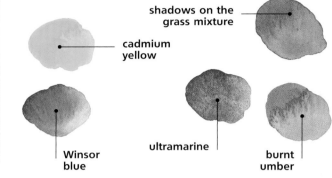

shadows on the grass mixture

cadmium yellow

Winsor blue

ultramarine

burnt umber

10 Mix a dark green from cadmium yellow and Payne's gray and use with the No.8 brush to paint some dark tree foliage behind the farmhouse roof. This will bring the house forward and accentuate the red of the roof. Paint the roof with light red, then float on some ultramarine to give it an aged look.

11 Use light red to paint the walls and roofs of the barns, weakening the tone and cooling the color with a hint of ultramarine as they go back in space. Add burnt umber/burnt sienna to the mixture and suggest the roof tiles with the sable script liner brush. Use Payne's gray and the No.8 brush for the corrugated iron parts of the barn.

12 Suggest just a few bricks on the nearest barns. Mix ultramarine/burnt umber for the barn interiors, adding a stronger tone for the deeper shadows. Add touches of yellow and the brick color to suggest straw spilling out of the doorways.

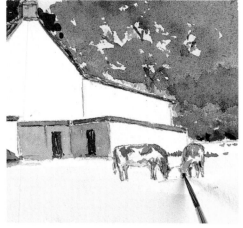

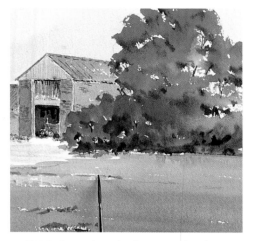

▲**13** Paint the tractor with Winsor red and Payne's gray, leaving flecks of white paper for highlights. Use the sable script liner brush to paint the hens in the brick color. Add Payne's gray shadows to hint at their form. Make the rooster darker, and put in his red comb.

▲**14** Mix ultramarine and a touch of burnt umber for the shadows on the walls of the house. Darken the mixture with more burnt umber for the doors. Use the sable script liner brush to paint the brown patches on the cows, using the same mixture as for the hens.

▲**15** Strengthen the foreground with raw sienna, adding streaks of brown and gray. When dry, mix the green used in Step 11 to extend the grassy area right across the foreground. Add patches of mud and clumps of grass with the sable script liner brush.

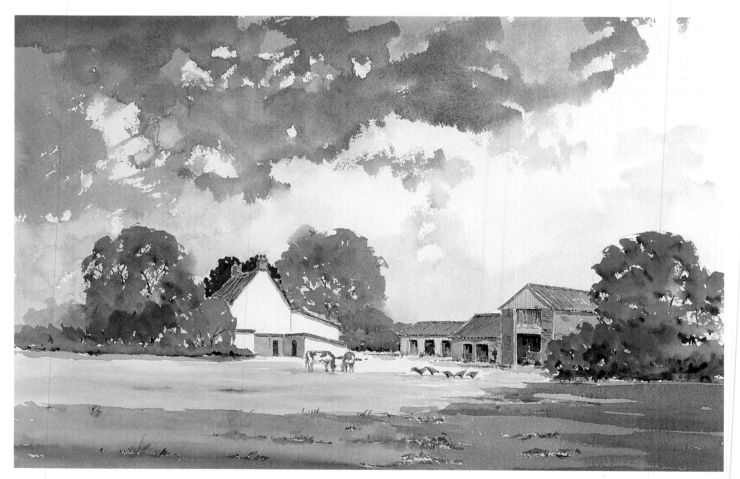

▲**16** To finish off, use ultramarine/burnt umber and the No.8 brush to put in shadows on the grass on the right. Dilute the wash and put in the shadows under the eaves and those cast by the barn, the cows and the hens. Add a touch of color with a tiny figure in front of the barn, using Winsor red and Payne's gray.

FINISHED PICTURE
This shows how useful shadows can be in a composition. The shaded foreground frames the view and gives depth to the scene.

Church Farm
by *Frank Halliday*

Lakeside landscape

Use graded washes to capture the progression of color from sky to horizon to shore. The wet-in-wet approach produces smoothly blended brushstrokes and, where two colors meet, soft blurred lines.

The sweeping expanses of water and sky in this picture (see page 192) are painted in graded washes, that is washes that change gradually from dark to light, or from light to dark, or are laid in two or more colors.

Working down from the top of the paper, the areas of sky were applied in broad, overlapping strokes, starting with a diluted blue/green. A little more paint was added to the wash mixture for each fresh stroke, making the color progressively brighter and stronger toward the horizon. The water was painted light in the distance where it reflects the sky, and increasingly darker toward the foreground shoreline as it picks up shadows and reflections from the surrounding landscape.

The colors in the sky and water also vary markedly from top to bottom. Add ultramarine to the wet blue/green sky at the horizon and a strong, dark indigo to foreground water.

▼ REFERENCE PHOTOGRAPH
A photograph of a farmer's house provided ample information and architectural detail to create the cottage in the landscape.

The setup

The lakeside view was painted from an on-the-spot sketch, but the artist felt a more specific reference—taken from a photograph—was needed for the whitewashed cottage.

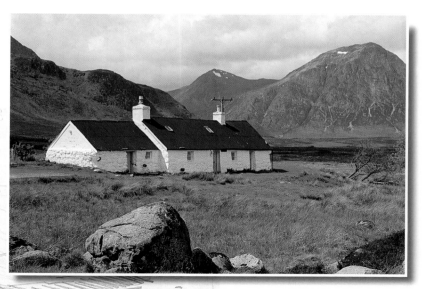

◄ PENCIL SKETCH
The elements of the picture are represented in a preliminary sketch. The size of the paper should not cramp the composition. If you feel your subject needs more space than you have allowed, extend the drawing by adding more paper.

What you need

- A sheet of stretched 21 x 15in (50 x 38cm) cold-press watercolor paper
- Staples and staple gun for stretching paper
- Tracing paper
- Masking tape
- Drawing board
- B and 4B pencils
- Eight paints: cobalt blue,

burnt sienna, Winsor blue, Winsor green, indigo, ultramarine, cadmium lemon, quinacridone red
- Three brushes: No.4, No.8, No.16 round sable
- 2in (50mm) soft flat brush for wetting the paper
- Two jars of water
- Mixing palettes

1 Make an outline drawing of the subject on tracing paper with the B pencil. Turn it over and scribble over the drawn lines on the reverse side of the tracing paper with the 4B pencil. Place the trace, right side up, on the stretched watercolor paper and tape it down with masking tape. Pressing firmly, go over the lines of the original drawing (inset right) with the B pencil.

2 Peel back the tracing paper to reveal the outline drawing of the subject on the watercolor paper (inset right). If the drawing is very pale, lightly redefine the lines with the B pencil so you can see them clearly.

3 A good technique if your paper is large and heavy is to staple it firmly to a board. Then, to ensure a crisp edge to the painting, stick masking tape around the picture area (inset far right). Press the tape down firmly to prevent the paint from seeping underneath.

quinacridone red

burnt sienna

cobalt blue

4 Working around the gables of the cottage, wet the picture area with clean water using the flat brush. Leave a few flecks of dry paper on the far shoreline to indicate distant buildings. Mix a cool, gray-purple wash from cobalt blue, burnt sienna and quinacridone red. Use the No.16 round brush to apply the wash in overlapping horizontal strokes, allowing the color to run freely into the wet areas. Remove the masking tape (inset). Let the painting dry; then apply more tape before moving on. This prevents a build-up of dark color around the edge of the painting.

◄5 Wet the sky and lake areas with clean water. Apply a wash of Winsor blue and Winsor green to the sky with the No.8 brush. Strengthen the color as you near the horizon. Add a little indigo to the mixture and paint the water, leaving streaks of unpainted undercolor to indicate reflected light. Add a few vertical strokes, lining these up with the cottage for the reflection of the building.

ultramarine

indigo

blue/green sky mixture

►6 While the paint is still wet, add a little ultramarine to the sky just above the horizon line. Then add a little indigo to the lake color and paint a few horizontal streaks on the surface of the water. Increase the indigo for the darker foreground water.

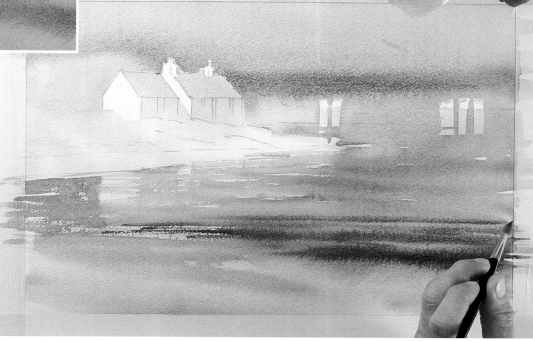

Expert opinion

Q What should I do when I am working from more than one reference and the light in the various sketches and photographs is coming from different directions?

A The light source in your painting must be consistent, otherwise the composition will look odd and the subject appear unconvincing. Choose your source of light before you start work and stick to it. In this painting, the direction of sunlight on the cottage was changed from that in the photograph in order to establish a strong light source from the left-hand side of the picture.

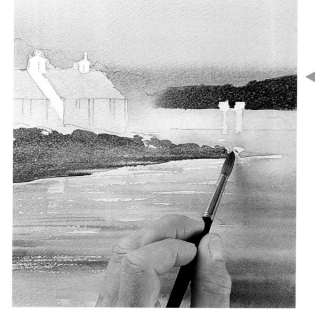

◄7 Wet the horizon of the distant hill. Paint the hill in a mixture of ultramarine and burnt sienna, allowing the color to flood into the damp horizon line.
 Paint the land immediately in front of the cottage in ultramarine and cadmium lemon with a touch of burnt sienna, leaving it jagged along the upper edge.

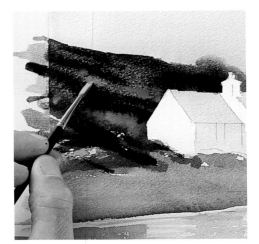

▲**8** Wet the sloping hill behind the cottage. Paint the wet area in a mixture of deep burnt sienna/cadmium lemon/indigo. Drop a few streaks of cadmium lemon into the wet painted color. Extend streaks of the same mixture in front of the cottage.

▲**9** Paint the foreground in mixtures of burnt sienna and indigo. Use the No.4 brush to define the roofs, windows and doors with a fine indigo line. Make a pale mixture of cobalt, quinacridone red and burnt sienna and block in the windows and doors.

▲**10** Darken the roof with diagonal strokes of cobalt blue/burnt sienna. Make sure the roof is paler than the background. Still using parallel strokes, add flecks of burnt sienna and lemon yellow to represent the lichen on the roof tiles.

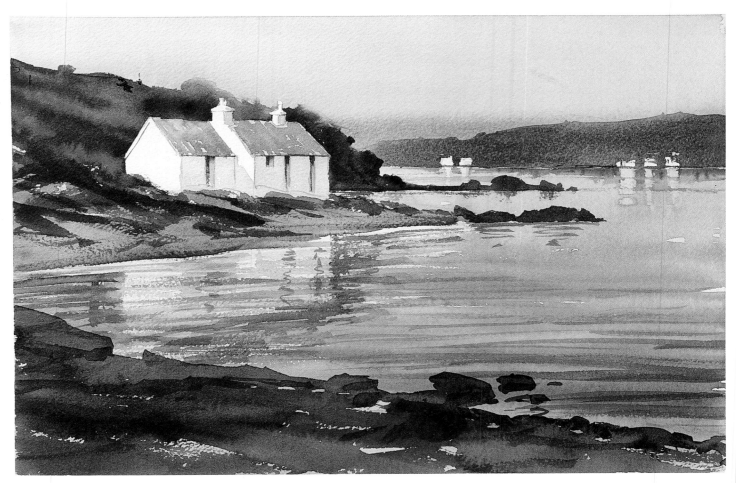

▲**11** To finish the picture, add some dark horizontal and zigzag shadows to the water in indigo with a touch of burnt sienna. Use broad strokes for the foreground shadows and narrow ones for the distance.

FINISHED PICTURE
Note how the blurred contours of the distant hills contrast with the sharp brushstrokes and clearly defined shapes of the middle and near-middle ground. The difference between the two effectively conveys a feeling of space and atmosphere.

Lakeside cottage by *Joe Francis Dowden*

Topiary garden

A group of clipped shrubs standing in long grass offers a wealth of intriguing shapes and natural textures.

Topiary is often associated with neat, well-tended flowerbeds and manicured lawns, but in this scene there is a charming contrast between the formal precision of the trees and the long grass in which they stand. With its strong, geometric shapes and crisp, graphic outlines, topiary is the visual antithesis of all that is graceful and flowing in nature.

In this painting, the artist used loose, free brushstrokes to depict the softness of the long grass—a perfect foil for the hard-edged trees, which he rendered with more precision and control. He made skillful use of a limited palette to create a harmonious range of greens, while the addition of gum arabic to the washes helped the paint to flow, creating convincing foliage textures.

▲ FINISHED PICTURE
The picture exploits the vibrant complementary pairing of red and green—among so much greenery, the warm red-brown of the house draws the eye.

The setup

After choosing the viewpoint for this composition, the artist exercised discretion to omit some tousled shrubs, leaving the long grass as the only untamed element in the orderly scene.

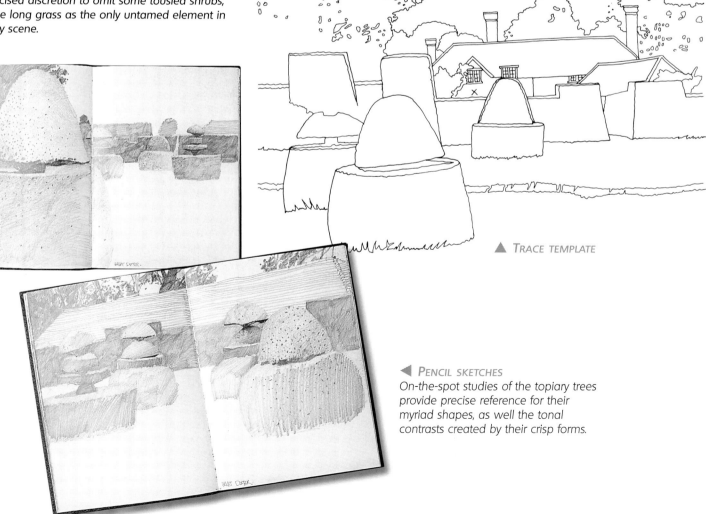

▲ TRACE TEMPLATE

◀ PENCIL SKETCHES
On-the-spot studies of the topiary trees provide precise reference for their myriad shapes, as well the tonal contrasts created by their crisp forms.

What you need

- A 21½ x 14¼in (55 x 36cm) sheet of good-quality 200lb (425gsm) cold-press watercolor paper, stretched onto a drawing board with gummed brown paper tape
- Spare sheet of watercolor paper, measuring approximately 21½ x 10in (55 x 25cm)
- HB and B pencils
- 10 paints: phthalo blue, sap green, yellow ocher, cadmium yellow, Payne's gray, sepia, burnt sienna, brown madder alizarin, raw umber, black
- Five brushes: No.1, No.4, No.6, No.12 round; ½in (13mm) flat
- Gum arabic
- Two jars of water
- Mixing palette

▲**1** Sketch the outlines of the subject lightly onto the stretched paper with the HB pencil. Mix a very diluted wash of phthalo blue and block in the sky with the No.12 round brush, working around the topiary trees, the roof and the chimneys.

◄**2** Use the No.12 brush and a light mixture of sap green/yellow ocher for the hedge, trees and grass in front of the house. Wash over the entire area with loose, free brushstrokes, keeping the foreground open. Don't worry if the wash bleeds into the sky a little—the distant trees will hide that. Let dry.

hedge and grass color

burnt sienna

Payne's gra

color for buildings

yellow ocher

sap green

▶**3** Use a loose, gray-brown mixture of burnt sienna/Payne's gray and the No.12 brush to paint the buildings. Paint around the shrubs at each end of the building, and reserve the whites of the eaves, windows and the white clapboard wall. Allow the paint to dry.

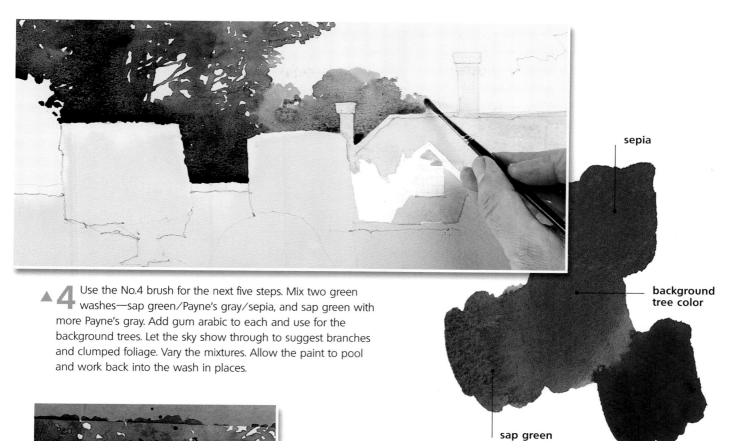

sepia

background
tree color

sap green

Payne's gray

▲ **4** Use the No.4 brush for the next five steps. Mix two green washes—sap green/Payne's gray/sepia, and sap green with more Payne's gray. Add gum arabic to each and use for the background trees. Let the sky show through to suggest branches and clumped foliage. Vary the mixtures. Allow the paint to pool and work back into the wash in places.

◀ **5** When you have painted all the distant trees, go back to the beginning and spatter a little clean water into the dry wash. The gum arabic in the wash encourages a dappled effect.

▶ **6** Now use a yellow-green mixture of sap green/raw umber to paint the shrubs at each end of the house. Intensify the color and add texture with additional layers of wash.

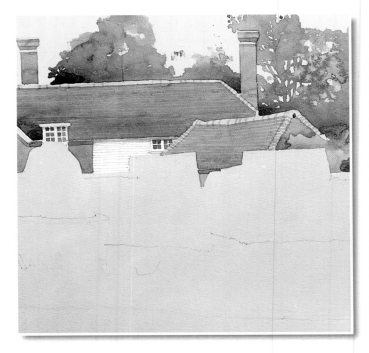

7 Darken the gray-brown building wash with burnt sienna/Payne's gray, and redden it with brown madder alizarin. Paint the roof and chimneys, leaving light highlights at the tops of the chimneys and the roof ridge (inset). Dilute the mixture for the lower barn roof, leaving the ridge and eaves pale. Add a little more alizarin and a touch of yellow ocher for the facing wall of the house. Let dry.

Payne's gray

brown madder alizarin

roof and chimney color

burnt sienna/
building wash

Tip

Grass is never flat—long grass especially has depth and texture. To render it sensitively, you need to create an internal dynamic with your brushstrokes to give it movement. Echo the direction of growth or the way the wind is blowing it, building up tone and texture with overlaid brushmarks for depth but not solidity.

8 Add a touch of black to the building wash and use the tip of the brush to suggest the rows of roof tiles. Paint the shadows under the eaves in Payne's gray. To add the final details to the building, change to the No.1 brush, and paint the window panes with black/Payne's gray. Use the B pencil to draw the clapboard lines.

◄ **9** Return to the foreground. Go back to the first sap green/yellow ocher wash and add plenty more yellow ocher. Use the No.6 brush to paint the long grass with loose, energetic strokes. Keep the brushwork free and open, changing the direction of the marks slightly from time to time. Let dry.

▶ **10** Build up the texture of the long grass with a second layer of the same wash. Use the edge of the flat brush, and spatter a little wash here and there for varied effects. When dry, repeat the process a third time, deepening the texture still more. Finally, soften the brushmarks in places with clean water and the No.12 brush to suggest the haze of feathery grasses.

▶ **11** For the path across the long grass, tear the spare sheet of paper in half lengthwise. Place the two halves across the support with a small gap between. Darken the grass wash and brush vertically across the gap with the flat brush (inset above). Leave it for a minute, then lift off the masks (inset right). This creates a soft, expressive edge for the mowed pathway.

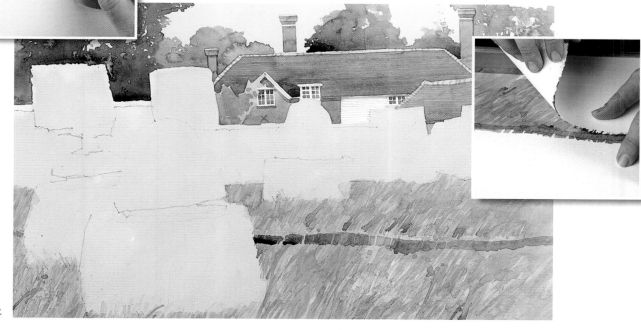

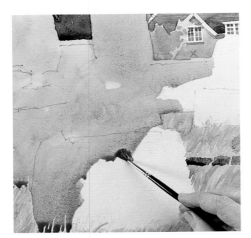

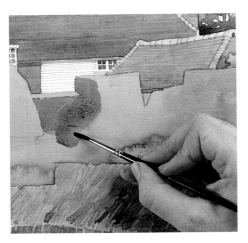

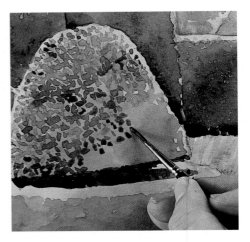

▲ **12** Use the No.4 brush for the rest of the painting. Make a bright green mixture of sap green/cadmium yellow and paint the topiary and shrubbery. Use a wetter wash in some places so it dries unevenly, hinting at the texture of the clipped foliage.

▲ **13** Mix sap green/raw umber/sepia and gum arabic. Paint the shrubbery first, then the trees in front. Leave highlights on the horizontal surfaces and create broken textures to suggest the foliage. Let the paint pool in places to create varied tones.

▲ **14** Darken the green mixture with sepia and touches of brown madder alizarin/Payne's gray. Paint the long shrubbery first to separate it from the trees. Depict the texture of the hedge with broken color, and spatter on clean water to open up the wash.

▲ **15** Use the same dark green mixture to work up the topiary trees, adding raw umber and black to the wash for the areas of deepest shadow. To advance the nearest tree, bring the foliage detail into focus with small, individual leaf-shapes, dabbing with the tip of the brush.

FINISHED PICTURE
Notice how the gum arabic helps to deepen the textural effects, emphasizing still more the contrast between the soft, long grass and the crisply trimmed small leaves of the topiary.

A topiary garden by *Ian Sidaway*

Harbor steps at low tide

Versatile yet subtle, delicate earth-color mixtures are ideal for capturing this harbor scene, rich in ochers, umbers and browns.

Earth colors are complex—often slightly muted versions of primary or secondary colors. Yellow ocher is a neutralized yellow-orange, for example, while Venetian red is a soft brownish red. They are wonderful colors to use. Intense but never garish, they can produce some very useful mixtures.

Here the artist began with watery washes of raw sienna with a little blue, green or red added. These subdued the white of the paper and made a good base for the colors laid on top. He used Rough paper with a slightly waxy surface that resists the water and allows the paint to create pools of color. These dry with crisp edges, while the pigment often separates and tiny particles settle in the indents of the paper to create a grainy texture.

Tip

If you stick some tracing paper to the board all around the watercolor paper, you can use it to try out the hue and intensity of each color before you apply it to the actual support.

The setup

Earth colors are perfect for this scene. The artist worked on a slightly raised board, so the paint ran down the paper and pooled at the edge of each brushstroke.

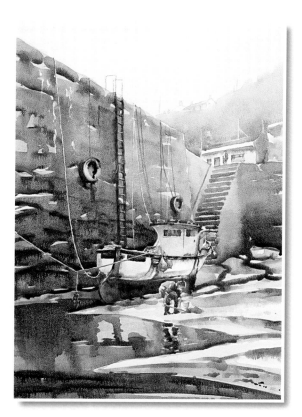

▲ FINISHED PICTURE
The painting was done on a cold morning in March, when the colors of nature appear muddy—perfect for a palette of earth colors.

◀ TRACE TEMPLATE

◄ **7** Paint the stones at the top of the left wall with the No.12 brush and burnt umber/cobalt/raw sienna. Work down, adding more cobalt or burnt umber. Leave some strips bare; let other areas run and spread. Drop in Indian red or raw sienna for rusty tones. Suggest the tidemark in ultramarine and burnt umber. Use the No.5 brush to paint around the boat.

► **8** Paint the steps in burnt sienna/raw sienna/cobalt. Drop Indian red/cobalt into the wet color on the right wall—adding burnt umber farther down. Wet the muddy trails, then paint them with this mixture. Wash raw sienna on the pilothouse. Drop in rose madder alizarin/cerulean to suggest the sun on white paintwork. Paint parts of the roof in cerulean/raw sienna. Paint the deck on the right in cobalt/rose madder/burnt sienna.

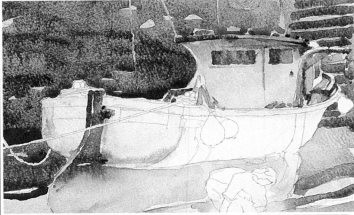

◄ **9** Use the No.4 brush and burnt umber/cobalt for shadows on the pilothouse roof. Continue with these colors for the windows—add cadmium yellow for the pilothouse curtains. Paint the stern with cobalt/raw sienna/burnt sienna. Use cobalt and burnt umber for the rudder blade and raw sienna for the rust on the hull. Paint the keel with a mixture of palette colors. Shape the boat by layering the shadows and rust. Let the paper dry between each layer.

olive green

burnt sienna

► **10** Rub off the masking fluid. Paint the tires with olive, burnt sienna, ultramarine and raw sienna, building up the shadows underneath to help place the tires against the wall. Let some color bleed down the wall and lift out color from the tires with a wet brush to shape their form. Paint the ladder in the same way with a similar color mixture. Lift off paint for the highlights on the rungs.

mix for tires

ultramarine

raw sienna

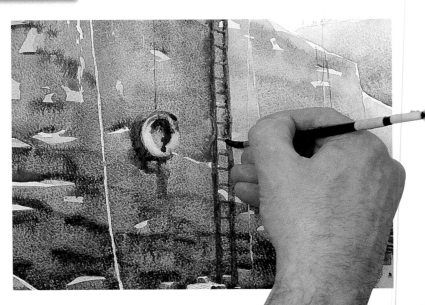

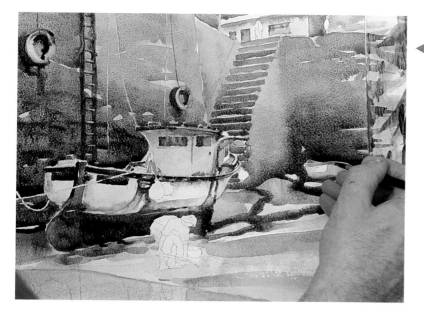

◄ **11** Using the No.12 brush, wash in wet layers of cerulean, cobalt, raw sienna and rose for the foreground water. Paint a darker wash at the foot of the side wall with raw sienna/cobalt and add burnt sienna for the shadows under the boat. Use the No.4 brush for the smaller boat, with washes of raw sienna and cobalt. Apply cobalt for the stripe around the top, going over it with rose and then burnt sienna.

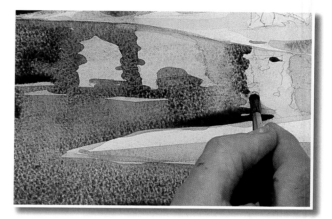

▶ **12** To work up the murky foreground, loosely wash in a very wet mixture of raw sienna/burnt umber/cobalt, allowing streaks to run down and form dark pools along the edge of the waterline. Paint around the edge of the reflections in the water, making them delicate and uneven.

◄ **13** Apply wet washes to the foreground water. Use burnt umber/ultramarine for the darkest tones. Use sweeping, gestural brushstrokes for the dark areas on the left. Spatter the paint to suggest pebbles on the right (inset below). Back on the wall, put in the handrail at the top of the ladder with a neutral color and the No.2 brush (inset left).

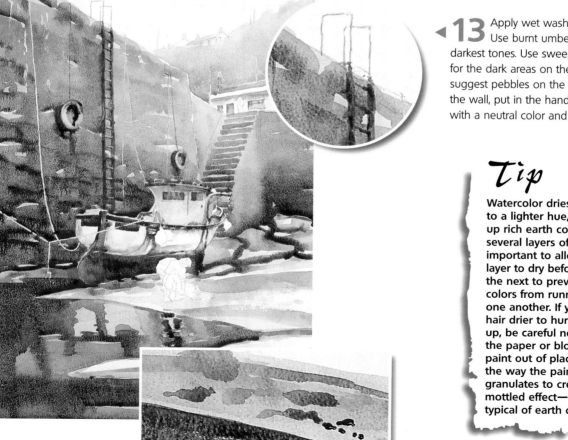

Tip

Watercolor dries naturally to a lighter hue, so to build up rich earth colors, apply several layers of wash. It's important to allow each layer to dry before applying the next to prevent the colors from running into one another. If you use a hair drier to hurry things up, be careful not to scorch the paper or blow the wet paint out of place. Notice the way the paint granulates to create a mottled effect—this is typical of earth colors.

ultramarine

alizarin crimson

wash for canal water

▲**1** Use the No.14 brush to make a light underpainting of the subject, establishing the position of the main dome and buildings. Paint the canal water in washy ultramarine/alizarin crimson, ready to receive the main colors, which will include complementary greens and ochers.

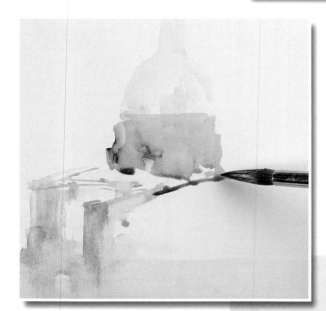

▲**2** Paint the shaded side of the dome in washy indigo. While this is still wet, block in the rest of the dome in cadmium yellow. Use the tip of the brush to drag the mixture along the roof, defining the top of the building.

▶**3** Block in shady areas on the buildings in washy permanent rose/ultramarine. Suggest sunlit areas in diluted cadmium yellow/permanent rose. Paint the horizon of the water in diluted ultramarine. Establish vertical reflections in permanent rose/cadmium yellow with touches of ultramarine.

◀ **4** Apply a pale wash of permanent rose to the sky. Overpaint the area in pure cadmium yellow, applying the color in vertical and horizontal strokes.

◀ **5** Paint the sunlit facades of the building in cadmium yellow/yellow ocher. Dab in architectural detail in indigo/ultramarine with the tip of the brush. Add dabs of these colors to the reflections in the canal as you work. Establish the smaller dome in separate washes of cadmium yellow and indigo, and paint the tiled rooftops in cadmium red/cadmium yellow.

▶ **6** Use light, vertical strokes to overpaint the sky above the buildings in cerulean/cobalt blue. Blend this into the alizarin/yellow underpainting on the left side. Strengthen the blue mixture to paint carefully around the dome, defining the shape with a clean, precise outline.

sky color

cerulean

cobalt blue

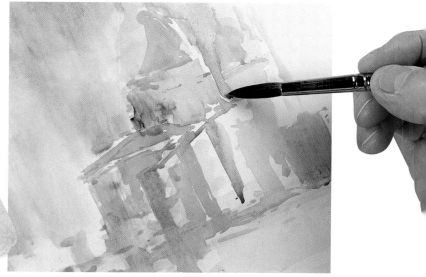

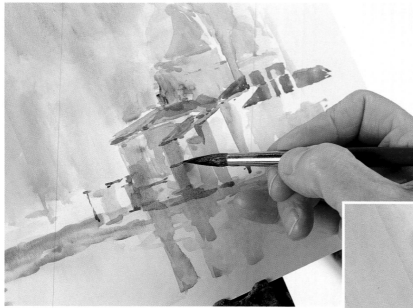

◄**7** Develop the buildings, strengthening the rooftops in a darker mixture of cadmium red/cadmium yellow. Work around the chimneys, leaving these as unpainted white shapes. Develop the buildings, dabbing in windows and archways in ultramarine and cadmium orange. Add linear shadows in ultramarine with the tip of the brush.

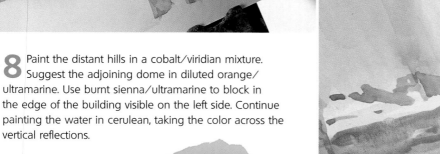

►**8** Paint the distant hills in a cobalt/viridian mixture. Suggest the adjoining dome in diluted orange/ ultramarine. Use burnt sienna/ultramarine to block in the edge of the building visible on the left side. Continue painting the water in cerulean, taking the color across the vertical reflections.

lemon yellow

cadmium red

mixture for distant buildings

Expert opinion

Q My initial washes are sometimes too dark because I find it difficult to judge how light or dark a color will be when it dries. Is there a simple way of getting this right?

A The safest method is to start light and build up the washes in layers until you get the tone you want. This gives you control over the final result. In this painting, very pale washes were used tentatively at first to establish the composition and the position of the buildings. Tones were built up gradually in a series of loosely overlaid colors, allowing the early washes to show through.

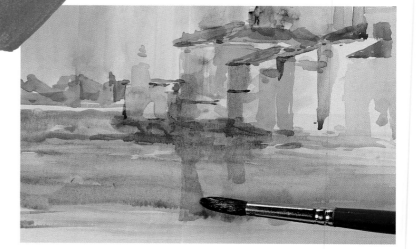

▲**9** Add a few broad strokes of viridian/cerulean to the water in the foreground, painting over the reflections. Add touches of pure cadmium red to the tiled roofs and block in the distant buildings in cadmium red/lemon yellow. Add a little of this mixture to the water.

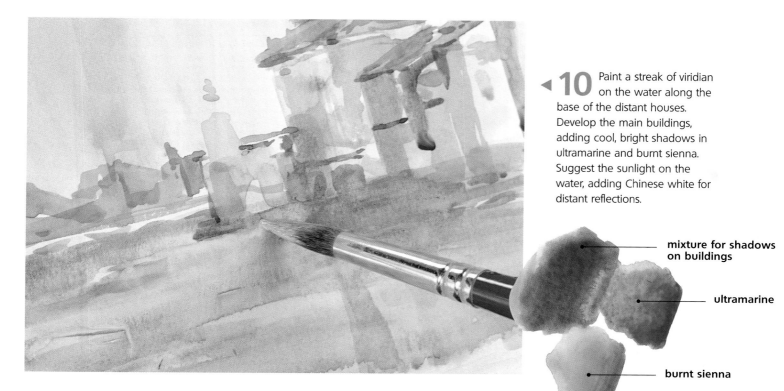

◄ **10** Paint a streak of viridian on the water along the base of the distant houses. Develop the main buildings, adding cool, bright shadows in ultramarine and burnt sienna. Suggest the sunlight on the water, adding Chinese white for distant reflections.

mixture for shadows on buildings

ultramarine

burnt sienna

◄ **11** Introduce a little black into the painting to define the bell towers and the curves on the two domes. These details should be suggested rather than overstated, so use fine, broken brushstrokes rather than heavy, continuous lines.

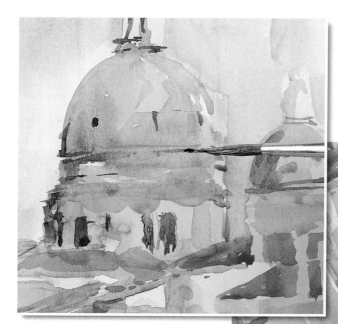

► **12** Strengthen any highlights and shadows in the architecture that now appear too faint compared with the surrounding tones. Add more highlights in yellow ocher/Chinese white, using the same color to add small, vertical reflections in the water.

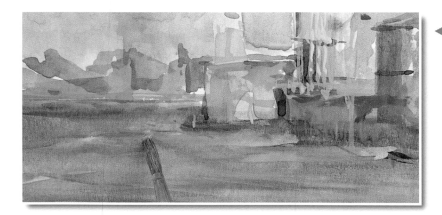

13 Add more detail to the main building in black. Strengthen the roof tiles in bright cadmium orange. Use the sable script liner brush to define the shadows and shapes of the rooftops in burnt sienna. Add a few strokes of Chinese white to the water in the foreground.

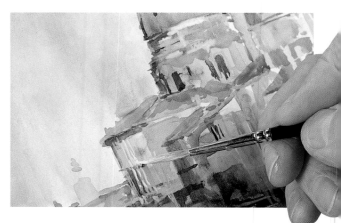

14 Change to the No.4 brush and block in any unpainted shadows and gables in ultramarine and burnt sienna. Add more detail to the buildings on the right, accentuating the sunlit areas on the dome and the facades in Chinese white/yellow ocher.

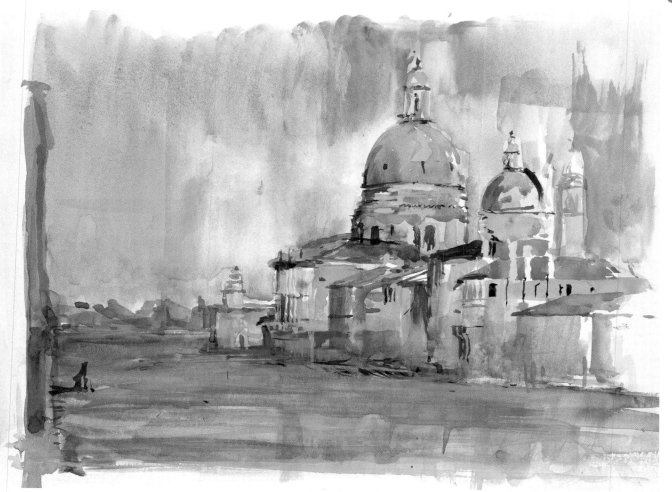

15 Define and darken the shadows on the tiled rooftops in burnt sienna. Dab cool shadows mixed from viridian/ ultramarine onto the front of the building. Finally, dab in suggestions of carved stonework around the base of the dome.

FINISHED PICTURE
The sky and canal have been deliberately left as areas of loose, bright overlaid washes, which contrast very successfully with the more controlled brushwork and detail on selected areas of the domes, bell-towers and facades.

The Grand Canal, Venice
by *David Carr*

Indian market

A busy street market offers contrasts of color, shape and tone—impose unity by developing the entire picture at the same time.

Exotic produce, billowing canopies and jostling shoppers provide a colorful, rewarding subject. With such complex material, it's important to simplify the subject, and to decide what the theme of the painting is to be. In this case, the artist focused on the pattern of lights and darks, the repeated curves of the baskets and the bright colors of the marketplace. There are several tricks for giving such a colorful subject a sense of coherence. Use a limited palette of colors and mix washes in a big palette or in several mixing saucers. Eventually you will produce a range of mixed palette washes—use these as a basis for your darkened tones and the colors will link together harmoniously.

The setup

This painting is based on two photos taken in a busy market in Mysore in India. The composition is taken from the right-hand photo, but two figures from the left-hand photo are also included.

▶ REFERENCE PHOTOGRAPHS
There is plenty of pictorial potential to be found in a busy and colorful street scene—the generous curves of the baskets in which the produce is displayed, for instance, and the swooping shape of the canopies.

◀ TONAL SKETCH
An analytical sketch such as this one simplifies the composition and helps with the consideration of patterns of lights and darks. This sketch was made on tinted paper with charcoal and white gouache for the highlights.

What you need

- A 20 x 15in (50 x 38cm) sheet of 140lb (300gsm) good-quality cold-press watercolor paper
- Masking tape
- Drawing board
- Soft carpenter's pencil
- Masking fluid and cotton swab
- 12 paints: cerulean, cobalt, Winsor blue, cadmium yellow, raw sienna, raw umber, yellow ocher, cadmium red, alizarin crimson, viridian, Winsor violet, Chinese white
- White gouache
- Two brushes: No.10 and No.12 round
- Charcoal
- Scalpel or utility knife
- Two jars of water
- Mixing palettes

▲**1** Make an underdrawing of the subject with the carpenter's pencil. Make the drawing more emphatic than usual because the subject is complex. This won't be a problem because the pencil lines will disappear under the strong, contrasting tones.

▲**2** Mask the highlights where the shafts of sunlight illuminate the heaps of fruit and vegetables. Use a cotton ball to apply the fluid.

Tip

Use a carpenter's pencil for tonal sketches. The broad tip gives quick and even coverage for areas of tone, and can be turned to give a narrow line.

▲**3** Mix a pale wash of cadmium red with cadmium yellow to give a warm tone for the foreground. Using the No.12 round brush, apply this color loosely, rolling the brush to get variegated coverage.

4 Block in the awnings. Use cobalt/cerulean for the large swathes of blue fabric—a pale wash where the light shines through, a darker tone where the fabric is bunched. Use raw sienna for the honey-colored awning. Add dark shadows in yellow ocher, raw umber and Winsor violet—this helps to establish a tonal range.

5 Mix cobalt, raw umber and Winsor violet—cobalt and raw umber granulate to give an interesting texture (inset). Using the No.12 brush, wash the mixture over the shadowy area on the left. Then apply a paler wash of the yellow ocher/raw umber/Winsor violet mixture under the honey-colored awning on the right to give this area a sense of depth.

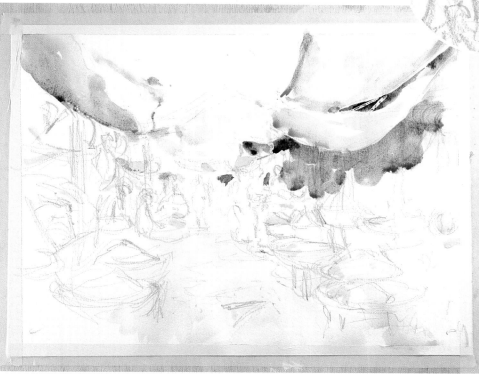

6 Add warm, dark shadows under the awning on the left—use a mixture of yellow ocher, raw umber and Winsor violet applied wet in wet.

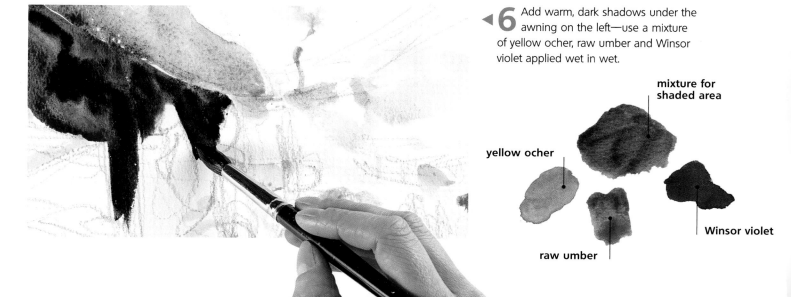

mixture for shaded area

yellow ocher

raw umber

Winsor violet

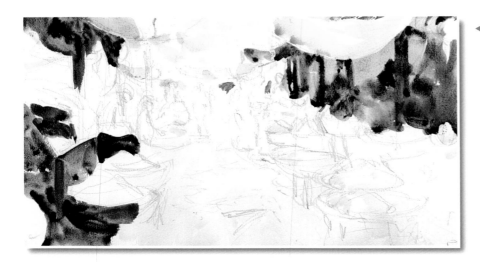

◀ **7** Develop the shaded area in the left foreground, using the mixture of yellow ocher, raw umber and Winsor violet. Then work into the shadows on the right with Winsor blue, raw umber and Winsor violet.

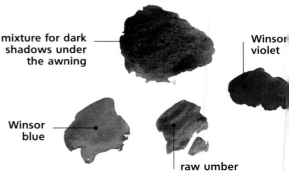

mixture for dark shadows under the awning

Winsor violet

Winsor blue

raw umber

▶ **8** Use cobalt and alizarin crimson for the pavement shadows, applying the color loosely. Mix yellow ocher and cadmium red and use this for the repeated curves of the baskets (inset). While the color is still wet, drop in darker tones wet in wet—use the yellow ocher/raw umber/Winsor violet mixture.

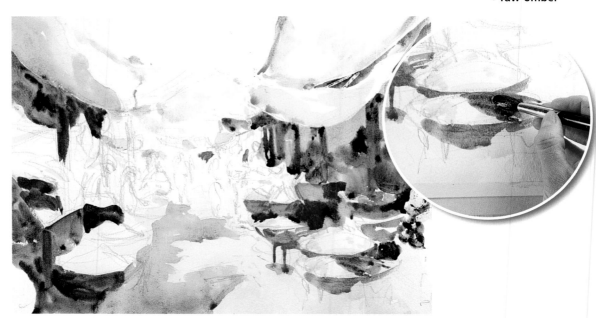

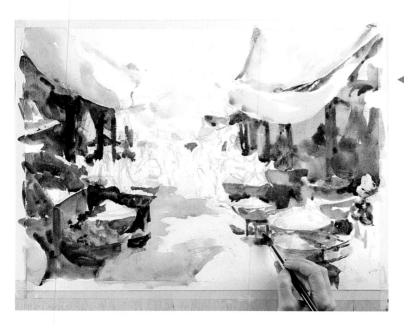

◀ **9** Add details to the left foreground. Use alizarin, raw umber and violet for the onions, viridian and cadmium yellow for the cool green, cobalt and cadmium yellow for the green peppers in the front, with cadmium yellow for the highlights. To keep the entire picture surface advancing, work on the right side, too, adding touches of dark tone and natural color.

Tip

The figures give a sense of scale, recession and movement. If you paint them very simply as small patches of color and light and dark tones, they will emerge from the patchwork of dabs of paint and be recognizable as figures. If they become too precise, smudge the paint with a tissue.

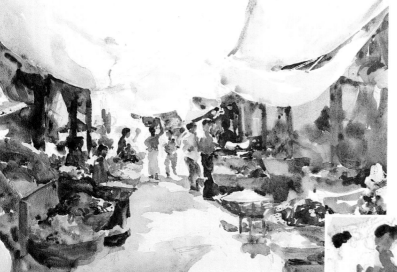

◀ **10** Render the vendors on the left with a few strokes of the brush. The man in the red shirt draws the eye into the picture (inset left). The graceful woman with the basket on her head (inset right) and the boy in lilac are "borrowed" from another photo. Add touches of burnt sienna in the background to close that area off.

◀ **11** Blob in a mixture of cobalt and cadmium yellow for the foliage in the background, and cerulean for the blue sheeting. The blue melts into the background and draws the eye into the picture space.

Expert opinion

Q Sometimes I don't stretch my paper and it buckles—is there any way of flattening a finished painting?

A Once the painting is completely dry, lay it face down on a drawing board. Wet it evenly with a sponge then fix it with a strip of gummed brown paper tape—as you would if you were stretching a clean sheet of paper. Let it dry naturally and flat. When you remove it from the board, it will be completely flat.

▲ **12** Remove some of the masking fluid from the highlights in the background on the left, and start to tighten up details of the fruits and vegetables.

▲**13** Use Winsor blue/raw umber/Winsor violet for the watermelons at the back on the right. Add shadows to the awning. Remove the masking fluid from the peppers in the front, then add shadows with a mixture of viridian/Winsor blue/alizarin.

▲**14** Remove the final bits of masking fluid. Apply touches of light and dark tone here and there to pull the image together—a pale blue wash over the peppers, for example. Use the scalpel or knife to scratch highlights into the peppers.

▲**15** Scratch in highlights on the fruits and the baskets. Use watercolor plus Chinese white to bring light into the shade under the awning: Winsor blue/cerulean/Chinese white for the melons; alizarin/Winsor violet/raw umber/Chinese white for the struts.

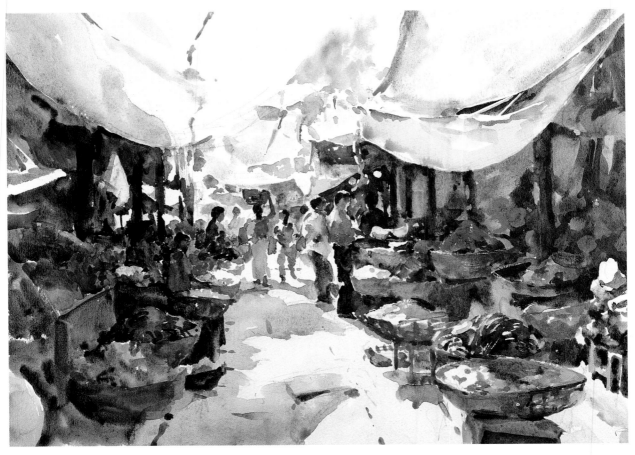

▲**16** To finish, use the tip of the No.10 brush to lay in the shadows on the edges of the paving stones in raw sienna/raw umber. The lightly indicated perspective lines draw the eye into the market and underline the sense of recession.

FINISHED PICTURE
The painting captures the rich color and pattern of this cheerful market scene, and the play of light and shadow that binds the complex and varied surfaces together.

Market in Mysore, India
by *Abigail Edgar*

Artist resources

You should be able to find the materials you need at your favorite local art or craft supply store, mail order catalog or web site. If you cannot find the items you need, you can try contacting one of the manufacturers or suppliers on this list.

Manufacturers

Ampersand Art Supply
1500 E. Fourth Street
Austin, TX 78702
Phone: (512) 322-0278
Toll Free: (800) 822-1939
E-mail: bords@ampersandart.com
Web: www.ampersandart.com

Da Vinci Paint Co.
(800) 55-DVP-55
www.davinicipaints.com
Watercolor paints
Web: www.davincipaints.com

Daler-Rowney USA
2 Corporate Drive
Cranbury, NJ 08512-9584
Tel (609) 655-5252
Fax (609) 655-5852
Web: www.daler-rowney.com

Daniel Smith
P.O. Box 84268
Seattle, WA 98124-5568
Toll Free: 1-800-426-7923 (customer service)
Fax: 1-800-238-4065
Web: www.danielsmith.com

Delta Technical Coatings
2550 Pellissier Place
Whittier, CA 90601
Tel: (800) 423-4135
Web: www.deltacrafts.com

Golden Artist Colors, Inc.
188 Bell Road
New Berlin, NY 13411
Phone: (607) 847-6154
Toll Free: (800) 959-6543
Fax: (607) 847-9868
E-mail: orderinfo@goldenpaints.com
Web: www.goldenpaints.com

Grumbacher, Inc.
2711 Washington Blvd
Bellwood, IL 60104
Toll Free 800-323-0749
Fax (708) 649-3463
Web: www.sanfordcorp.com/grumbacher

HK Holbein Inc.
P.O, Box 555
20 Commerce Street
Williston, Vermont 05495
Tel: (802) 862-4573
Fax: (802) 658-5889
Web: www.holbeinhk.com

Liquitex Artists Materials
P.O Box 246
Piscataway, New Jersey 08855
Tel: 1-888-4-ACRYLIC
Web: www.liquitex.com

Pearl Paint
308 Canal Street
New York, NY 10013
Tel: (212) 431-7931
Web: www.pearlpaint.com

Suppliers

Art Supply Warehouse (ASW Express)
5325 Departure Drive
Raleigh, NC 27616-1835
Toll Free: 1-800-995-6778
Fax: 1-919-878-5075
Web: www.aswexpress.com

Asel Art Supply
2701 Cedar Springs
Dallas, TX 75201
Toll Free 888-ASELART (for outside Dallas only)
Tel (214) 871-2425
Fax (214) 871-0007
Web: www.aselart.com

Back Street, Inc.
3905 Steve Reynolds Blvd.
Norcross, GA 30093
Tel: (770) 381-7373
Fax:(770) 381-6424

Cheap Joe's Art Stuff
374 Industrial Park Drive
Boone, NC 28607
Toll Free: 1-800-227-2788
Fax: 1-800-257-0874
Web: www.cjas.com

Dick Blick Art Materials
P.O. Box 1267
695 US Highway 150 East
Galesburg, IL 61402-1267
Toll Free: 1-800-828-4548 (to place an order)
Toll Free: 1-800-933-2542 (for product info)
Toll Free: 1-800-723-2787 (customer service)
Fax: 1-800-621-8293
Web: www.dickblick.com

Flax Art & Design
240 Valley Drive
Brisbane, CA 94005-1206
Toll Free: 1-800-343-3529
Fax: (415) 468-1940
Web: www.flaxart.com

Hobby Lobby
7707 SW 44th Street
Oklahoma City, OK 73179
Tel: (405) 745-1100
Web: www.hobbylobby.com

Home Depot U.S.A., Inc.
2455 Paces Ferry Road
Atlanta, GA 30339-4024
Tel: (770) 433-8211
Web: www.homedepot.com

Michaels Arts & Crafts
8000 Bent Branch Drive
Irving, TX 75063
Tel: (214) 409-1300
Web: www.michaels.com

New York Central Art Supply
62 Third Avenue
New York, NY 10003
Toll Free: 1-800-950-6111
Fax: (212) 475-2513
Web: www.nycentralart.com

Silver Brush Limited
92 Main Street, Bldg. 18C
Windsor, NJ 08561
Tel: (609) 443-4900
Fax: (609) 443-4888

The Artist's Place
16000 Yucca St.
Hesperia, CA 92345
Toll Free 1-800-278-7522
Tel (760) 947-7400
Fax (760) 947-7111
Web: www.artistplace.com
General art materials, including encaustic materials and tools

Zim's Crafts, Inc.
4370 South 300 West
Salt Lake City, UT 84107
Toll Free 1-800-453-6420
Tel (801) 268-2505
Fax (801) 268-9859
Web: www.zimscrafts.com

Index

Page numbers in *italic* indicate illustrations

Acknowledgements

Paul Banning 25; Chris Beetles (Roy Hammond) 19, 83, 163; (Charles Knight) 37; Linda Birch 3(l), 38, 60, 63–64, 147–152; Bridgeman Art Library (Trevor Chamberlain/Private Collection) 15, (Izabella Godlewska de Aranda/Private Collection) 51, (Lesley Fotherby) 49, (Patrick Procktor RA/Redfern Gallery, London) 95; David Carr 99(br), 111–116, 205–210; Trevor Chamberlain 31; John Cleal 87; David Curtis 167–172; Derek Daniells 117–122; Peter Davey 17; Joe Francis Dowden 3(cr), 9(tl,br), 23–24, 30, 32, 34, 36, 50, 52, 56, 101–104, 177–182, 189–192; Eaglemoss 21–22, 68–70, 72–74, 76–78, 80–82, 84–86, 88–94, 96–98; Patrick Eden/Isle of Wight Photography 133(b); Abigail Edgar 211–216; Eye Ubiquitous/W. McKelvie 189(t); Shirley Felts 99(bl), 173–176;

Peter Folkes 79; 183–188; Dennis Gilbert 11, 99(tr), 157–162; Kate Gwynn 12, 20; Frank Halliday 105–110, 183–188; Robert Jennings 45, 67; Brian Lancaster 39, 53; John Lidzey 13; Ronald Maddox 55; Mall Galleries/Andy Wood 29; Peter Marshall 9(tr), Sally Michel 59; Keith Noble 3(cl), 18, 91, 199–204; Kay Ohsten 127–132; John Raynes 99(tl), 141–146; Polly Raynes 40, 61–62, 137–140; Darren Rees 57–58; Royal Watercolour Society/Michael Whittlesea 33; Ian Sidaway 3(r), 16, 26(l), 27–28, 193–198; Adrian Smith 123–126, Stan Smith 153–156; Hazel Soan 47; Tate Britain/Mark Heathcote 163(t); Jenny Wheatley 71, 75; Albany Wiseman 9(bl), 14, 26(tr), 41–44, 46, 48, 54, 133–136.

Thanks to the following photographers:
Edward J Allwright, Simon Anning, Paul Bricknell, Mike Busselle, Mark Gatehouse, Brian Hatton, Peter Marshall, Graham Rae, Nigel Robertson, Steve Shott, John Suett, Steve Tanner, George Taylor, Mark Wood.